hidden architecture

buildings that blend in

Lannoo

Introduction

The world's best-known buildings are mostly grand edifices, designed to make a bold statement that signals their importance. For centuries, architects have been commissioned to create palaces, cathedrals, government buildings, concert halls, museums and, more recently, giant residential and office towers that dominate their surroundings. Certain contexts, however, demand subtle and discreet architectural interventions that blend in with their urban or rural settings. These hidden buildings are often skilfully designed to minimise their visual presence, and built using materials that complement their context.

This book presents 33 innovative architectural projects that are concealed in settings which include cities, suburbs, forests, mountains and deserts. It explains whom these buildings were designed for, how they were constructed, and why they are hidden. None of these examples is completely invisible; rather they all sit discreetly within the existing environment or merge with their surroundings to disguise their overall mass. Some are partially buried underground or are topped with planted roofs so they appear as an extension of the landscape. Others nestle among trees in dense forests, or are squeezed onto tight urban

sites encircled by neighbouring buildings. Each one has a reason for being hidden, which has prompted a unique architectural response.

The book is divided into five sections that focus on a particular context in which buildings are commonly concealed, or a technique architects regularly turn to when there is a need to camouflage their projects. The five sections help to group the case studies loosely together and include introductions that explore the different approaches to hidden architecture in more detail. Many of the projects fit within more than one of the categories; they are placed in the one that best encapsulates their defining feature.

The first section looks at buildings Hidden in Nature. These are mostly residences constructed in locations that require protection to preserve their natural beauty. The second brings together innovative examples of buildings Hidden in the City. These houses, hotels, museums and educational buildings are situated in dense urban settings where it is sometimes necessary to adopt a disguise in order to provide privacy or avoid disrupting the existing cityscape.

The final three sections examine common approaches used to help buildings blend in with their environment. Underground Buildings focuses on structures that merge with the natural terrain. These buildings are embedded into hillsides or submerged below ground to preserve the existing landscape as much as possible. Green Roofs are often used to cover structures so they disappear into the surroundings, particularly when viewed from above. These living surfaces have environmental benefits and can even be used for agriculture. The final section explores how architects use mirrored and transparent materials to make buildings appear less dense or dominant. Glass and Mirrors may reflect a structure's surroundings or allow views straight through it, creating visual illusions that distort or conceal the form.

Why buildings are hidden

It is becoming increasingly difficult to find places on Earth where human beings haven't already made a noticeable mark. Wherever people live, our buildings and infrastructure provide visible indicators of our

Introduction

presence. Away from inhabited areas, the remaining natural wildernesses are continuously being encroached upon by agriculture, mining and deforestation. Land and oceans are being plundered to provide food and resources for our communities, while the atmosphere and climate gradually react to the waste produced by our industrialised society.

Preserving the appearance of beautiful places and fragile ecosystems is becoming increasingly important as urbanisation continues at an unprecedented pace. Planning regulations are one of the key tools local authorities use to prevent inappropriate development. These laws exist to protect areas of outstanding natural beauty, as well as sites of historical or social significance. Hiding a building from view is sometimes accepted as a compromise when new development is required. Even if a structure cannot be completely concealed, it is often possible to design an appropriate form that may help secure the necessary permissions for it.

Responses to regulations vary depending on the specific laws relating to a site. Planning restrictions often outline the permissible built area, how tall a building can be, and how its design should respond to the surrounding environment. In certain locations, for example, the law may allow a property's usable floor area to be expanded if a portion of this space is hidden underground. Greek firm Scapearchitecture took advantage of a local building code when designing a holiday home embedded in a hillside on the island of Paros (page 104). Reinstating the original slope above the main living areas allowed the internal dimensions to be double what would have been permitted if the house had been built entirely above ground.

Another common reason for hiding or disguising a building is to protect the privacy and security of its occupants. Particularly in urban environments, it may be important to limit overlooking by neighbouring buildings and present a closed façade to the surrounding streets. Houses in these inner-city settings often feature living spaces shielded behind robust, solid walls that offer no clue to what is inside. Architects must then find inventive ways to ensure the occupants have adequate access to natural light, views and fresh air. The best hidden buildings manage to balance their low-key external appearance with high-quality interior spaces that still feel connected to the outdoors. This can be achieved by

including skylights, enclosed courtyards or cleverly positioned openings, or by using materials that provide views only from inside to outside.

Many planners, developers and private clients today recognise their responsibility to build only where necessary and to ensure whatever is constructed will enhance its surroundings. Rather than choosing to design buildings that attract attention, they opt for a more discreet approach focused on preservation, practicality and sustainability. With the right brief and with support from clients, engineers and planning authorities, a good architect helps to fulfil these requirements while adding value to a site. Buildings that are intelligently designed to blend in with their context make a strong statement about the need to protect the world we live in and how to leave it in a better state for future generations.

How buildings are hidden

The methods architects use to conceal buildings are many and varied. Factors that typically influence the approach taken include the project's context, brief, budget and architectural ambitions. The case studies included in this publication range from diminutive residential extensions constructed using affordable, off-the-shelf materials, to big-budget cultural institutions. Whatever method is used to conceal a building, the project's success is likely to depend on a combination of creative thinking, technical ingenuity and attention to detail.

Making a building disappear into its surroundings is a challenging and unusual task that requires a talented, progressively minded architect. This book features work by some of the world's largest and most innovative firms, including MVRDV, Sou Fujimoto Architects, BIG, Snøhetta and AL_A. These companies have built their reputations by creating ground-breaking buildings that challenge architectural conventions. Plenty of examples of hidden architecture developed by emerging architects and smaller practices are also included here. The majority of these are residential buildings, often completed on a tight budget and in close collaboration with the clients. The quality and uniqueness of the various outcomes demonstrates the value a good architect brings to any project, particularly when an unconventional solution is required.

Introduction

Many examples of hidden architecture utilise complex construction methods, cutting-edge technologies and advanced materials to embed themselves in their site or to blend in with the landscape. Buildings submerged in the ground represent a particularly significant challenge that often requires major structural works, including retaining walls and frameworks capable of supporting extremely heavy roofs. The green roof of whisky brand The Macallan's distillery, for example, is placed on top of a complex timber and steel framework comprising approximately 380,000 individual components (page 148), while AL_A's subterranean extension for London's V&A Museum is buried 18 metres below ground and is supported by 50-metre-long foundation piles driven into the earth within a metre of a Grade I Listed building (page 80).

Not every site or project brief demands a technically sophisticated or highly engineered response to limit a building's visibility. Sometimes the intelligent application of contextually appropriate materials is enough to help a structure blend in with its environment. Several of the projects included in the Hidden in Nature section use local timber, stone or other materials to echo the tones and textures of the surroundings. These carefully chosen surface finishes will develop a natural patina that enhances the connection between the architecture and the landscape.

Rather than cladding a building with materials chosen to complement the local environment, some architects choose to incorporate mirrored surfaces that reflect the surroundings. Highly polished metal panels or coated plastics may create solid surfaces that appear to merge with and distort our perception of the building's form and mass. Alternatively, one-way mirror glass offers a solution that conceals the interior spaces while allowing those inside to look out. In settings where a building would otherwise dominate the scene, mirrors and glass can make the structure appear smaller, lighter and, in some cases, almost invisible.

One of the most important reasons for hiding a building is to preserve the world's beautiful landscapes, but architecture can even do more to protect nature in these fragile places. Each of the projects

presented here approaches sustainability in a different way, using modern design methodologies to produce buildings that are cleaner, greener and more efficient. Some limit their size and therefore their physical impact on the landscape, while others maintain the natural character of their site by allowing plants to grow under or over them. Still others utilise cutting-edge technologies such as highly insulating windows or ground-source heat pumps to reduce a building's energy requirements. Similar outcomes can be achieved by using more traditional architectural techniques such as shading devices to prevent unwanted solar gain, choosing materials that help to regulate heat, and including openings that allow breezes to ventilate the interior naturally.

Several of the projects feature green roofs that reinstate the original surface area of the landscape that the building occupies. Others introduce greenery to places where it didn't exist before, helping to beautify their environment and providing a habitat for wildlife. All of these are valid and vital responses to the urgent need for more responsible and sustainable building practices. Hidden buildings designed to blend in with their environments should also seek to ensure their impact on the landscape and climate is a positive one, allowing future generations to continue experiencing these magnificent places just as nature intended them.

Where buildings are hidden

There are hidden buildings in cities and rural locations all over the world. This book includes projects from 22 countries, including Finland, South Korea, Portugal, Japan, Uruguay, the USA, Iceland and Costa Rica. Many more could have been featured, but this selection provides a global overview of some interesting and inspirational examples. Wherever there are ambitious clients and innovative architects who care about preserving the condition of the environment and the public realm, you can expect to encounter buildings that are carefully and subtly inserted into their surroundings. These hidden gems may not attract the same attention as some of the world's more spectacular and iconic buildings, but their progressive designs and technical ingenuity make them well worth seeking out.

1. Hidden in Nature

16
Chapel of Sound
OPEN

20
Cloaked House
Ernesto Pereira

24
Costa Rica Treehouse
Olson Kundig

28
High Desert Retreat
Aidlin Darling Design

34
House of the Big Arch
Frankie Pappas

38
Holiday Home by
Thingvallavatn
KRADS

44
Under
Snøhetta

2. Hidden in the City

54
Amos Rex
JKMM Architects

58
House in Konohana
FujiwaraMuro Architects

64
Shiroiya Hotel
Sou Fujimoto Architects

70
TURF
Landprocess

76
The Earth
TEAM_BLDG

80
V&A Exhibition
Road Quarter
AL_A

3. Underground Buildings

90
Hill Country Wine Cave
Clayton Korte

94
Jipyoung Guesthouse
BCHO Architects

98
N Caved
Mold Architects

104
Secret Garden House
Scapearchitecture

108
Skamlingsbanken
CEBRA

112
The Hill in Front of the Glen
HW Studio

118
Tirpitz
BIG

4. Green Roofs

126
Åkrafjorden Cabin
Snøhetta

130
Green Line House
Mobius Architekci

136
Hourglass Corral
DECA Architecture

140
House Behind the Roof
Superhelix - Bartłomiej Drabik

144
Planar House
Studio MK27

148
The Macallan Distillery
Rogers Stirk Harbour + Partners

152
Villa Aa
C.F. Møller Architects

5. Glass and Mirrors

160
Arcana
Leckie Studio

164
La Madriguera
Delavegacanolasso

168
Depot Boijmans Van Beuningen
MVRDV

174
Glass House
OFIS arhitekti

180
Sacromonte Landscape Hotel
MAPA

186
The Invisible House
Rural Design

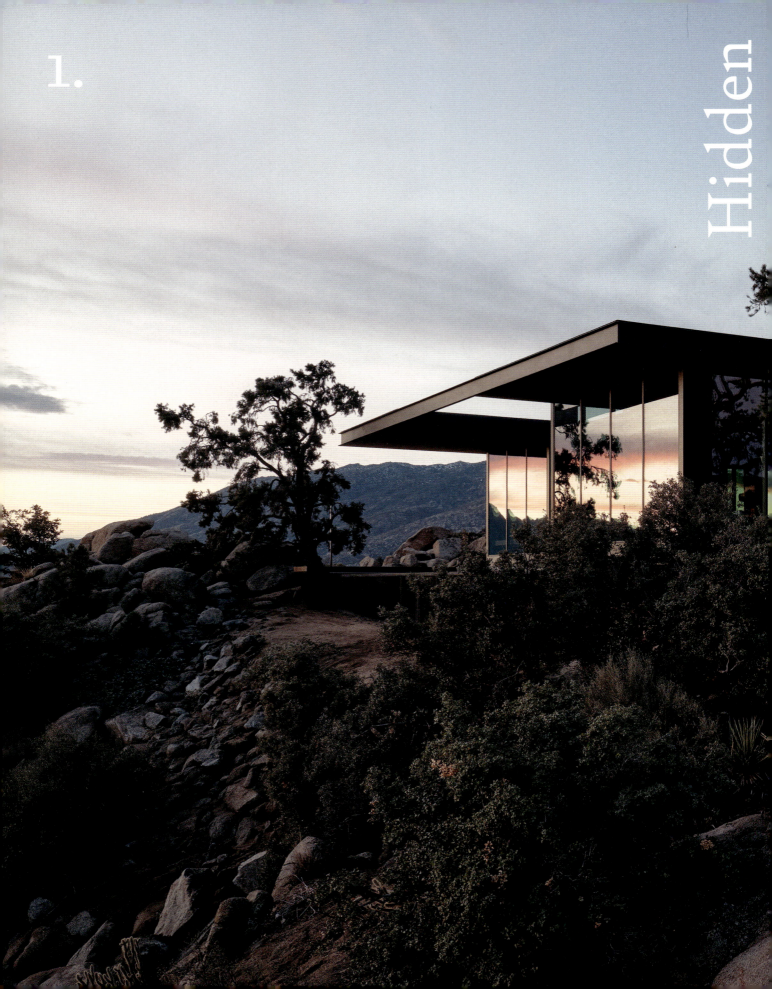

1.

Hidden

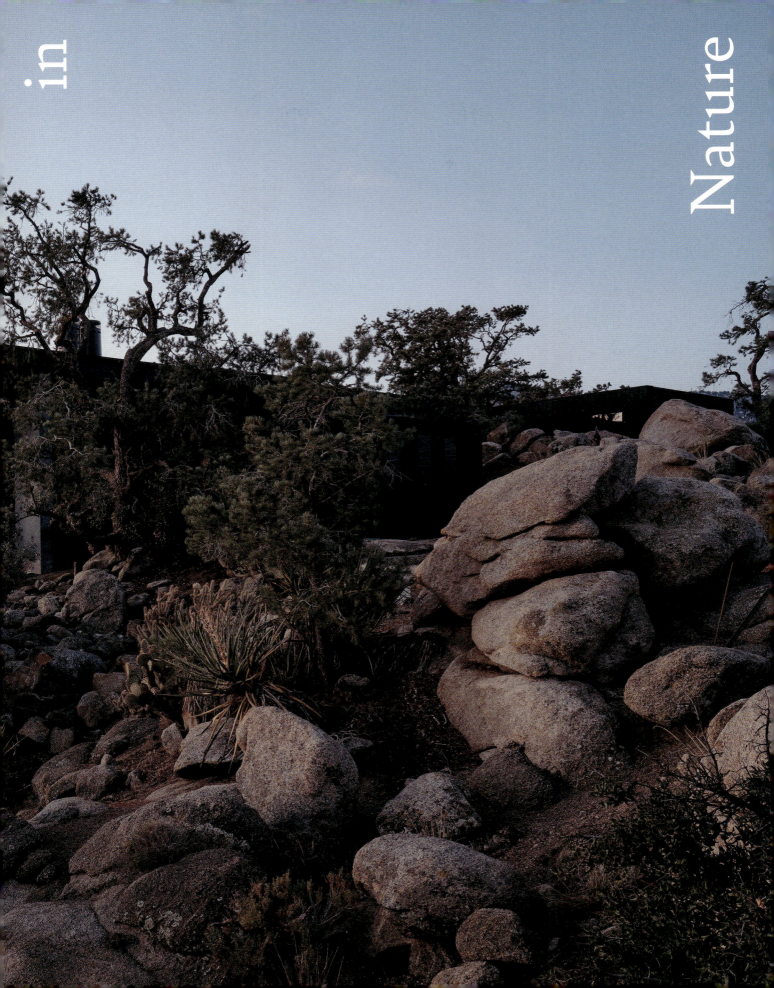

1. The American architect Frank Lloyd Wright once claimed: 'The good building is not one that hurts the landscape, but one which makes the landscape more beautiful than it was before the building was built.' The projects featured in this section seek to protect or embellish the existing landscape by blending in with the natural scenery. Their settings in forests, deserts or mountain regions often inform every aspect of the architecture, from the building's position and orientation to the use of construction methods and materials that complement the surroundings.

The most ancient and primal forms of shelter are found in nature. Our earliest ancestors lived in caves and forests, starting fires for warmth and using materials from the environment to create the first tools. Many modern residences and retreats seek to promote a basic way of living that helps their occupants feel close to nature. These projects typically adopt a sustainable and low-impact approach to their design and construction, resulting in buildings that are as much part of their environment as they are hidden within it.

Some of the finest examples of modern residential architecture take cues from their rural surroundings. Frank Lloyd Wright's Fallingwater house, completed in 1937 in Bear Run, Pennsylvania, is often cited as one of the most influential houses ever built, due to the way it seamlessly integrates with its natural setting. Fallingwater blurs the boundaries between inside and outside, with living spaces distributed across a series of stacked floor plates that cantilever over the adjacent waterfalls. The building epitomises Wright's 'organic architecture' philosophy, which sought greater harmony between people and nature.

The legacy of Fallingwater and other examples of organic architecture may be observed in many contemporary projects that seek to coexist with nature. Architects working in scenic locations often look for innovative ways to minimise the building's physical as well as its visual presence, in order to preserve a site's ecology and biodiversity. Structures that touch the ground lightly or slot in round landscape features help to ensure that existing flora and fauna continue to thrive. Frankie Pappas, the architects of House of the Big Arch (page 34) in South Africa's Waterberg mountains, surveyed an area of dense forest using a laser scanning device to identify a suitable plot for the building, which was constructed without damaging a single tree. In California, Aidlin Darling Design's High Desert Retreat (page 28) nestles among boulders and mature pine trees, while the Costa Rica Treehouse designed by Olson Kundig (page 24) is arranged over three compact storeys to allow views out over the treetops while limiting its impact on the forest floor.

Buildings designed to blend in with nature often make use of materials that echo the colours and textures of their surroundings. Timber cladding is a popular choice for buildings immersed in woodland as it helps to disguise the structure among surrounding trees. Exposed concrete, hand-made bricks and weathering steel may also be used to introduce surface textures and patina that feel appropriate in various natural settings. House of the Big Arch, for example, was built using stock bricks that echo the reddish-brown earth of its forest site, while the blackened-timber walls of the High Desert Retreat add a textured finish that is in keeping with the natural surroundings. The Chapel of Sound concert hall by OPEN (page 16) features a rugged, cast-concrete shell that echoes its mountainous setting in China's Hebei province. The irregular concrete surfaces contribute to a design that resembles a giant boulder, resulting in what the architects described as 'a thoughtful structure that fits naturally into such a unique landscape'. Snøhetta's design for a restaurant that is partially submerged in the sea on Norway's Atlantic coastline (page 44) represents an extreme example of a building that is fully integrated into its wild setting. The monolithic concrete volume breaks the surface of the water and was designed to transform over time into an artificial reef, providing a habitat for marine species.

The revered Japanese architect Tadao Ando once said: 'We borrow from nature the space upon which we build.' The buildings he designed in rural settings – as well as those of architects he admired such as Frank Lloyd Wright and Louis Kahn – seek to exist in harmony with nature rather than infringing on it. They create a dialogue with nature that emphasises our primal relationship with the earth, water, wind and plants. Respect for nature needs to remain at the forefront of architectural thinking as we seek to preserve the landscape, environment and cultural heritage of the places we build in. By cleverly concealing structures in natural settings, we can continue to create spaces of great value that are also ecologically and contextually appropriate.

Chapel of Sound

OPEN

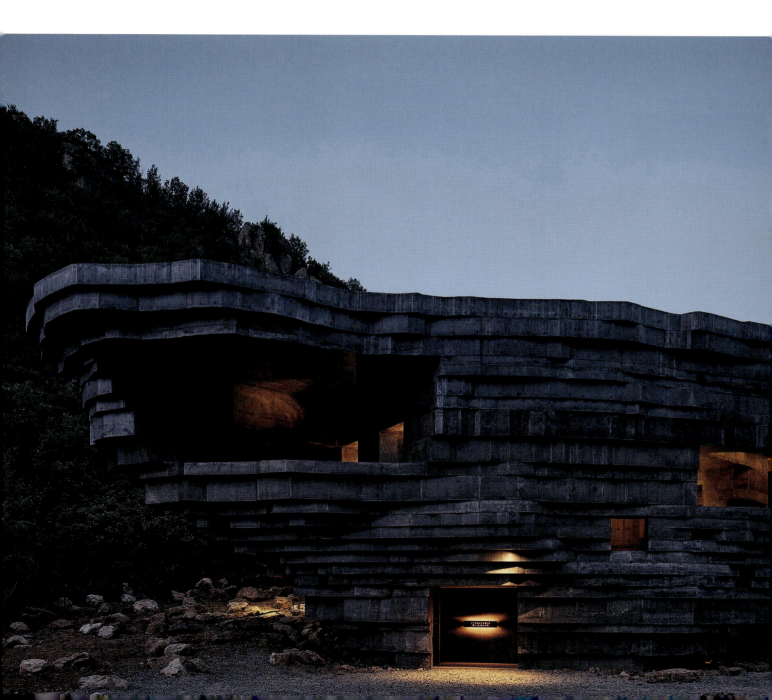

Chengde, China

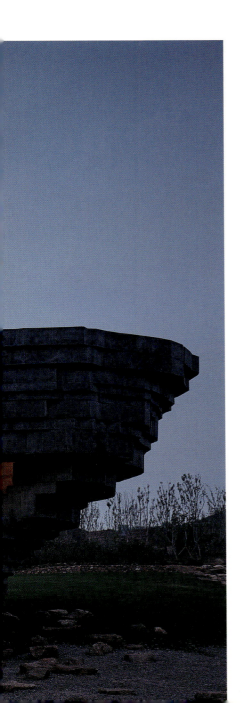

The monolithic form of this concrete concert hall in Chengde, China, references the surrounding mountain scenery and helps the building merge with its rugged natural setting. The Chapel of Sound is located in a valley approximately two hours by car from Beijing and was designed by architecture firm OPEN. The building contains an open-air amphitheatre along with an outdoor stage, viewing platforms and amenities for performers and audiences. At times when there are no performances scheduled, visitors can enjoy the sounds of nature and the views across the valley to the nearby Great Wall.

The concert hall is shaped like an inverted cone to minimise its footprint. The gently rounded form resembles a mysterious boulder that has landed gently in the landscape. Stacked layers that each cantilever outwards slightly from the one below create an irregular surface that is clearly man-made yet evokes the sedimentary rock formations of the surrounding mountains. The building was constructed using concrete enriched with an aggregate of local mineral-rich rocks to enhance its connection with the site.

OPEN collaborated closely with acoustic and structural engineers to optimise the acoustic performance of the central auditorium without the need for additional sound-absorbing materials. The architects wanted to ensure the building can also be used for contemplation and as a place to reconnect with nature. Openings in the walls allow the sounds of birdsong and rustling leaves to enter the space, which incorporates stepped seating. On wet days, rainwater cascades through a void in the centre of the roof and is quickly drained away by gutters embedded in the floor. The roof void allows daylight to illuminate the interior and contributes to the natural ventilation of the building, which has no heating or air conditioning. Minimising the concert hall's energy requirements helps to reinforce the sense of the architecture existing quietly and sustainably in the landscape.

< The concert hall's rough exterior references the striated rock formations of the nearby mountains.

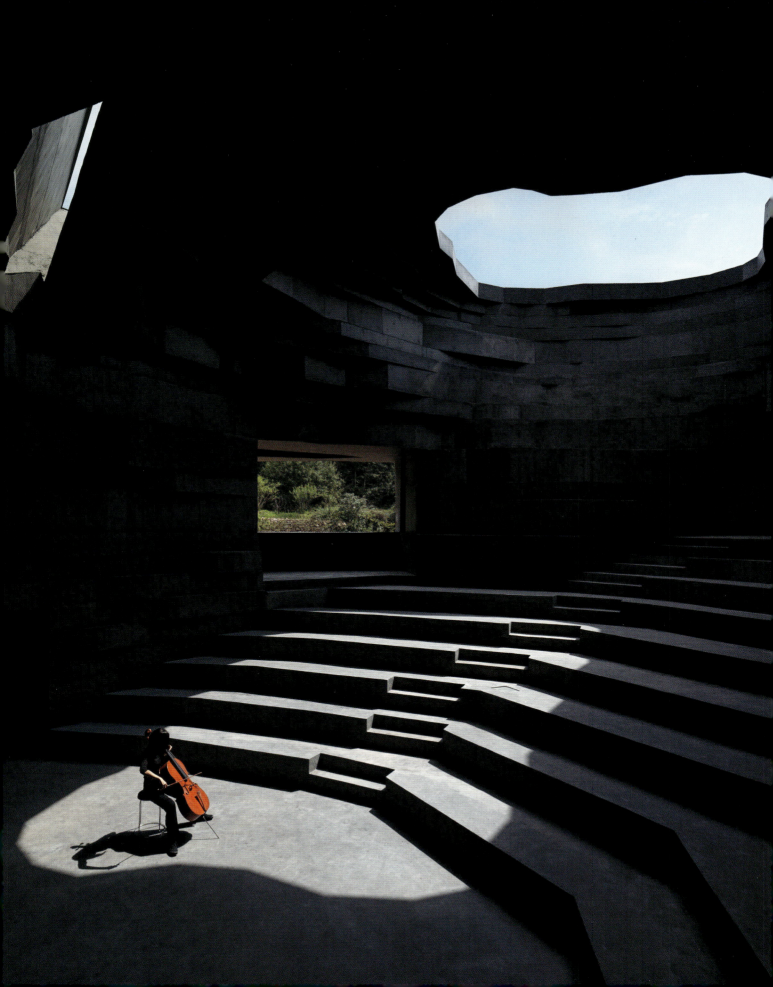

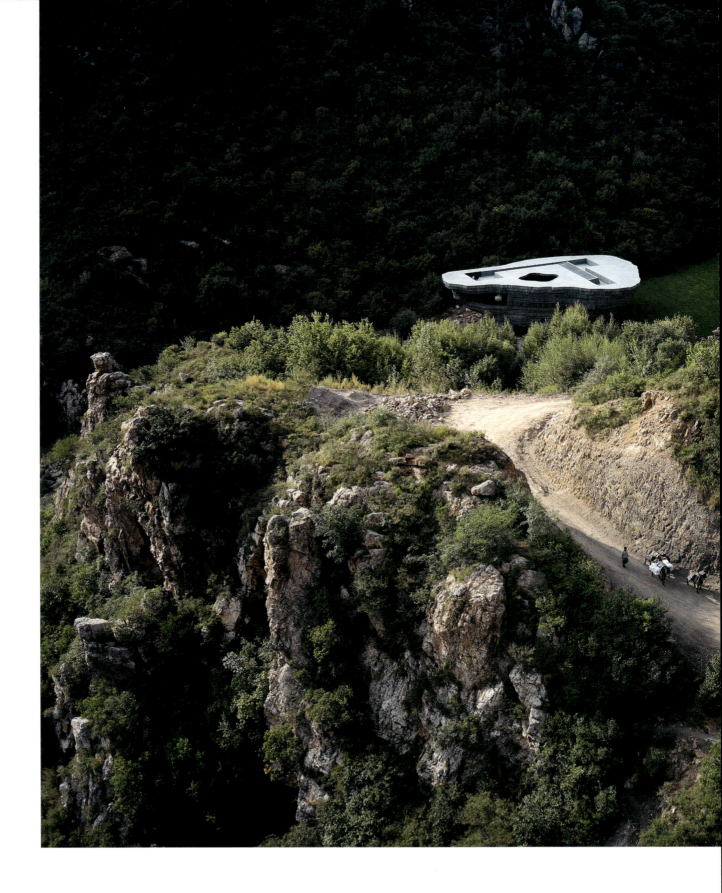

< A void in the roof allows daylight and breezes to enter the semi-outdoor auditorium.
^ The building can be used as a place for community gatherings and individual contemplation.

19.

Cloaked House

Ernesto Pereira

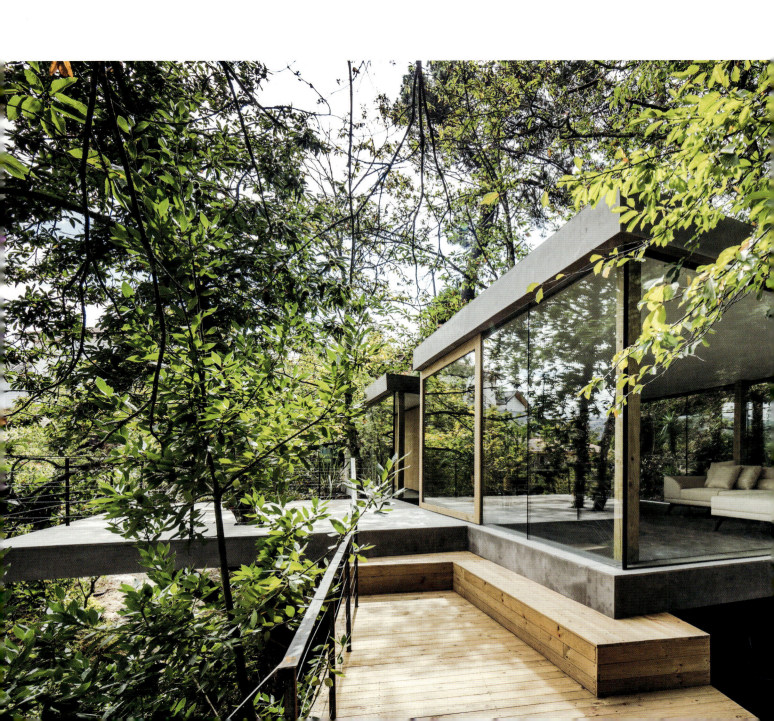

Marco de Canaveses, Portugal

Architect Ernesto Pereira employed several innovative techniques to make this house on the outskirts of the Portuguese city of Marco de Canaveses blend in with its natural setting. The building is set among chestnut trees on a steep hillside site and is oriented to optimise views across a valley. Pereira chose to adapt the house to fit within the existing landscape, rather than altering the site to accommodate the building.

The floor plan of the Cloaked House is divided into a sequence of rooms and small patios that are arranged round existing trees. Holes inserted into the patio areas allow the tree trunks to extend, untouched, through the floor slab. Almost all of the house's external walls are made from glass to immerse the occupants in the forest. The transparent surfaces also minimise the building's visual presence within the landscape and maintain views straight through the living spaces. This creates the illusion that furniture inside the house is occupying a clearing surrounded by greenery. Some of the rooms are lined with sliding doors that can be opened to connect the interiors with the terraces.

Pereira used a palette of materials that was carefully chosen to create a dialogue with the natural surroundings. Wooden pillars supporting the roof echo the verticality of nearby tree trunks. The raw, exposed grain of the squared-off columns introduces a natural texture that is complemented by timber joinery. The concrete floor and roof slabs lack any rendered finish and feature a patina that merges with dappled light filtering through the trees.

Deciduous trees surrounding the house provide effective solar shading during the hot summer months. In winter, once the trees have shed their leaves, the sun's rays pass through the branches and warm the interior. The building is topped with an earth-covered roof to help enhance its connection with nature and further camouflage it from the road above.

< The house's design is informed by its setting on a sloping plot surrounded by chestnut trees.

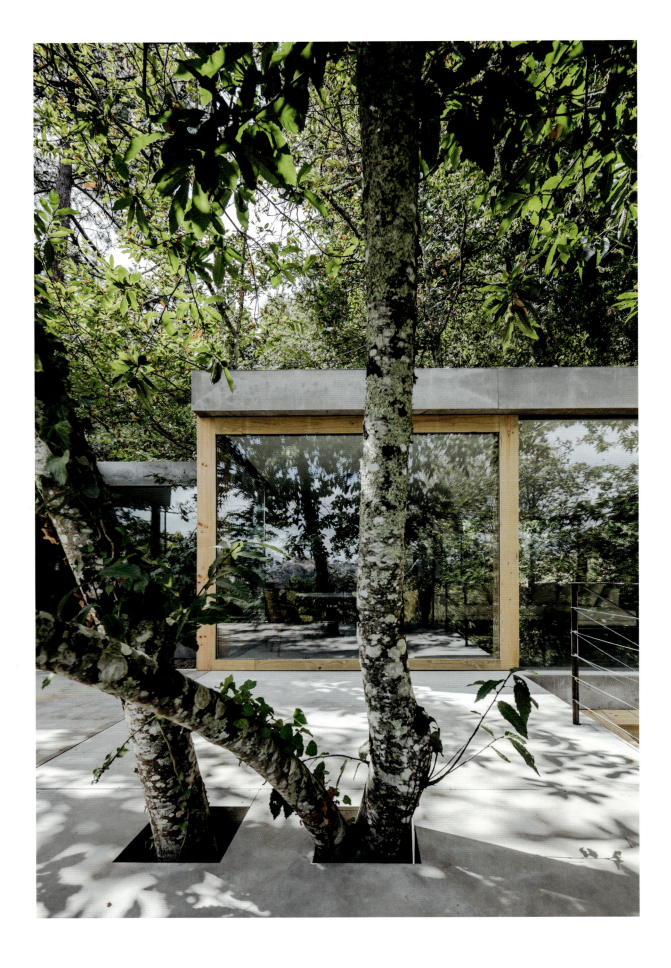

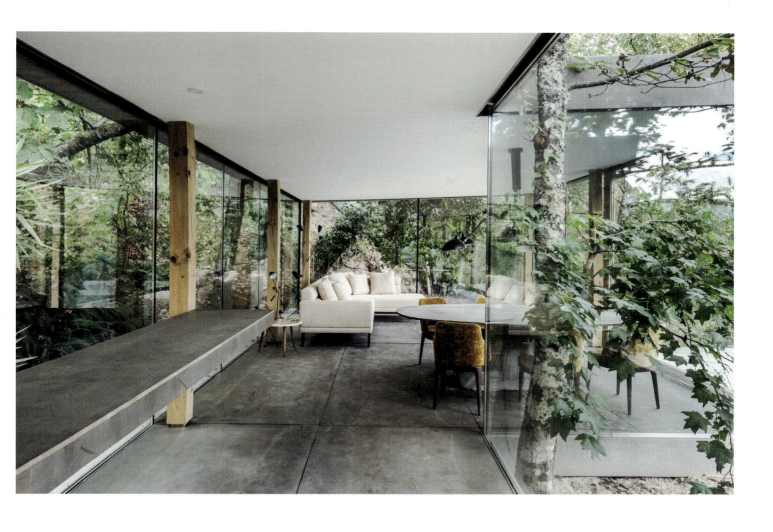

∧ Glass walls minimise the building's visual impact on the site and enhance its connection with the forest.
< Rooms are slotted in around the trees, some of which extend through openings in the external deck.

Costa Rica Treehouse

Olson Kundig

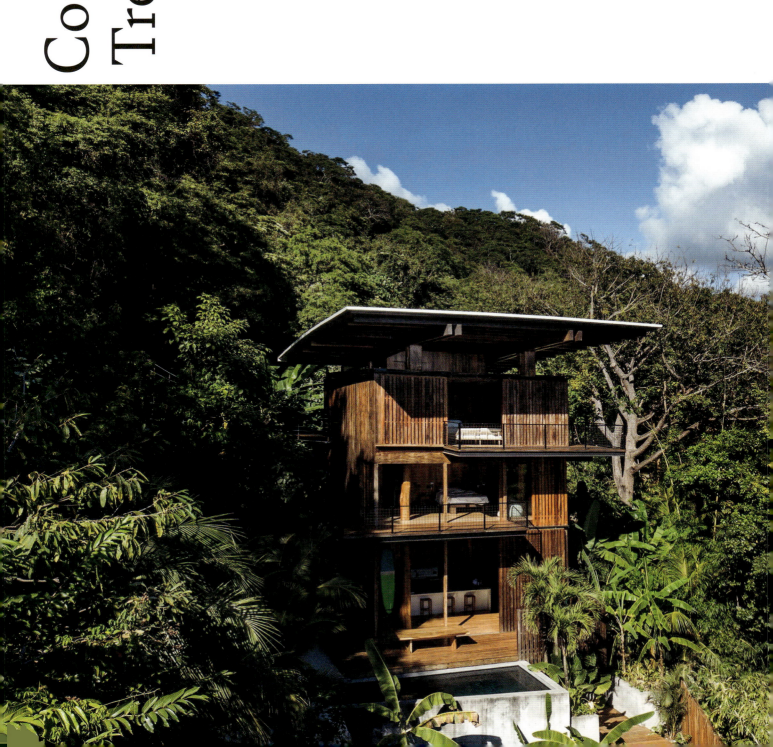

Santa Teresa, Costa Rica

The dense tropical jungle of Costa Rica's Puntarenas province conceals this house designed by Seattle-based architecture firm Olson Kundig for clients who enjoy surfing at the nearby Playa Hermosa beach. The building nestles into its forested site and features living spaces that are raised above the jungle canopy to make the most of views towards the Pacific Ocean.

The owners of the Costa Rica Treehouse are avid environmentalists, so the building is designed to minimise its impact on the landscape. Olson Kundig developed a proposal with a small footprint that occupies just 93 square metres of the forest floor. The compact plan is optimised by organising the living spaces vertically over three floors, which engage with the jungle in different ways. The bottom level contains a kitchen and dining area connected to a poolside deck that is sheltered by the dense undergrowth. The middle floor houses a bedroom hidden from view among the trees, while the living area on the upper floor opens onto a terrace suspended above the forest canopy.

The house was built entirely using locally harvested teak wood, which helps it blend in with the surrounding vegetation while reflecting the clients' commitment to sustainable land management in Costa Rica. Large tree trunks are used as columns to support the floors and roof. The building is designed to operate passively, with no artificial cooling. Taking cues from open-sided surf shacks, the top and bottom floors can be completely opened to the elements, allowing breezes to ventilate the interior naturally. Large wooden shutters can be retracted to allow daylight and fresh air into the living spaces, or closed to provide privacy and security when the house is not in use. The building also features solar panels and a rainwater collection system to further reduce its environmental impact.

< The house is inspired by its jungle setting and is built entirely from locally harvested teak wood.

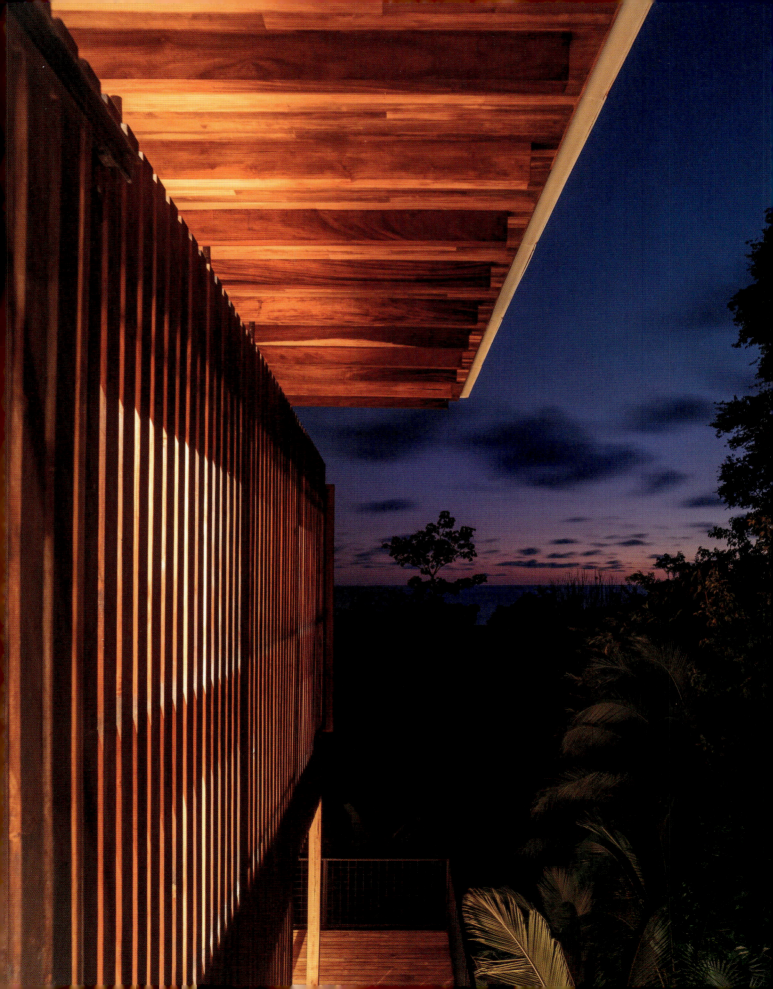

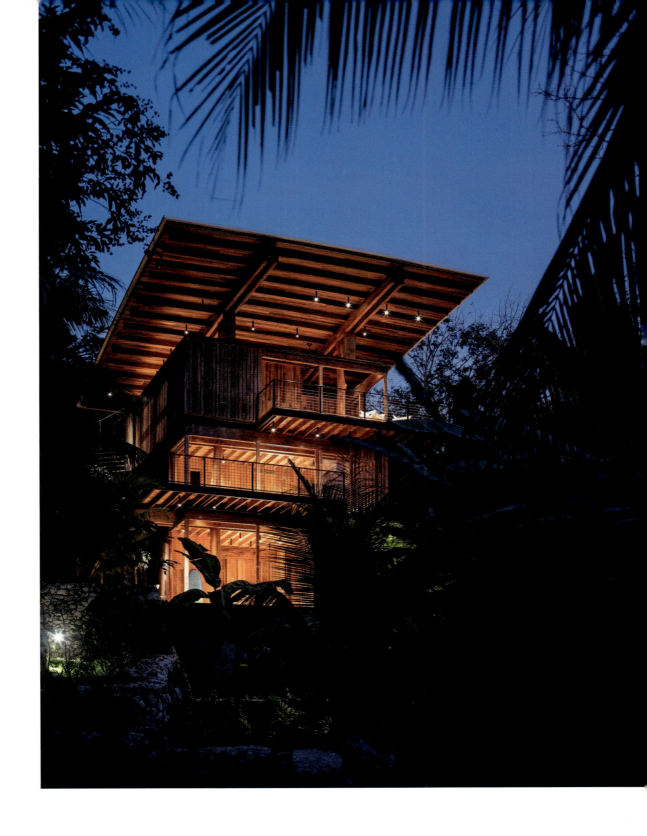

< Living spaces that are open to the elements feature double-screen shutters to provide privacy when required.
∧ An intentionally small footprint minimises the building's impact on the site.

27.

High Desert Retreat

Aidlin Darling Design

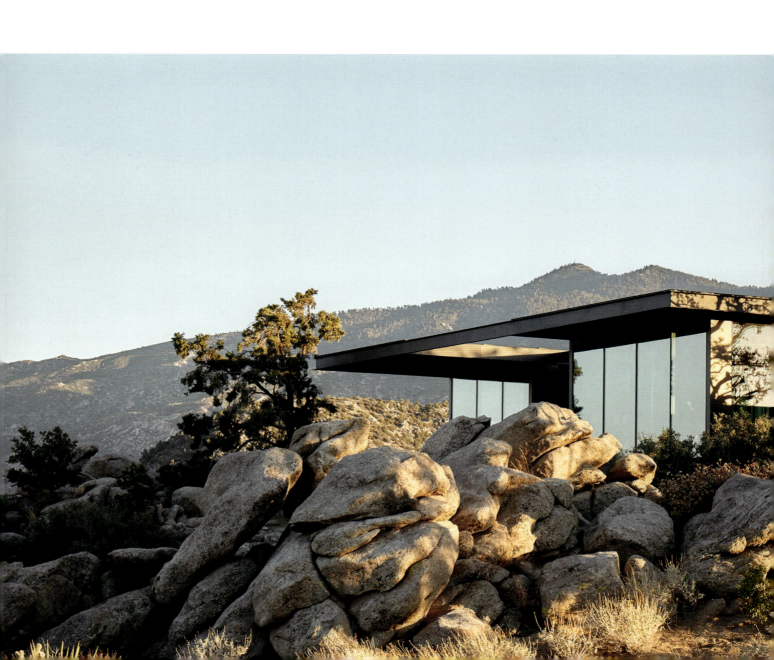

Palm Desert, USA

High Desert Retreat is a single-family residence designed to fit discreetly on a rocky plateau outside Palm Desert, California. The building is ensconced among an outcrop of boulders and comprises a series of low, rectilinear volumes that limit its visibility in the landscape. Its external walls are clad in blackened timber that contrasts with the lighter tones of the desert terrain, while introducing a textural finish that complements the surrounding natural environment.

San Francisco architecture office Aidlin Darling Design was asked to create a rural retreat that responds to the unique desert climate and makes the most of spectacular views towards the Coachella valley and the San Jacinto mountain range. The project brief required the building to be constructed without removing any of the site's mature pinyon pine trees. The property's seven interconnected wooden volumes slot in among the existing rocks and trees, extending outwards in places to create rooms and terraces that feel immersed in the desert scenery.

A pair of parallel concrete walls defines a route from the garage and driveway towards a glazed entrance at the centre of the building. The front door leads into a dining room that functions as an important circulation space connecting the public and private areas. The dining hall is lined with operable windows on one side and connects with a poolside terrace on the other. This allows breezes rising up the hillside to pass through and ventilate the house naturally.

The volumes containing the living spaces and bedrooms are clad externally with pine wood that was burnt, wire brushed, stained and sealed to make it resistant to rot, insects and warping owing to the dramatic diurnal temperature changes that occur in this desert climate. The interior features a material palette of concrete, wood, stone and steel, chosen to maximise durability while introducing natural tones and textures. The building is topped with a wooden roof that extends out beyond the façades and incorporates latticed sections to provide shade where required. A single aperture in the roof frames a view of the sky and exposes the pool area to the warm sunshine.

< High Desert Retreat nestles into a rocky plateau overlooking the Coachella valley.

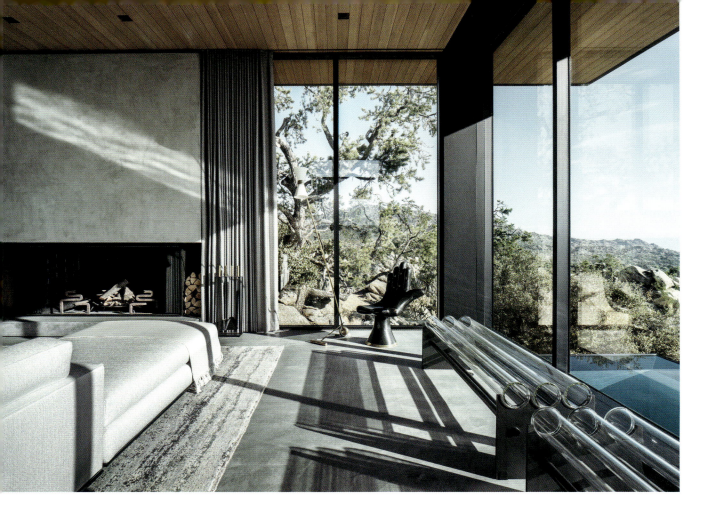

∧ Full-height glazing and ceilings that extend beyond the façades blur the boundaries between inside and outside.
> Sliding doors allow the interior to be opened up to outdoor spaces shaded beneath solid or slatted canopies.
>> A pair of concrete anchor walls partially shield the house from view on the approach.

High Desert Retreat / USA

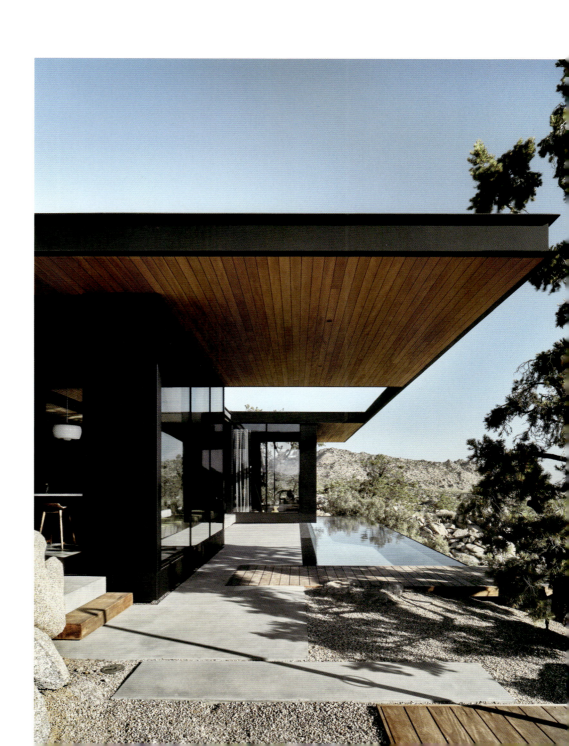

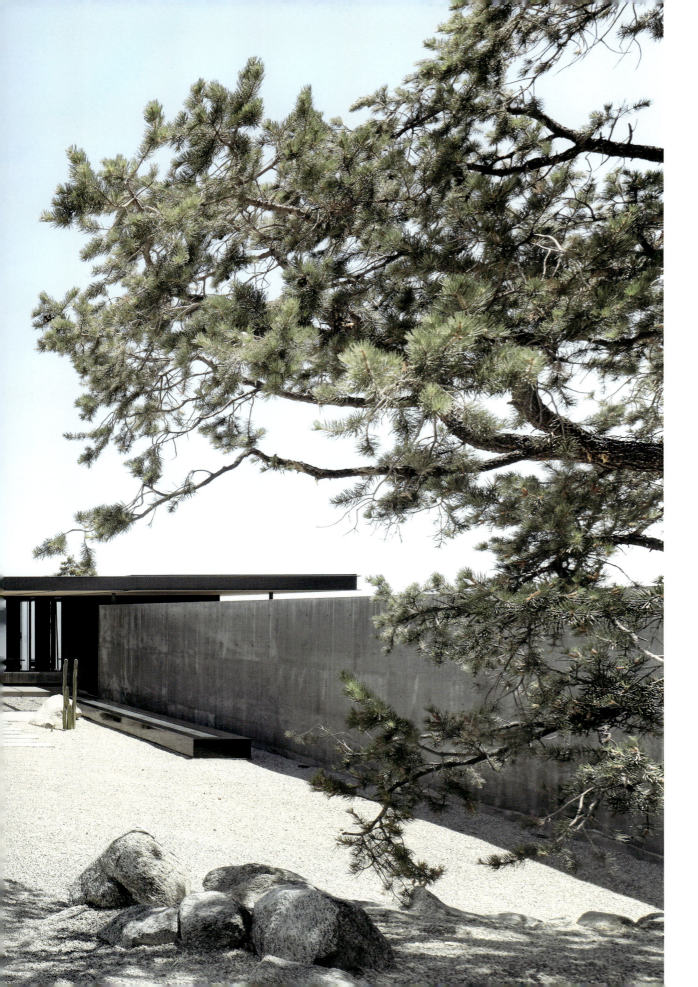

House of the Big Arch

Frankie Pappas

Waterberg, South Africa

The owners of this house hidden in a nature reserve in South Africa's Waterberg mountains wanted to ensure it minimises any disturbance to the protected bushveld environment. Architecture collective Frankie Pappas designed House of the Big Arch to fit round existing rocks and trees, creating a habitat where the clients can live alongside the forest's plants and animals.

Frankie Pappas developed the project for clients who are heavily involved with conservation and were keen for the property to disappear into the riverine forest landscape. To avoid removing any of the existing trees, the building is squeezed onto a sloping plot between the forest floor and a sandstone cliff. The house measures just over 3 metres wide and its elevated living spaces extend into the canopy without impacting on a single branch. Unoccupied areas beneath the building ensure wild animals can continue to move unimpeded across the site.

The main living areas are positioned on the first floor to make the most of the available light and views. A ramp leads up to a tall, narrow entrance on the eastern side, where the kitchen is located. A wood-and-glass bridge containing the dining room spans the gap between the kitchen and a lounge embedded in the hillside. A second bridge leads to a deck on top of the brick arch that gives the project its name. This open-air living space incorporates an oven, fireplace and pool, all with superb views over the nearby valley.

House of the Big Arch was constructed using materials selected to help it blend in with the dense forest. The portions of the building that touch the forest floor are constructed from a rough stock brick chosen to match the weathered sandstone found on the site, while the structural bridging elements are made from sustainably grown timber. The building was designed to have a negligible impact in terms of the resources it consumes. It is entirely off grid, with water collected from the roof and solar energy harvested using large photovoltaic panels. Its orientation reduces direct exposure to strong sunlight, and carefully positioned openings allow breezes to ventilate the interiors.

< House of the Big Arch treats its bushveld setting with respect by disappearing among the rocks and trees.

< The long and narrow building was carefully positioned so it doesn't disturb a single tree.
v Interior and exterior living spaces are raised to the height of the forest canopy to optimise views across the valley.

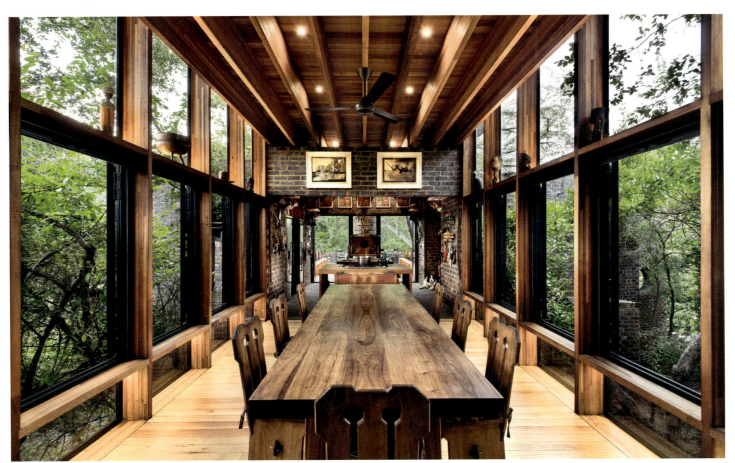

House of the Big Arch / South Africa

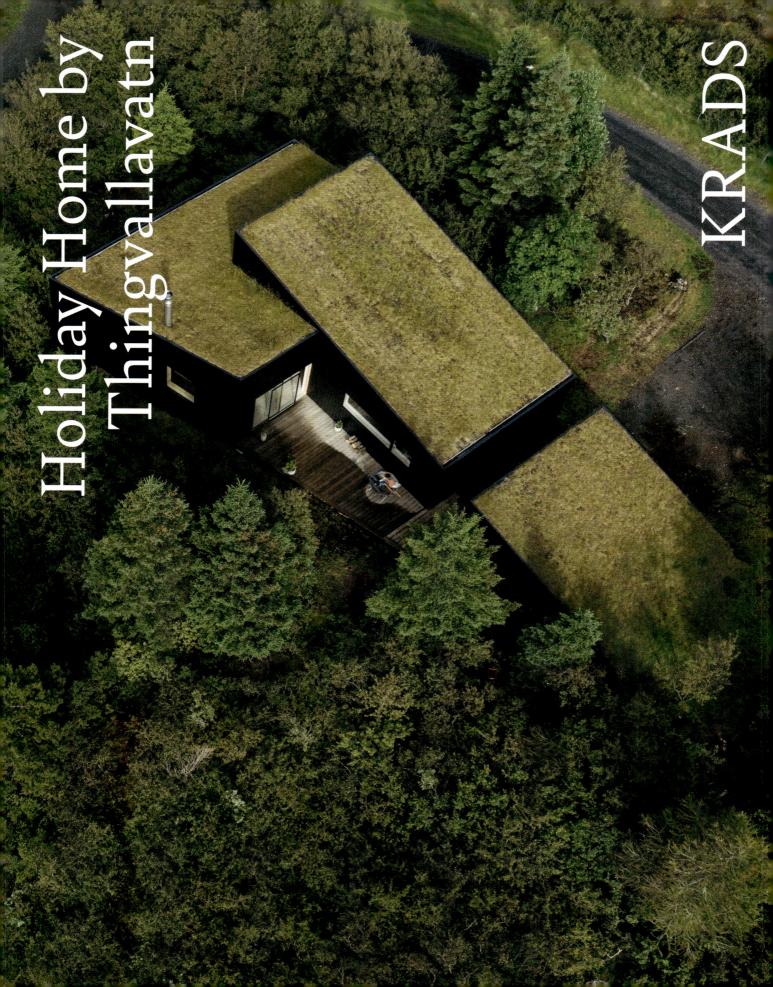

Thingvallavatn, Iceland

Holiday Home by Thingvallavatn occupies a densely vegetated site near a lake in south-western Iceland. Danish and Icelandic architecture studio KRADS designed the building to follow the terrain and to blend in with the surrounding greenery. The house nestles among trees and features a green roof that slopes in two directions to mirror the undulating landscape.

The holiday home is positioned on a north-facing slope that leads down to the shore of the Thingvallavatn lake. The site was chosen to allow the building to merge with its surroundings while providing specific views of the impressive scenery. The main living areas are elevated above the undergrowth and incorporate large windows that look out across the lake towards the Skjaldbreið mountain. A south-west-facing terrace maintains a sightline through the adjacent living space to the lake beyond.

A key objective for the project was to preserve the existing landscape and vegetation wherever possible. The floor plan responds to the site's topography, with the rooms distributed across three staggered planes that slot in among existing trees. Each block is topped with a sloping roof covered with local grass and moss. The north-facing surface is accessible from a playroom on the upper floor, while the roof of the adjacent boathouse extends to meet the ground. From the top of the roof, the owners can look out over the treetops to a panoramic vista of the landscape.

The green roofs that help to camouflage the building are complemented by a palette of natural materials. The elevations are clad entirely with blackened timber that evokes the bark of the nearby trees and the shadows produced by rocky outcrops. Wood is used throughout the house's interior to add warmth and natural texture to the living spaces. Floors made from pale pine wood incorporate steps connecting the various split levels, including a sunken lounge positioned next to the large windows.

< The holiday home comprises three timber-clad volumes topped with green roofs that slope in two directions.

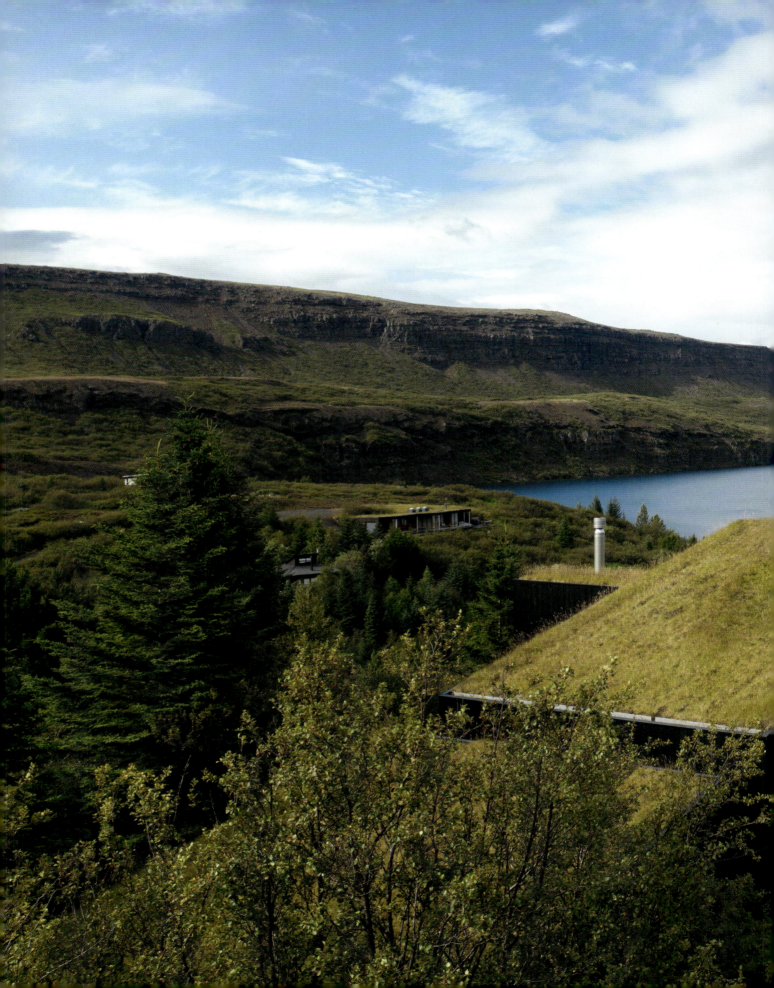

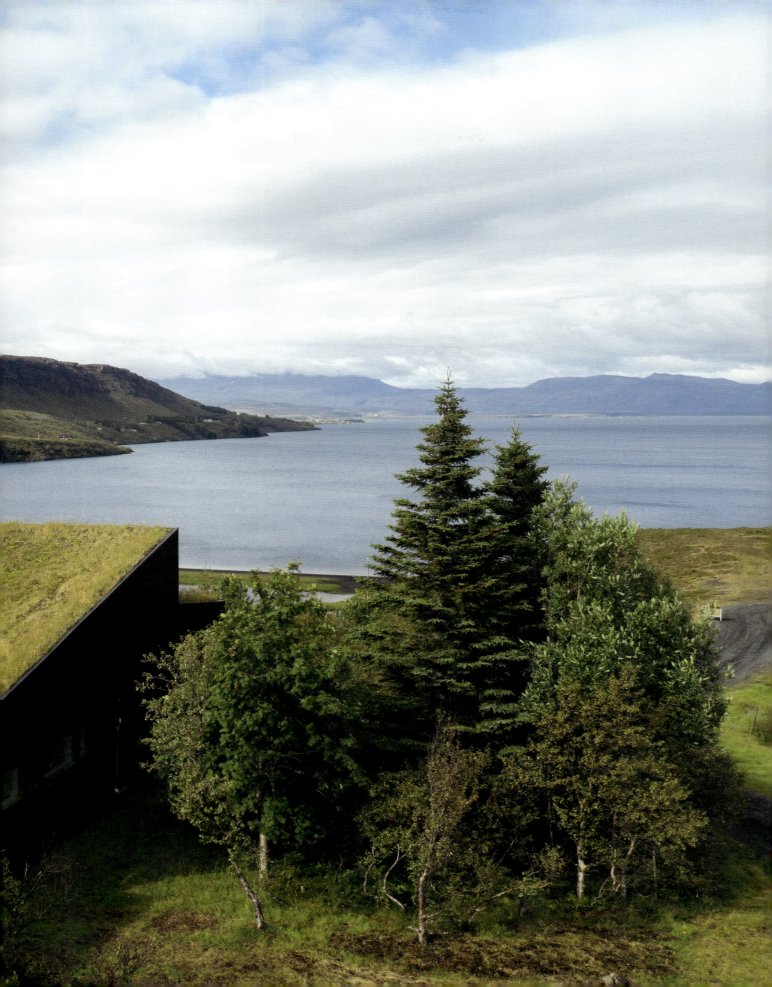

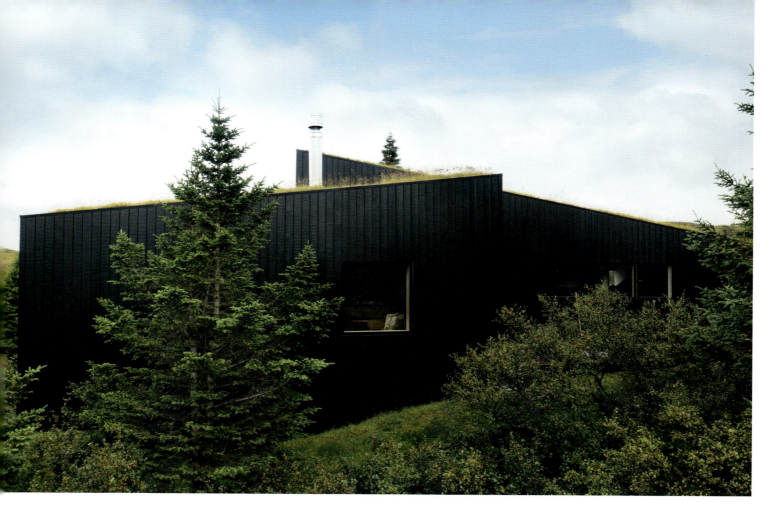

<< The building's accessible roofs are covered with native mosses and grasses.
^ The house's location was carefully chosen to integrate with the surroundings while framing selected views of the landscape.
> The main living space and adjoining terrace look out towards the nearby Thingvallavatn lake.

Holiday Home by Thingvallavatn / Iceland

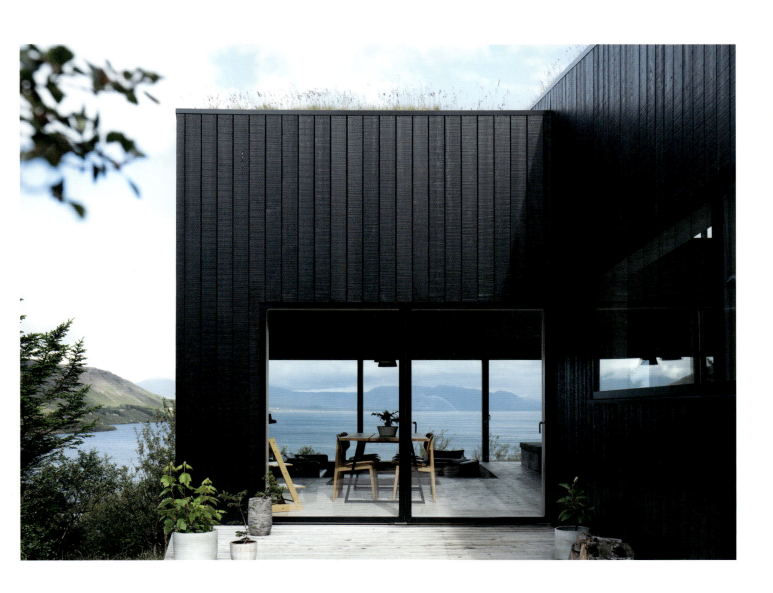

Under

Snøhetta

Båly, Norway

Half-submerged in the icy waters of the North Sea on Norway's southern coast, Europe's first underwater restaurant allows guests to gaze out at the seabed as they dine. Under is located in the remote village of Båly in Lindesnes, where storms thrash the rocky shoreline and fish flourish in the unique marine ecosystem. The restaurant was designed by architecture firm Snøhetta to blend in with this unspoiled natural setting, creating a unique experience for diners while also functioning as a research centre for studying marine biology.

The restaurant is designed as a sloping, 34-metre-long concrete tube that invites visitors to descend beneath the waves to a dining area incorporating a large panoramic window. The architecture complements its geographical and aquatic context, with the robust concrete shell evoking the tones and textures of the surrounding rocks. Over time, the underwater section will transform into an artificial reef colonised by sea kelp and crustaceans.

Guests enter into a foyer lined with oak that creates a welcoming ambience. Textile-clad ceiling panels contribute to the hushed acoustics. As they follow the stairs leading past a mezzanine bar to the submerged dining hall, the fabrics' colours change gradually to evoke a sunset dropping into the ocean. The restaurant seats 35–40 dinner guests, the standout feature being the 10.8-metre-wide acrylic pane that provides views of the sea life. During the day, a turquoise glow from the water filters into the dining area, while at night the seabed is illuminated by lights on the building's exterior.

Under aims to support the delicate ecological balance between land and sea by promoting sustainable consumption and a greater understanding of where food comes from. The restaurant uses ingredients sourced locally from the land and the sea. The building also facilitates the study of marine biology and fish behaviour through cameras and scientific tools installed on and outside the structure.

< The restaurant's dining room is located underwater at the end of a monolithic 34-metre-long concrete tube.

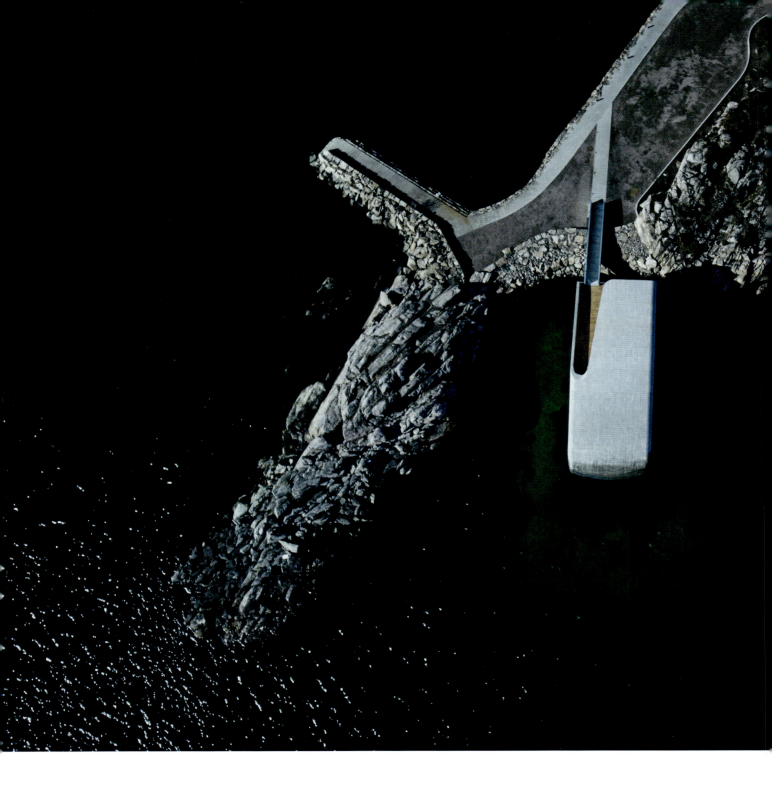

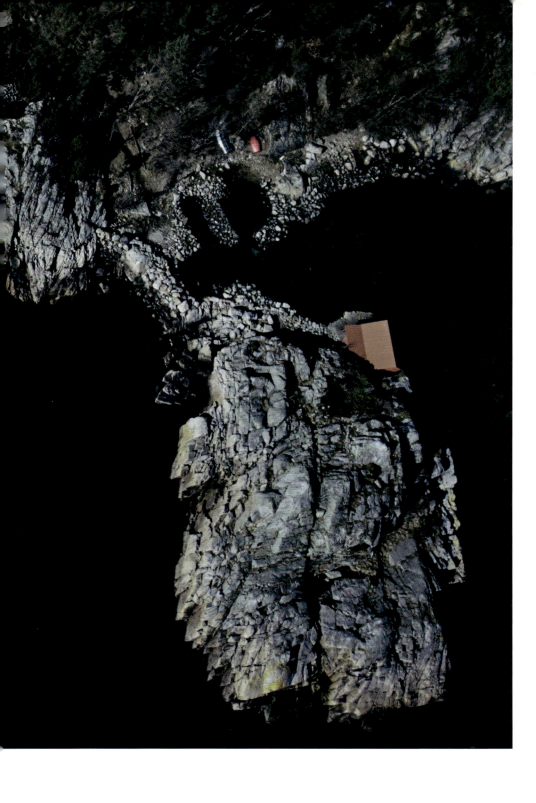

The building extends from the shoreline and will eventually function as an artificial reef.

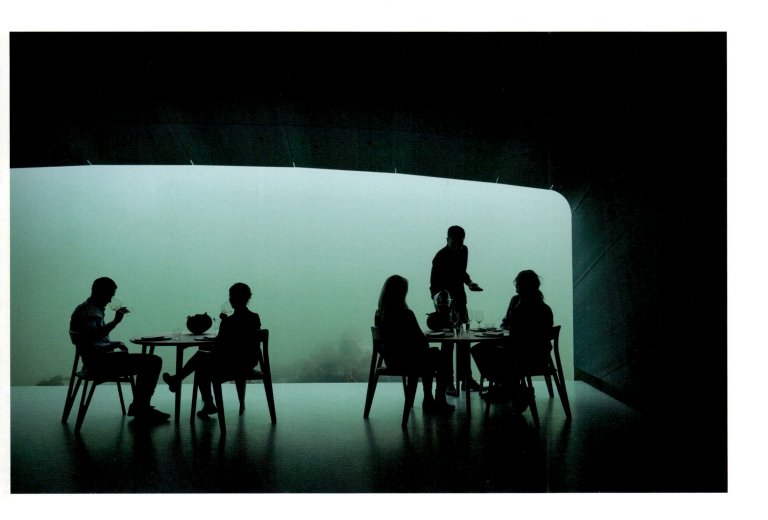

< The oak-clad interior helps to create a warm, welcoming atmosphere inside the restaurant.
∧ At the seabed, 5 metres below sea level, a massive window provides views of the marine life outside.

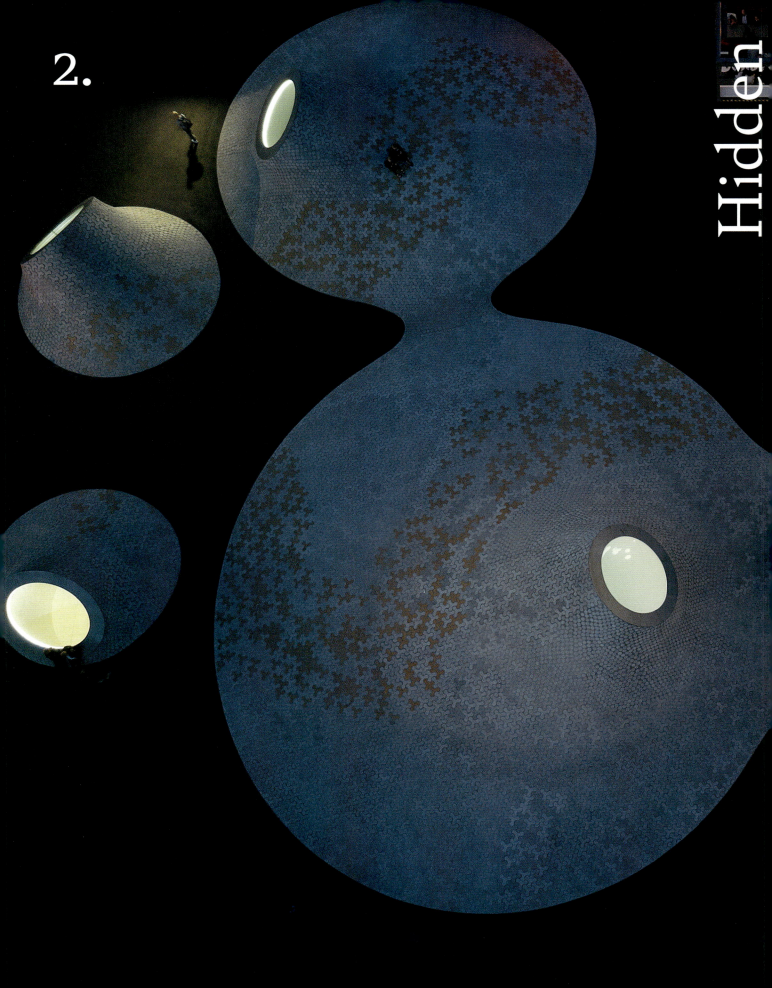

2.

Hidden

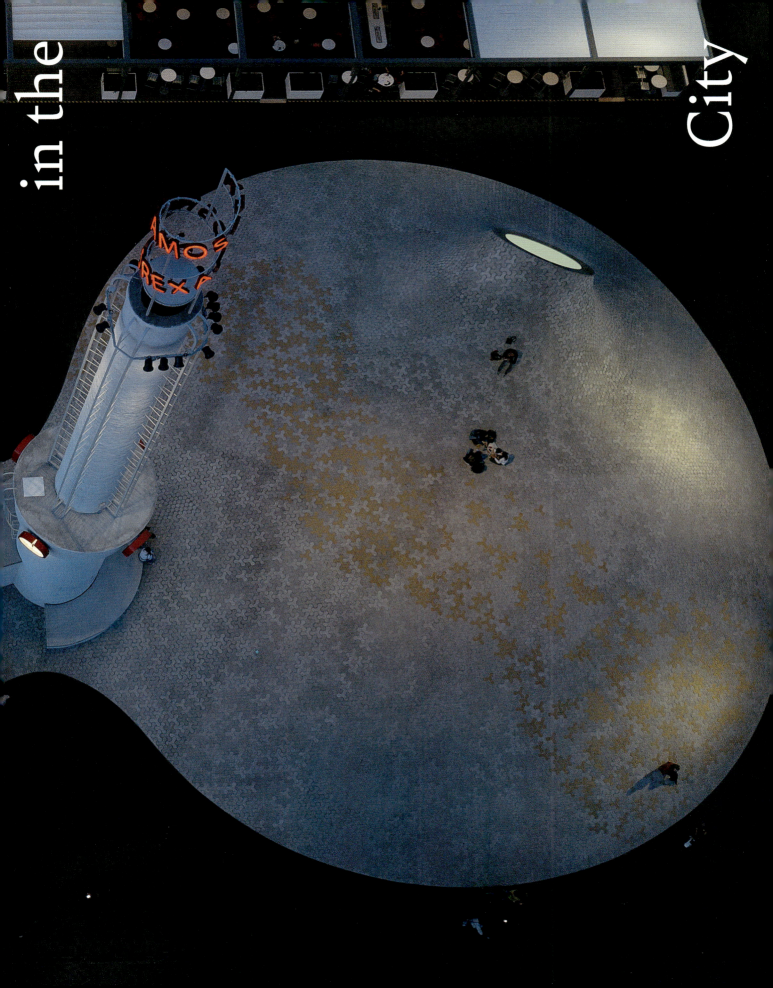
in the City

2.

Most of the projects in this publication are located in rural areas and are hidden in order to prevent disruption to their natural settings. However, it is sometimes necessary or beneficial to conceal a building in a particular urban context. This may be to maintain the appearance or functionality of a valued public space, or to protect the privacy of a building's occupants. Busy urban centres are not easy places to hide in, so architects need to develop inventive ways to conceal buildings by locating them underground, incorporating them into the existing streetscape, or positioning them behind solid walls.

Privacy is a key concern when designing buildings for residential projects in urban locations. New homes in cities are often overlooked by other properties, or are in close proximity to streets and public thoroughfares. In these settings, architects must balance the client's need for privacy with the equally important requirements for natural light and views.

For decades, Japanese cities have struggled with a lack of affordable land on which to build new housing. As a consequence, homes are often squeezed tightly together on compact lots in order to reduce costs. FujiwaroMuro Architects created a house in Konohana (page 58) that is shielded from the adjacent road behind a pair of curving concrete walls. One of the walls encloses a parking area and the other hides a private terrace next to the house's living areas. The external walls provide concealment while helping to define the relationship between the home and its surroundings.

in the City

Public space in urban centres is precious and often needs to be protected from private development. Parks, plazas, streets and squares provide important places for people to meet and relax. They are part of a city's social fabric and are often used for larger gatherings or events such as concerts, exhibitions and rallies. New buildings must be carefully planned to avoid disrupting the vital functionality these spaces provide.

One way of facilitating development without compromising public space is to incorporate new amenities beneath the existing streetscape. When the team leading a project to expand Helsinki's Amos Rex art museum realised it would not be able to create the new spaces required inside existing buildings bordering the city's Lasipalatsi Square, it decided to build them underground instead (page 54). The new galleries are positioned beneath the square and their presence is indicated by domed roofs topped with skylights that allow people to gaze into the exhibition halls from above.

London's V&A Museum adopted a similar approach with its new Exhibition Road Quarter, which includes a large gallery space inserted beneath an existing courtyard (page 80). The previously unused space is now activated as an alternative entrance to the museum that connects it with the adjacent pedestrianised street. Both the V&A Museum project and the Amos Rex museum conceal functional areas below ground, while creating lively spaces for public use at street level.

Parks and green spaces play a major role in making cities more attractive and healthier places to live and spend time in. Plants help to neutralise urban pollution by absorbing toxins from the air, as well as reducing the urban heat island effect. Green walls and green roofs are becoming increasingly popular as developers look to ensure their projects meet the latest sustainable planning requirements and contribute to beautifying the local environment. The Green Roofs section (page 122) focuses on innovative buildings hidden beneath planted surfaces, but some projects with green roofs are included here to demonstrate their value in urban contexts.

In the Japanese city of Maebashi, architect Sou Fujimoto covered an extension to the Shiroiya Hotel (page 64) with grass and plants to create a new park-like public space. Passers-by can use a set of steps that winds its way across the Green Tower to access the hotel's lounge and restaurant or to move between two streets on either side of the building. Chinese architecture office TEAM_BLDG set out to retain the natural landscaping of a waterfront park in Guangzhou when designing a small service centre for an adjacent sports facility (page 76). The building is discreetly integrated into the existing topography and appears as a continuation of the park when viewed from the neighbouring skyscrapers. The final green-roofed building in this section shows how urban farming practices are helping to make cities more sustainable and productive. The Thammasat University Rooftop Farm (page 70) is used for growing food and providing renewable energy, as well as helping to hide the large educational building beneath its landscaped roof.

Amos Rex

JKMM Architects

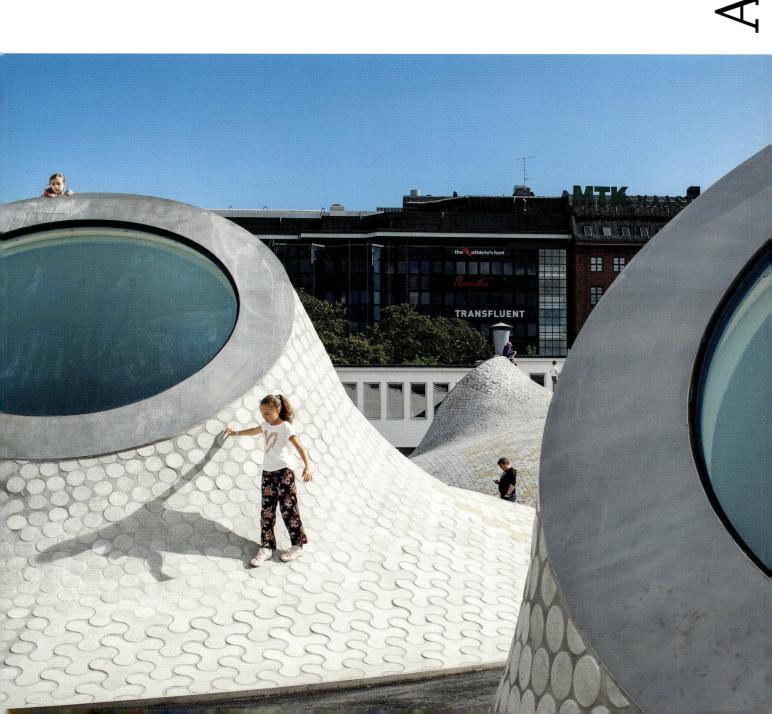

Helsinki, Finland

< Circular skylights provide a visual connection between a plaza and the hidden galleries below.

Amos Rex is an art museum located in the heart of Helsinki, Finland. The museum consists of two parts: a series of subterranean galleries and a renovated, heritage-listed 1930s building. The new exhibition spaces are submerged beneath a public square and their presence is indicated by several concrete domes that protrude from the surface. The domes form an undulating landscape that activates the plaza, creating an urban space that anyone in the city can use and enjoy.

Finnish firm JKMM Architects oversaw the expansion of the museum, together with an upgrade of its existing home in the modernist Lasipalatsi (which translates as 'glass palace'). No overground extensions were allowed, so the architects proposed a series of underground spaces topped with the domed roofs. The five tile-covered protrusions draw people towards the museum and allow them to peek into the galleries below through circular skylights. Visitors are able to walk over or sit atop the sloping surfaces, which can also be used as grandstands or stages for events.

The roofs were cast on site using steel-reinforced concrete to create vaults that allow for wide, column-free exhibition spaces below ground. Each of the skylights is oriented towards a particular view, such as the historic chimney in the middle of Lasipalatsi Square. The openings allow daylight to illuminate the flexible exhibition spaces and communal areas, including the museum's lobby.

The minimalist foyer's ceiling is dominated by a 250-square-metre light artwork by Petri Vainio, which incorporates over three hundred LED lights to ensure the underground entrance feels bright and welcoming. Beyond the lobby, the galleries' domed ceilings are covered with perforated aluminium acoustic discs. Both internally and externally, the new spaces display a futuristic aesthetic that marks them out as twenty-first-century additions to this historic site. Although much of Amos Rex is hidden from view, the museum provides a bold intervention in the urban landscape.

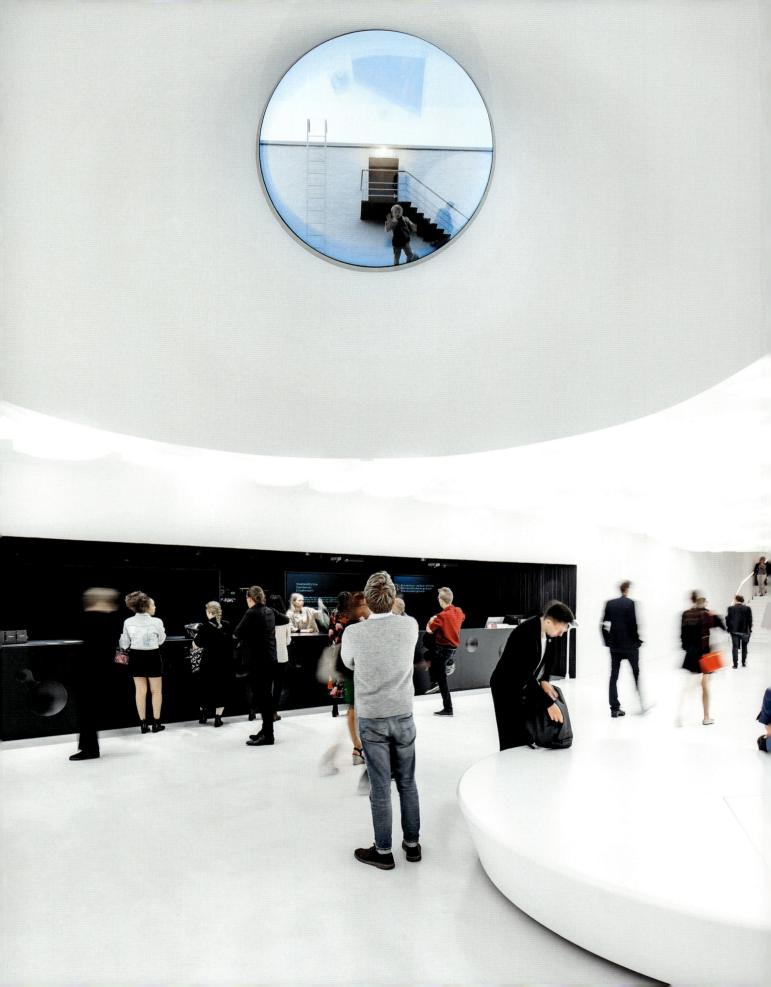

< Exhibition and circulation spaces hidden beneath the existing public square are topped with domed ceilings.
∧ The circular apertures allow daylight to reach the subterranean spaces and frame specific views of the city above.

Osaka, Japan

The relationship between public and private spaces in a dense inner-city context provided the starting point for this residential project designed by FujiwaraMuro Architects. The owners of House in Konohana wanted to reserve part of its plot in Osaka's old town for use as a public car park. The property therefore had to provide private living areas that could be hidden from the adjacent street and parking zone.

The solution proposed by the architects involved constructing a pair of arced concrete walls that divide the site into quarters with different degrees of exposure to the surrounding neighbourhood. The concrete surfaces reference similar structures used throughout the city to separate public and private spaces, with their curved shapes intended to introduce a softer and more attractive feature to the streetscape.

One of the walls encloses the three-car public parking area, while the other forms a boundary between the house and a single parking space used by the owners. A gap between the walls creates an inviting path leading towards the house's entrance. The two external areas are described as the 'outer public' and 'outer private' spaces, while the house itself is separated into 'inner public' and 'inner private' zones. The public area contains the entry hall, along with a toilet and a Japanese-style room for entertaining guests. The inner private space accommodates an open-plan living room that connects with a courtyard sheltered behind the curved wall.

The two walls are positioned to allow glimpses of the house's more public areas while completely concealing the private spaces where the family spends most of its time. One of the walls extends through the glazed façade into the building, creating an internal division between the public and private living areas. The wall's shape helps to guide movement through the building and provides lines of sight between certain areas while blocking others from view. The exposed concrete surface introduces a characterful element that unifies the house's internal and external spaces.

< Two curving concrete walls separate public and private areas at the house in downtown Osaka.

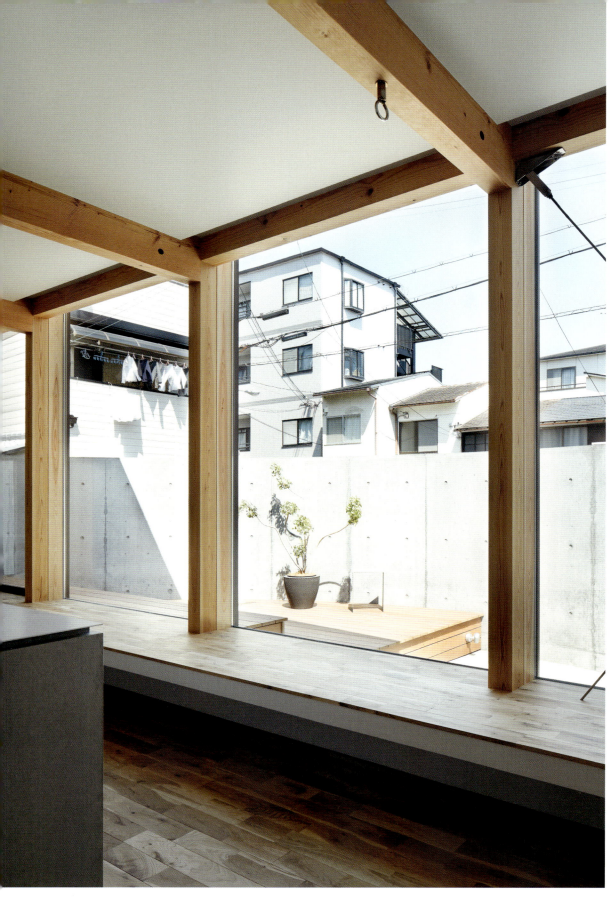

< Living spaces are hidden from the street by one of the walls, which also conceals a private courtyard.
v The wall enters the building and becomes an internal partition that guides movement through the space.
>> The outer arced wall defines an area facing the street that can be used as public parking.

House in Konohana / Japan

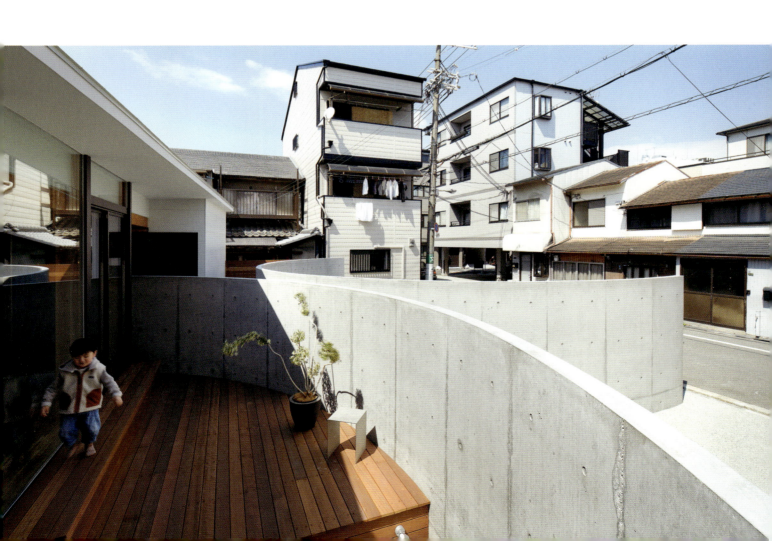

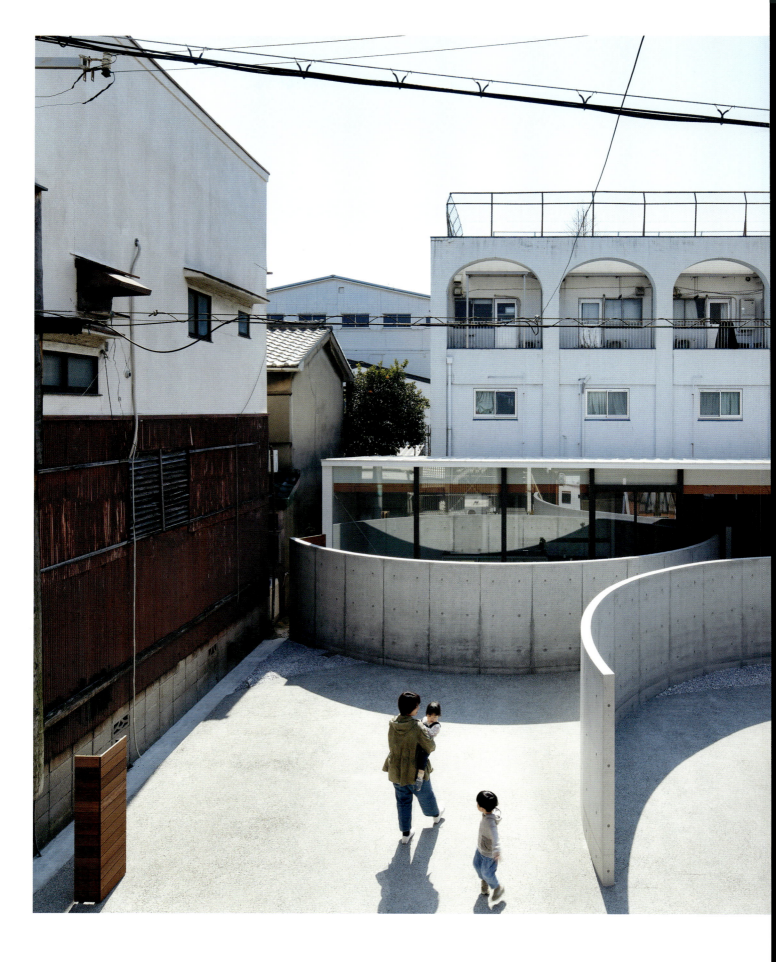

63. Hidden in the City

House in Konohana / Japan

Shiroiya Hotel

Sou Fujimoto Architects

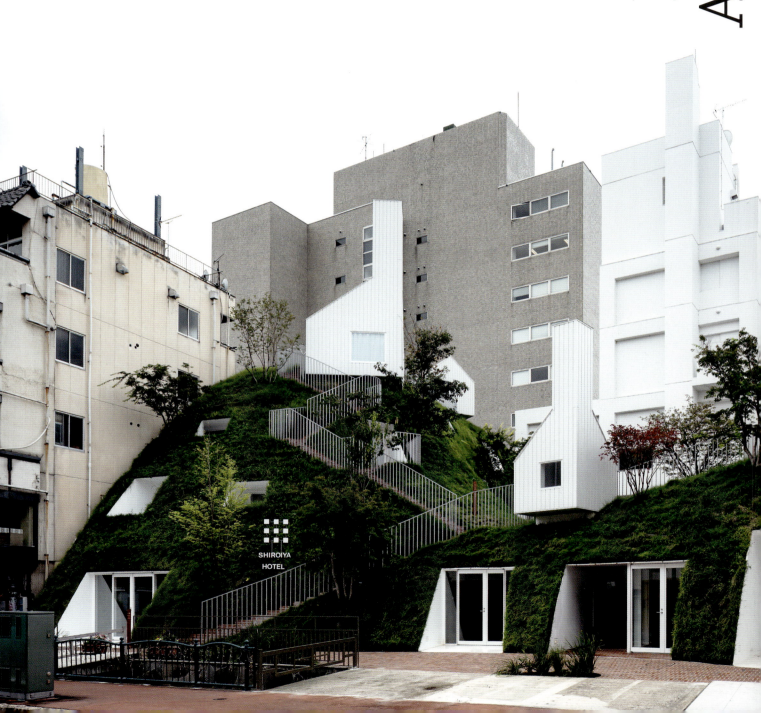

Maebashi, Japan

A man-made hill partially conceals guest rooms and amenities at this hotel in the Japanese city of Maebashi. The Shiroiya Hotel occupies the site of a traditional Japanese inn that has welcomed guests for over three hundred years. The modernisation project led by Sou Fujimoto Architects involved renovating an existing 1970s building and adding an extension that contributes to the revitalisation of the surrounding neighbourhood. A brick path leads over the grassy mounds and through the hotel, connecting streets on either side and inviting visitors to explore this new addition to the urban realm.

The brief for the new Shiroiya Hotel was to create a 'living room for the city', so Sou Fujimoto's studio set about converting the existing concrete Heritage Tower into a more vibrant and publicly accessible space. A typographic artwork by American artist Lawrence Weiner creates a bold statement on the main façade, which incorporates large openings leading towards the hotel's lobby, restaurant and lounge. The extension at the rear of the building, called the Green Tower, contains new spaces including a bakery, patisserie and coffee shop. The undulating extension also supports plants and trees that introduce a natural feature to this urban setting.

Floors and walls inside the four-storey Heritage Tower were removed to create a large central atrium. This space acts as an extension of the street outside, with daylight pouring in through large skylights, and plants making it feel like an outdoor plaza. The building's geometric concrete framework was retained and is enhanced by artist Leandro Erlich's installation comprised of illuminated tubes that weave round the structure. Stairs and bridges that criss-cross the atrium provide constantly changing vantage points that replicate the experience of walking round a city.

The hotel aims to promote creativity and innovation in all its forms. In addition to enjoying the various artworks on display throughout the building, guests can choose to stay in suites created by Fujimoto or Erlich, or by invited designers Michele de Lucchi and Jasper Morrison. The brick stairs built into the Green Tower provide access to small cabins containing a Finnish sauna and an installation by artist Tatsuo Miyajima.

< The Green Tower evokes the scenery of the Tone river region, creating a natural landscape in the heart of the city.

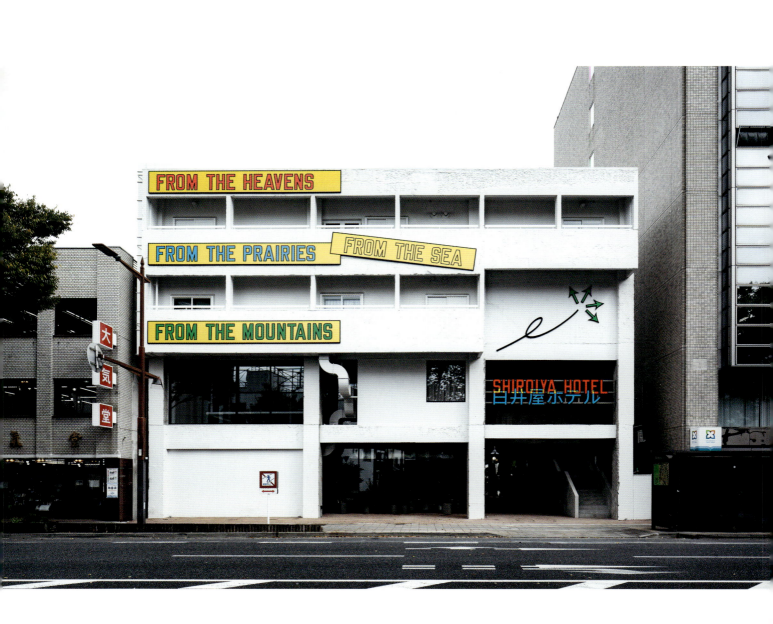

< The concrete façade of the original Heritage Tower preserves the appearance of the former Shiroiya Ryokan.
∧ Small rooms and cabins positioned on the Green Tower contain amenities including a Finnish sauna and an exhibition space.
>> The vast atrium contains a lounge where local residents and guests can come together.

Hidden in the City

67.

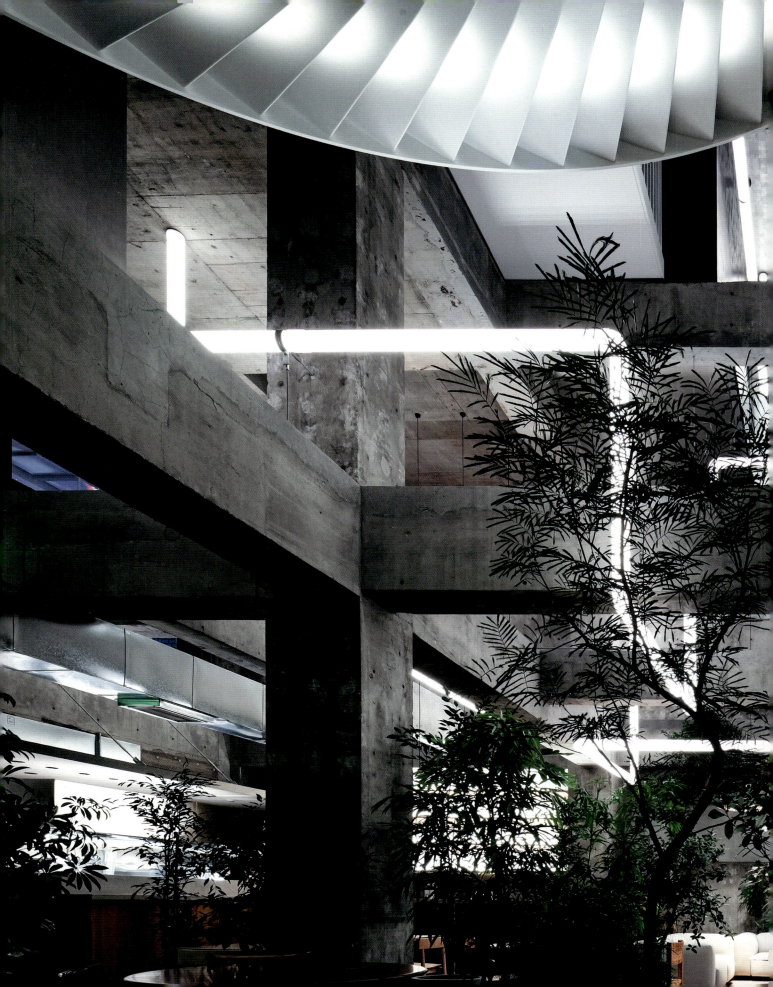

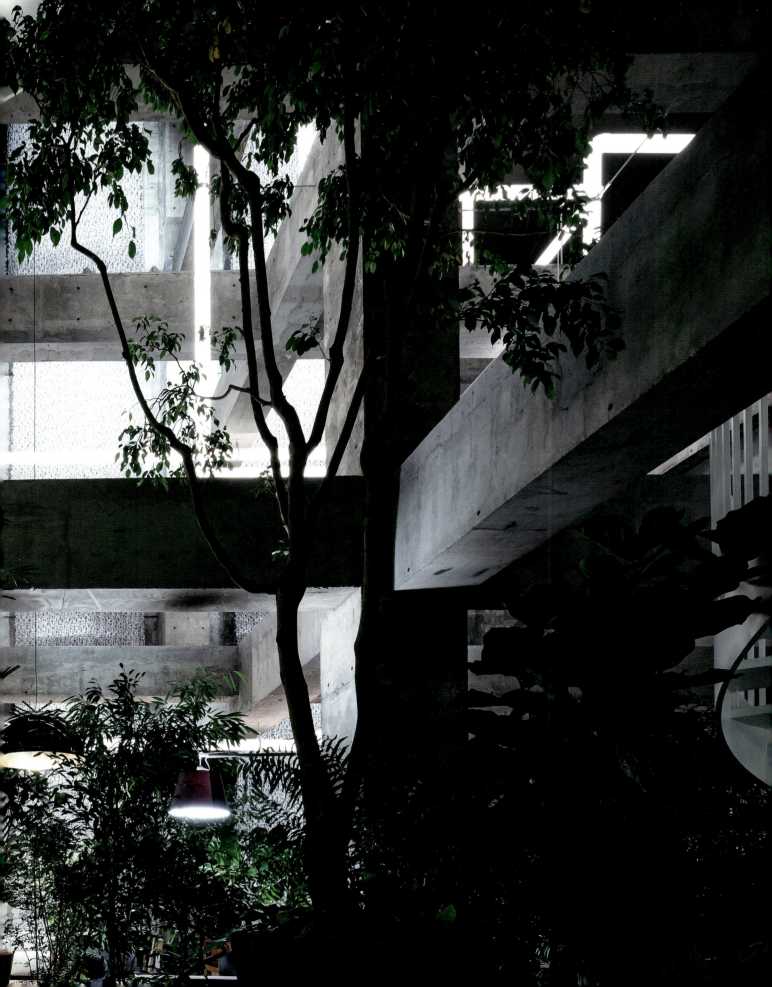

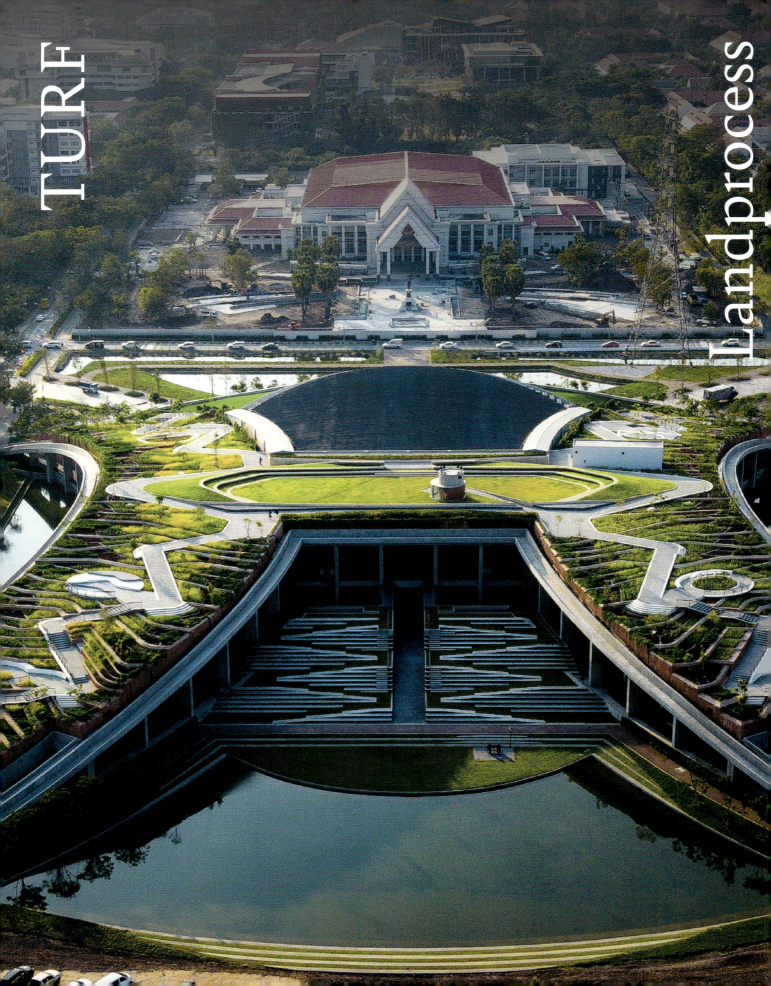

Bangkok, Thailand

Asia's largest organic rooftop farm covers this multipurpose study centre at Thammasat University in Bangkok, Thailand. The Thammasat University Rooftop Farm (TURF) was developed by landscape architecture firm Landprocess to transform the building's 22,000-square-metre rooftop into a functional farm, creating an inclusive circular economy for the campus that incorporates sustainable food production, renewable energy, organic waste, water management and public space.

The Puey Ungphakorn Centenary Hall is located on the main axis of the university's Rangsit campus and was designed by Arsomsilp Community and Environmental Architect to accommodate classrooms and activity spaces. Landprocess's proposal for the expansive roof was influenced by traditional agricultural practices employed throughout South-East Asia, where mountainous terrain is shaped to form terraces suitable for growing rice and other crops.

TURF is carved into a series of cascading platforms that utilise the latest green-roof technologies, along with solar panels for producing energy. An intelligently designed rainwater harvesting system channels run-off down through the various terraces, allowing it to irrigate crops before being collected in four large retention ponds at the base. The stepped plantations support more than 40 edible species, including rice, fruit trees and indigenous vegetables and herbs. The placement of the plants is determined by microclimates resulting from their specific sunlight exposure, water flow and elevation.

The rooftop farm also incorporates multifunctional public spaces along with a dozen oval-shaped classrooms for outdoor learning. These spaces support a year-round programme of sustainable agriculture workshops. At the highest point of the building, a large amphitheatre offers an accessible and flexible recreational space with panoramic views of the urban farm and the surrounding campus. The landscaping project creates a green cloak round the building that transforms the unused rooftop into a practical space for growing crops that are harvested to feed the local community.

< Neglected space on the university building's rooftop was used to create an urban farm.

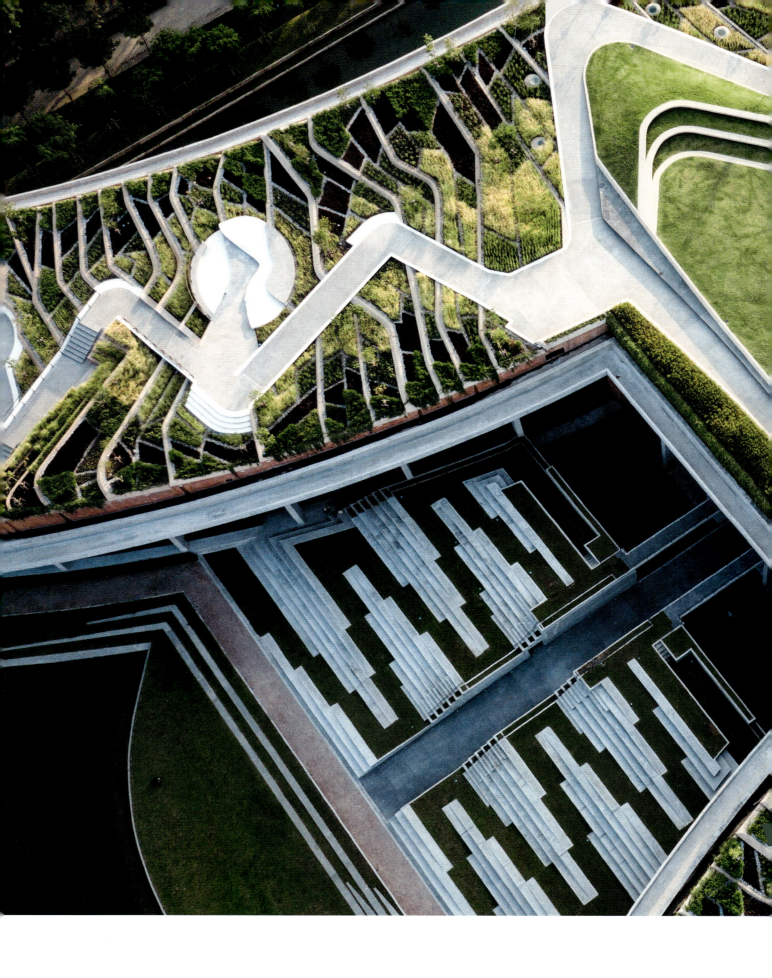

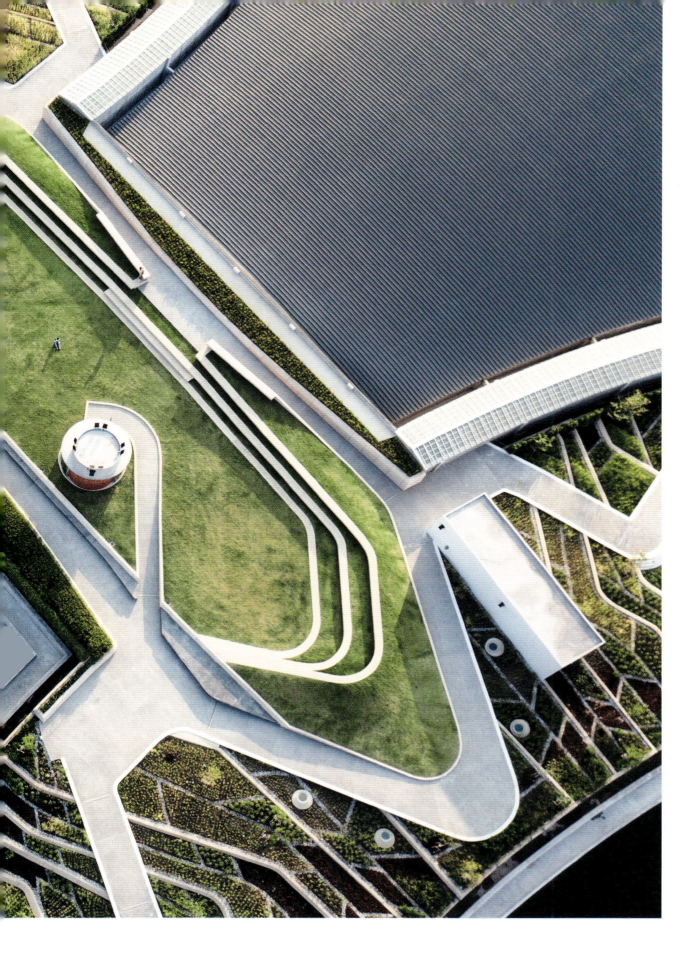

<< The building is concealed beneath cascading segmented layers inspired by traditional terraced rice paddies.
v The rooftop incorporates sustainable food production, renewable energy, organic waste, water management and public space.
> More than 40 edible species including rice, vegetables, herbs and fruit trees provide up to 20 tonnes of organic food each year.

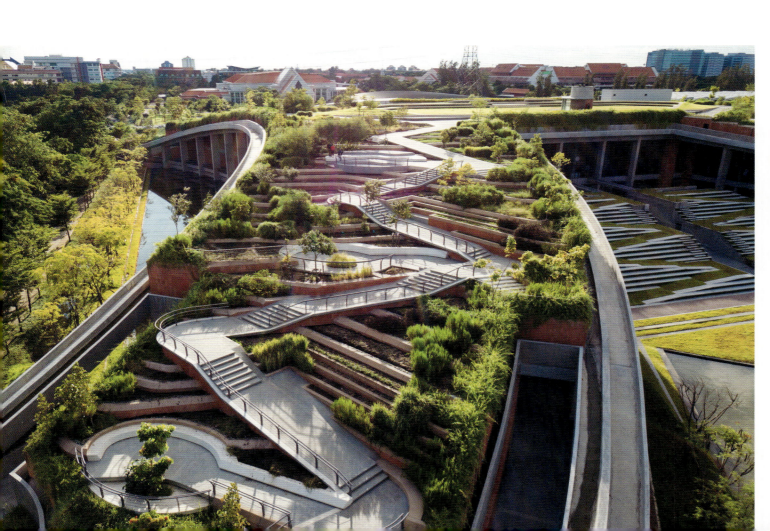

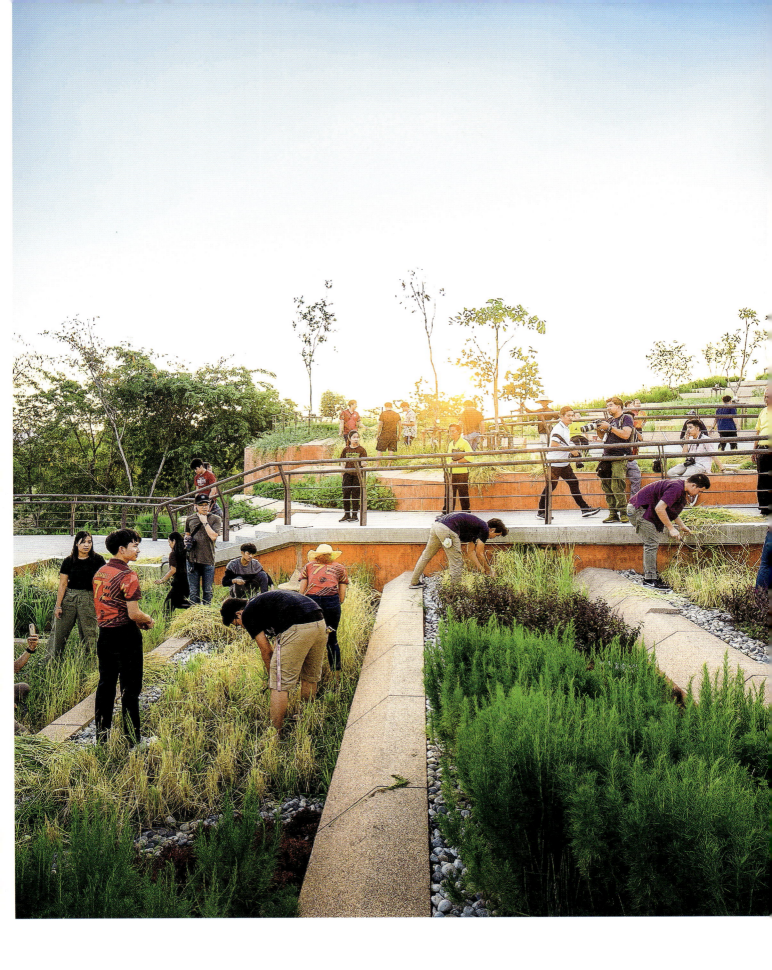

The Earth

TEAM_BLDG

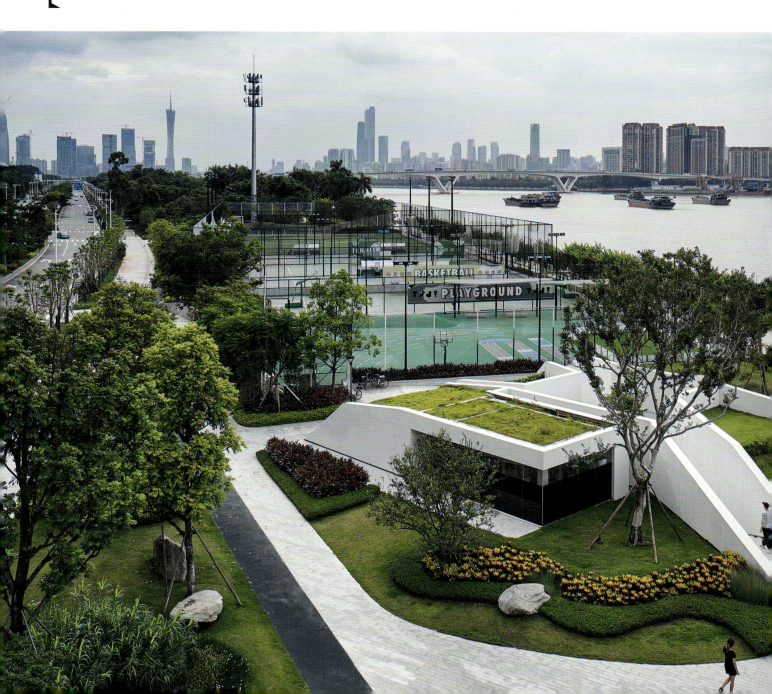

Guangzhou, China

Surrounded by skyscrapers on the waterfront of Guangzhou's Pazhou island, The Earth is a small and subtle service centre for a sports facility that integrates with the existing landscaping. The building is comprised of an artificial hill divided into separate functional zones by a series of white terrazzo walls. Planted roofs covering the four spaces slope down to the ground, making it appear as if the structure is emerging from the surrounding park.

The project designed by Shanghai architecture office TEAM_BLDG contains changing rooms, public toilets, a reception area, and utility spaces for the adjacent Pazhou Poly Sport Park. This neighbourhood on the South Bank of the Pearl River has undergone significant urbanisation in recent years and is now dominated by towers including the Poly Building and the InterContinental Hotel. The architects wanted the new public service centre to merge with the waterfront landscape and virtually disappear when viewed from the adjacent skyscrapers.

The building's hill-like form echoes the undulating topography of the park's landscaping, and its central axis aligns with a path connecting the waterfront promenade to the nearby road. One corner is sliced off to indicate clearly the position of the public entrance, which is set into a bright-white surface facing the street. The other spaces are accessed from a central courtyard reached via paths cut into the grass-covered mound. The paths create a cross-shaped plan divided into four distinct parts. Each block is lined with terrazzo panels that distinguish the building as a man-made intervention in the landscape.

The facility's calm and minimal interiors feature exposed concrete columns and ceilings, along with brushed stainless-steel fittings including the simple sanitary ware and reception desk. The practical and durable materials emphasise the contrast between internal and external spaces. At night, interior lighting spills out through various openings in the white walls to illuminate the courtyard and indicate the position of the different entrances.

< The service centre building merges with the landscape of a park next to the Pearl River in Guangzhou.

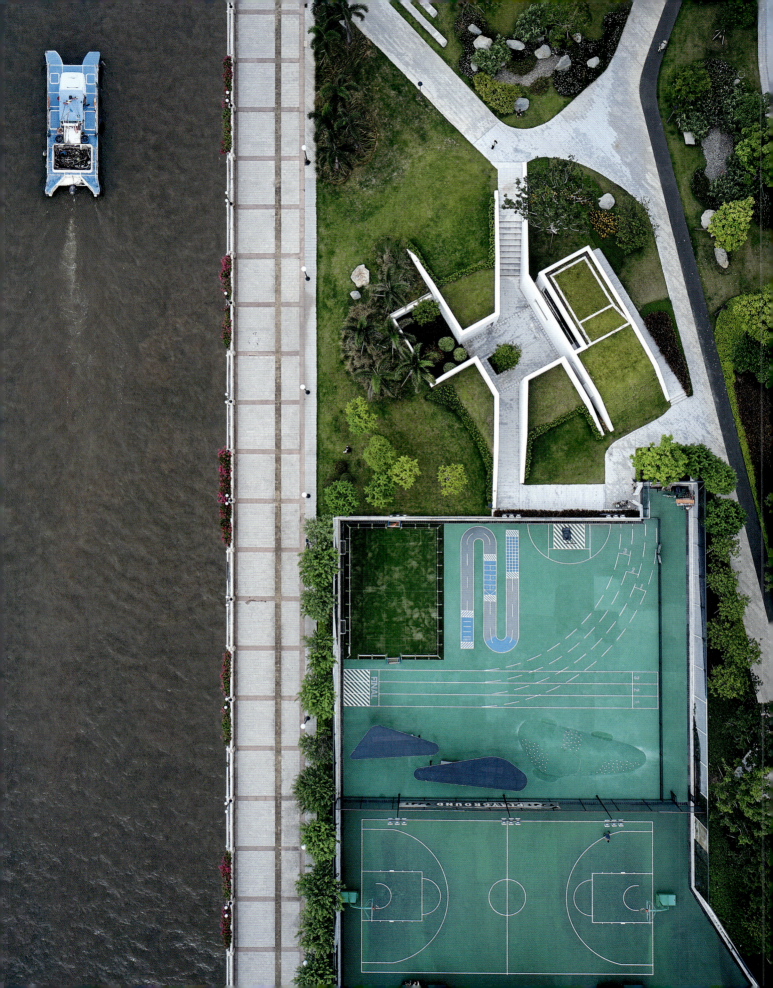

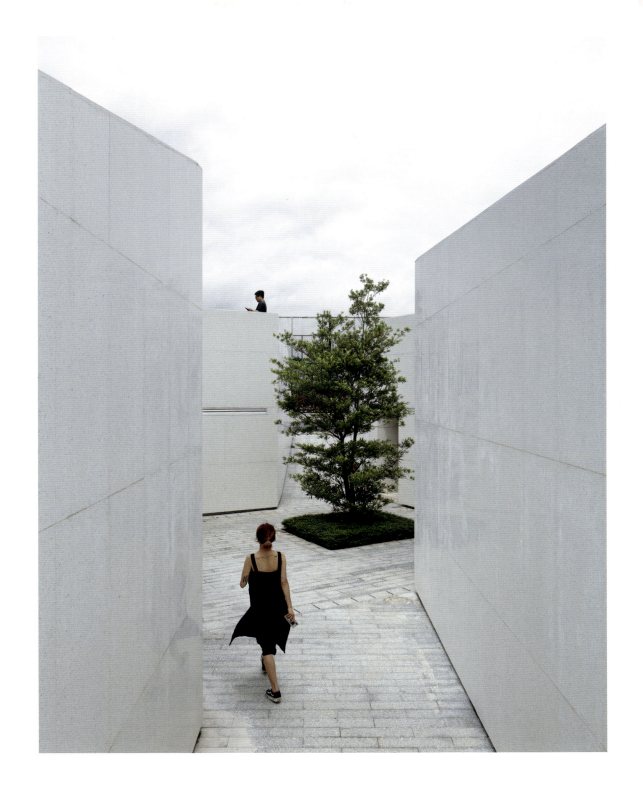

∧ Paths lead from the park towards a courtyard at the centre of the building that is enclosed by walls clad with white terrazzo.
< Four separate blocks arranged around the courtyard contain the main functional areas.

79.

V&A Exhibition Road Quarter

AL_A

London, England

The Victoria & Albert Museum occupies a prominent location in the heart of London's South Kensington museum district. In 2011 architecture firm AL_A won a design competition to create a new entrance, courtyard and gallery for the museum, which is one of the world's leading institutions dedicated to art and design. The Exhibition Road Quarter was designed to enhance the V&A's connection with the city while celebrating its existing Victorian buildings. By hiding most of the new spaces underground, the project provides space for a new public square that extends the adjacent pedestrianised street into the museum.

The Exhibition Road Quarter occupies a site that originally housed coal-fired boilers used to heat the buildings and galleries. A colonnade erected in 1909 as part of architect Aston Webb's scheme to hide the boilers was opened up to allow access to the new entrance. Webb had originally conceived this space as a public garden, and AL_A's design for the Sackler Courtyard reinstates it as a place for people to gather and relax.

The 1,200-square-metre courtyard is covered with more than 11,000 hand-made porcelain tiles that reference the museum's dedication to promoting art, craft and manufacturing. The plaza's folded floor wraps round a large oculus which provides a visual connection with the gallery below. A café and shop on the opposite side of the courtyard are topped with an angular tiled roof that swoops round a corner and rises up to touch the second floor of the museum.

Steps and ramps towards the rear of the plaza guide visitors into a light-filled entrance hall, from which a dramatic staircase descends to the purpose-built, 1,100-square-metre gallery. This column-free hall is one of the largest temporary exhibition spaces in the UK and provides a flexible venue for the V&A's high-profile shows. Submerged 18 metres beneath the courtyard, the room is illuminated from above by daylight entering through the oculus. Its folded roof is an innovative solution to the need for structural stiffness. Like the rest of the project, it is a contemporary intervention that cleverly and discreetly supports the museum's ongoing evolution.

< A large exhibition space hidden beneath a public courtyard is topped with a dramatic folded roof.

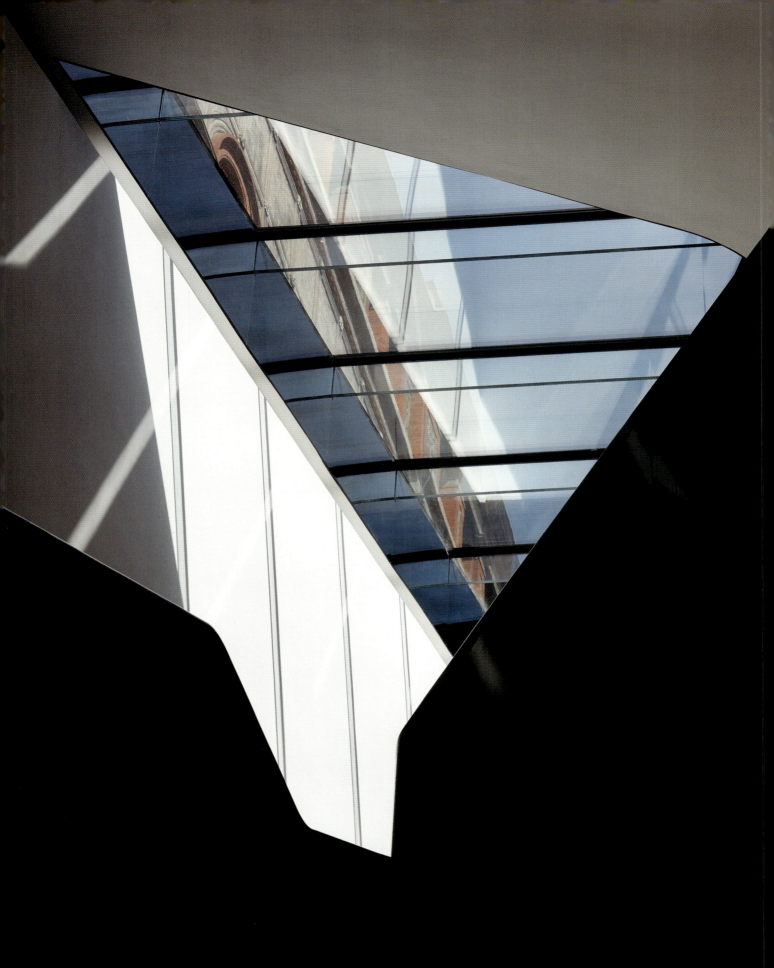

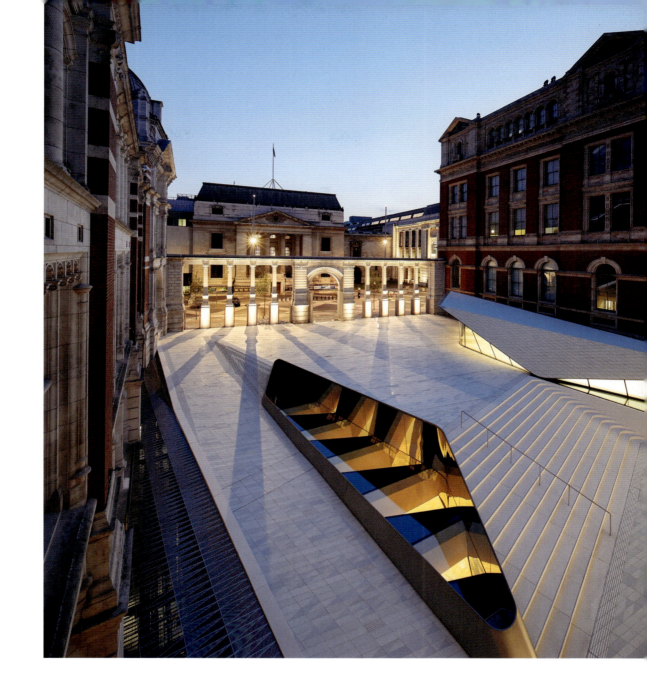

< Openings in the roof allow daylight to reach the subterranean spaces and create a visual link with the older parts of the museum.
∧ The public courtyard extends from the street to a set of steps that descends to a new entrance.
>> The outdoor space is covered with more than 11,000 porcelain tiles that continue over sloping roof sections.

Hidden in the City

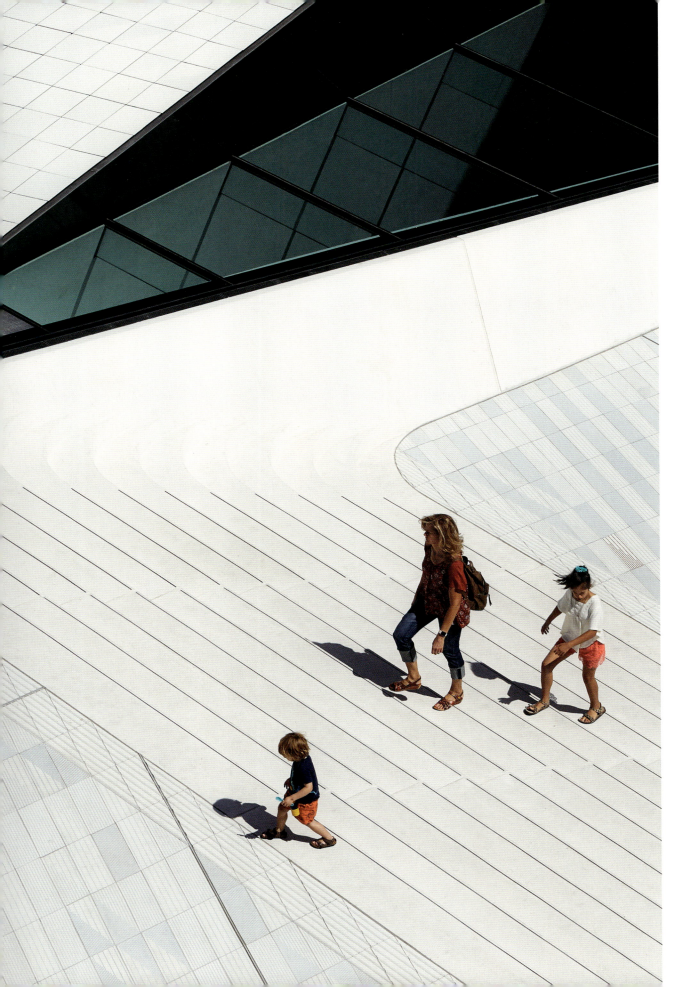

3.

Underground

Buildings

3. Building underground can be a practical way to create sheltered and unobtrusive spaces that minimise visual disruption to their site. It is possible to insert subterranean structures discreetly into settings such as areas of outstanding natural beauty, or other locations in which conventional construction would be considered inappropriate or impractical. Buildings embedded in the earth also offer an almost primal sense of security, replicating the cocooning comfort our ancestors experienced when they sought shelter in caves and other natural havens.

The most common reason for locating a building below ground is to preserve a site's existing use or appearance. Many scenic areas have strict planning regulations in place to protect views and prevent damage to delicate ecosystems. Incorporating a building into the landscape reduces its visual presence, while allowing the original topography and natural features to be reinstated. A project that exemplifies this approach is the Skamlingsbanken visitor centre in Denmark's southern Jutland region (page 108), which features a green roof that supports native plant species and contributes to the rich biodiversity of the existing moraine landscape.

Natural caves represent the archetypal underground habitat, one which human beings have used as shelter for millennia. Several of the projects featured here could be described as man-made caves; they consist of voids carved into a cliff face or hillside to provide privacy and protection. The Hill Country Wine Cave by Clayton Korte (page 90) is the most recognisably cave-like building included in this selection. The wine cellar and tasting room is inserted into a limestone cliff and features a single opening to the outside.

Its fully glazed elevation ensures the interior receives plenty of daylight and doesn't feel claustrophobic – a critical consideration for underground architecture.

There are numerous engineering and spatial challenges involved with subterranean construction. Robust retaining walls are typically required to prevent the piled earth or rock round the building from collapsing inwards. The building's roof must be able to support the weight of whatever material is placed on top of it. Contemporary engineering technologies and materials enable architects to overcome these issues while also allowing them to design large, open spaces buried beneath the ground.

Some of the cleverly constructed residential projects in this section are concealed within coastal hillsides and accommodate subterranean living spaces with spectacular views. The N Caved house by Mold Architects (page 98) and Scapearchitecture's Secret Garden House (page 104) feature retaining walls that follow the slopes of their hillside sites and allow for expansive glazed façades looking out towards the sea. Both properties take advantage of building codes in Greece that allow underground structures to be larger in size than those built above ground, as long as the original topography is reinstated.

Illuminating underground spaces is a key issue requiring a clever architectural solution. A common approach is to incorporate windows in elevations that are above ground or that face onto internal courtyards and terraces. Voids carved into the earth allow natural light to penetrate parts of the floorplan that lack external views. These open-air spaces prevent the adjacent rooms from feeling dark and claustrophobic, as well as providing usable outdoor areas that are private and hidden from view. HW Studio's retreat in rural Mexico (page 112) is submerged in a forest and features a row of bedrooms that look onto a secluded sunken terrace, while some of the living spaces at BCHO Architects' Jipyoung Guesthouse (page 94) are arranged round a series of angular courtyards lined with concrete retaining walls. The Tirpitz museum in Norway designed by BIG (page 118) includes a central courtyard that allows daylight to enter four subterranean spaces through large glazed walls. These inventive solutions result in subterranean spaces that are practical, safe and comfortable places to spend time in.

Hill Country Wine Cave

Clayton Korte

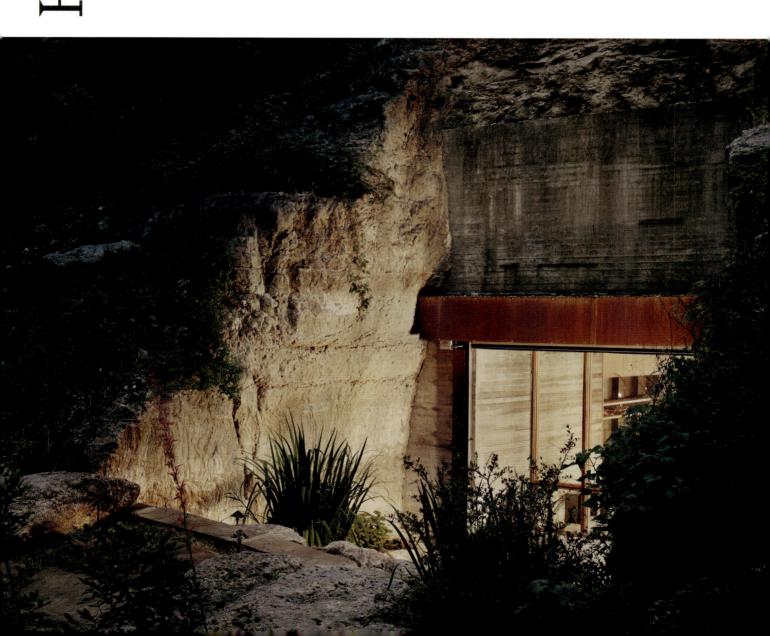

Texas, USA

An existing cave carved into a limestone cliff on the eastern edge of the Texas Hill Country was transformed by local architecture office Clayton Korte into this private wine cellar discreetly integrated into the owner's ranch. Tucked away out of sight around a river bend, the cave is shielded by tall trees and is almost invisible within the lush landscape. A simple yet richly detailed wooden interior inserted into the rock provides a refuge that is ideal for preserving and enjoying wine in a unique setting.

Clayton Korte was tasked with creating a comfortable and inviting space within the existing shotcrete-lined tunnel, which extends approximately 21 metres into the north-facing hillside. A simple paved path flanked by boulders and vegetation leads towards an entry court that offers glimpses of the interior through a large glazed opening. The entrance is set into a massive concrete portal created to shore up loose limestone at the cave mouth. The concrete surfaces extend into the interior and provide a predictable surface onto which the wooden insert was fixed.

The architects were required to work within the existing dimensions of the cave, which was not watertight or originally intended for such a use. Sections of the original shotcrete walls remain visible within the interior, where the natural texture is complemented by joinery that adds a sense of warmth to the space. A bar area near the entrance is lined with ebonised wall panelling and cabinets that contrast with a lighter Douglas fir ceiling incorporating lighting and air diffusers. The central island bar is topped with live-edge cedar planks harvested from the estate.

At the rear of the space is a cellar for a private collection of about four thousand bottles of wine. The cellar includes a table for entertaining and tasting wines set beneath an arched ceiling. Looking back along the length of the cave, the large opening at the entrance provides a visual connection to the outdoors and allows northern light to filter into the subterranean space.

< The private wine cave is embedded in the north face of a solid limestone hillside.

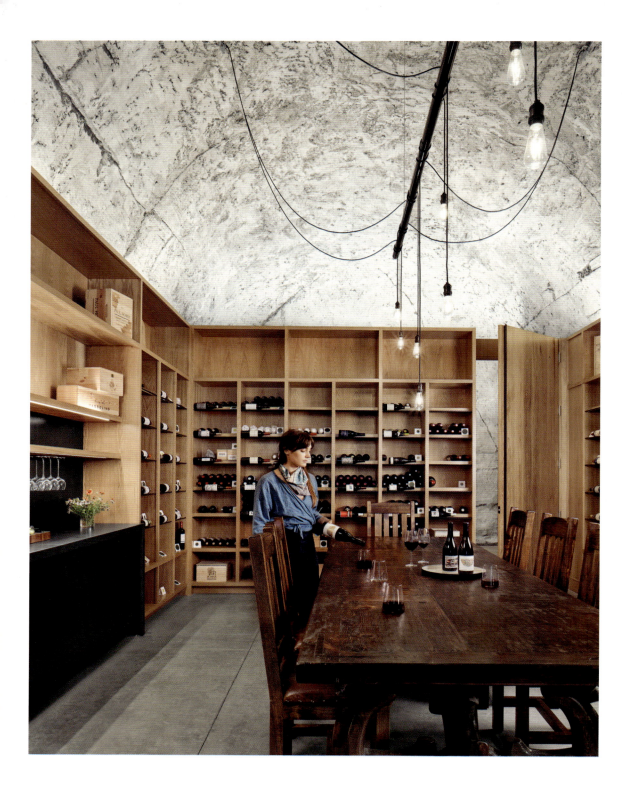

∧ The cellar provides storage for a collection of around four thousand wine bottles.
> A concrete portal moulded to the irregular limestone surface frames the opening to the cave.

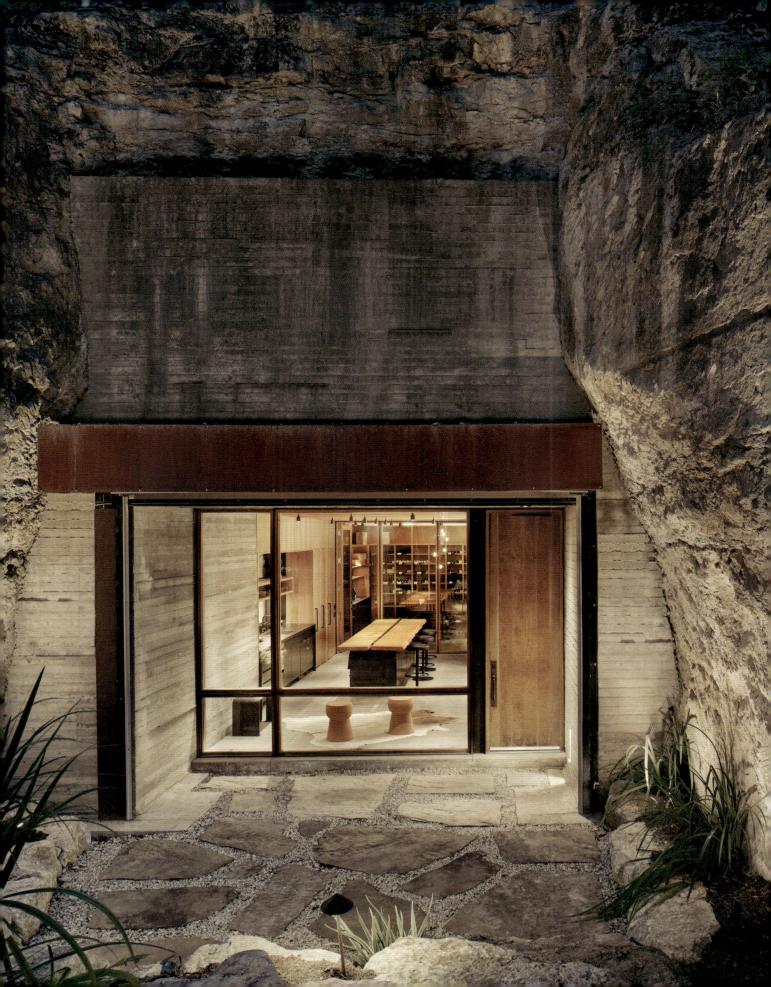

Jipyoung Guesthouse

BCHO Architects

Geoje Island, South Korea

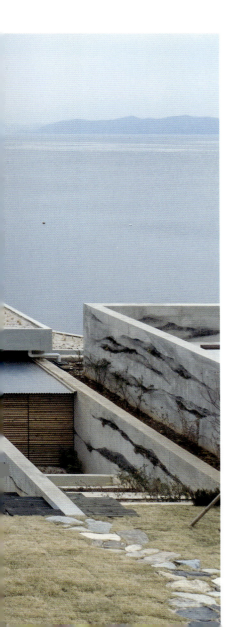

Rooms at this guesthouse on South Korea's Geoje Island are embedded in the clifftop site and topped with planted roofs that form terraces looking out towards the sea. Seoul-based BCHO Architects designed the Jipyoung Guesthouse for a local woman who wanted to offer accommodation that feels connected to nature. Unlike the designers of other local developments that impose themselves on the picturesque coastline, architect Byoung-soo Cho set out to create a building that disappears into the landscape and minimises its ecological impact.

The main mass of the guesthouse complex is submerged below ground to conceal it from view, while green roofs reinstate local flora to help it merge with the site. All of the buildings feature poured-concrete walls that lend them a rugged appearance in keeping with the natural surroundings. Some of the walls and floors were blasted with high-pressure water jets to expose the rough aggregate and create gaps that plants can grow in, enhancing the architecture's connection with the earth.

Gashes carved into the terrain at the northern end of the site create courtyards flanked by two guest suites and a central communal dining hall. The accommodation blocks feature full-height sliding glass doors that connect the bedrooms with angular gardens enclosed by low concrete walls.

Stone paths lead from the site's entrance to a row of six additional south-facing suites. The rooms are carved into the sloping topography and are reached via steps that descend gradually into the earth. Inside, large openings frame a view of the sea that stretches away to the horizon. Sliding doors open onto a private deck incorporating a bathtub that feels immersed in the scenery. The simple interiors combine exposed concrete walls with polished concrete floors and timber joinery, which adds a warm, natural element to the pared-back material palette.

< Suites at the Jipyoung Guesthouse are buried into the side of a cliff and topped with green roofs.

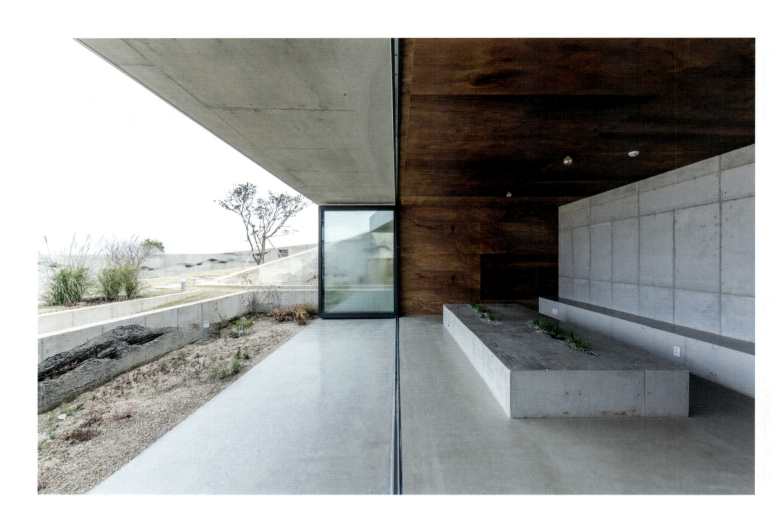

^ Full-height windows lining the communal kitchen retract to open the space up to the garden.
> Voids inserted into the landscape form external spaces intended to bring people closer to nature.

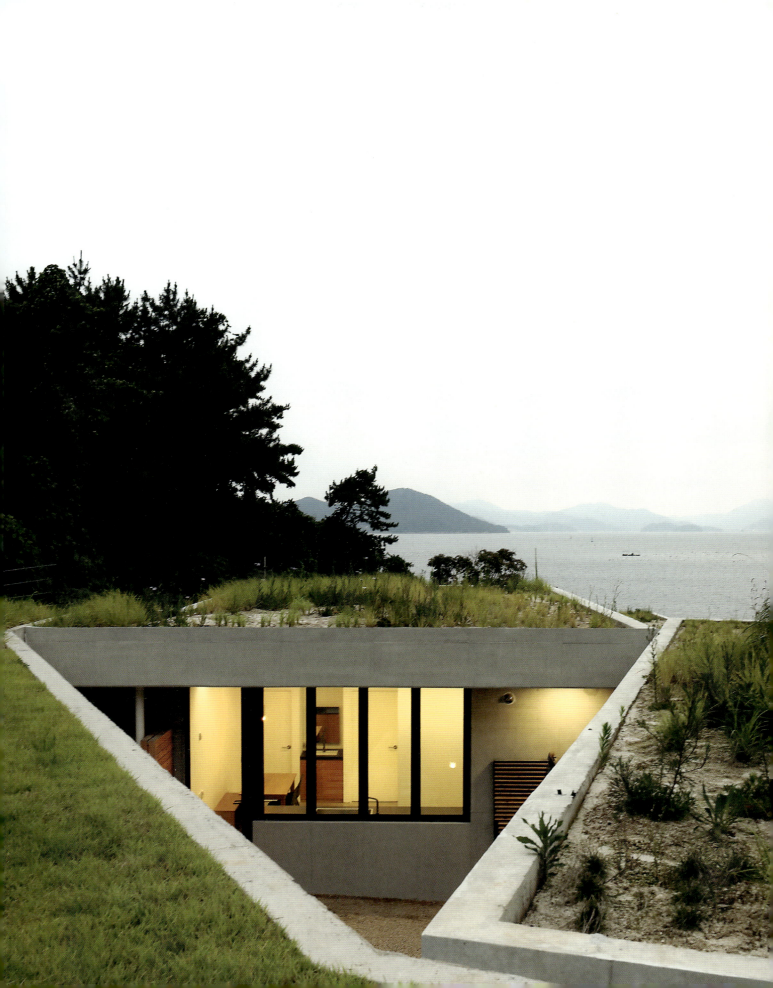

N Caved

Mold Architects

Serifos, Greece

Embedded in a hillside on the Greek island of Serifos, the N Caved house faces out towards the Mediterranean Sea and is barely visible from its surroundings. Athens-based Mold Architects chose to excavate into the sloping site to protect the building from the strong, northerly winds. Each of the property's three stepped levels features full-height glazing that provides expansive views from the subterranean spaces. Large terraces allow the living areas to extend outside, while a concealed courtyard ensures daylight reaches the more private rooms to the rear of the house.

An external staircase on the southern edge of the property gradually reveals the house's hidden spaces, which are set back into the hillside. The narrow slit containing the stairs frames views towards the sea on the descent, while only the sky is visible when looking upwards. Stone retaining walls flanking the stairs and living areas follow the angle of the slope and help to draw the eye towards the horizon. The rugged surfaces accentuate the house's connection with the natural landscape and their robust construction contrasts with the transparency of the perpendicular glazed openings.

The house is entered at the level of a mezzanine overlooking the main living room. This open-plan space contains a lounge and dining area, and a concealed kitchen lined with east-facing windows. The rest of the interior features an orthogonal plan that forms a three-dimensional grid of solids and voids.

Three bedrooms on the upper level open onto terraces on one side and the hidden garden on the other. The main bedroom suite is situated on the same level as the living area, while a self-contained guest suite is positioned down the slope. Throughout the property, a palette of stone, exposed concrete, wood and metal helps to achieve the desired effect of a natural cavity hewn into the rock.

< The house is inserted into a hillside to protect it from strong north winds while providing views of the sea.

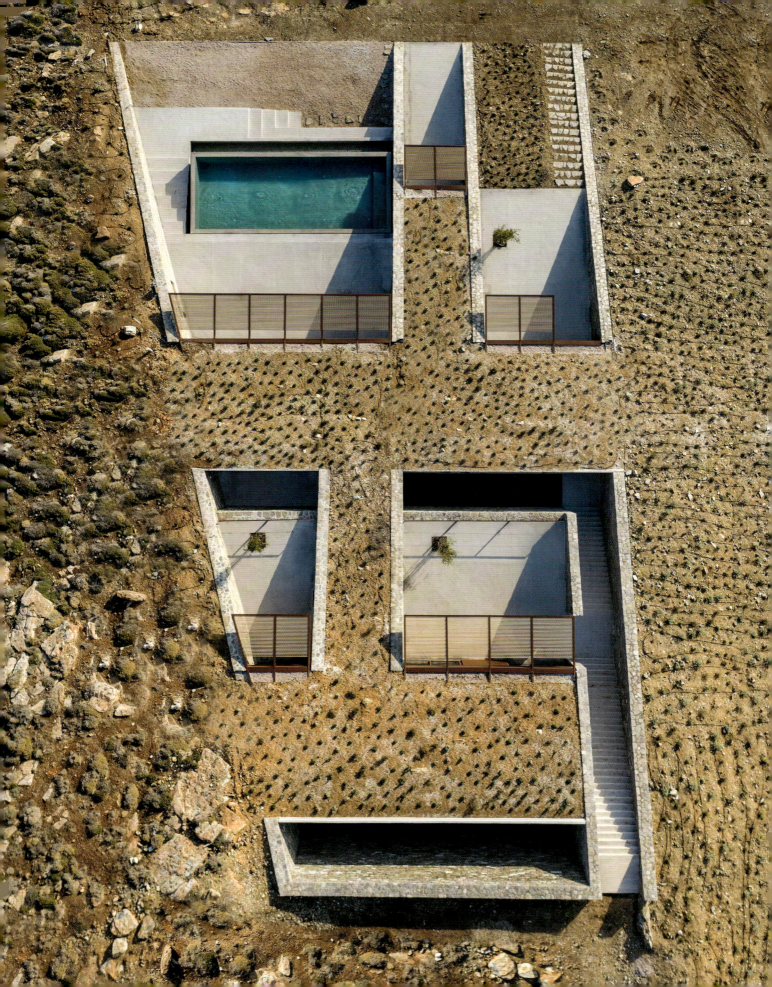

< Residential areas are arranged in a rectangular grid of solids and voids on the upper portion of the site.
v The internal material and colour palette was chosen to evoke the rugged feeling of a natural cave.
>> The bedrooms and living areas are connected by internal and external staircases.

N Caved / Greece

Secret Garden House

Scape-architecture

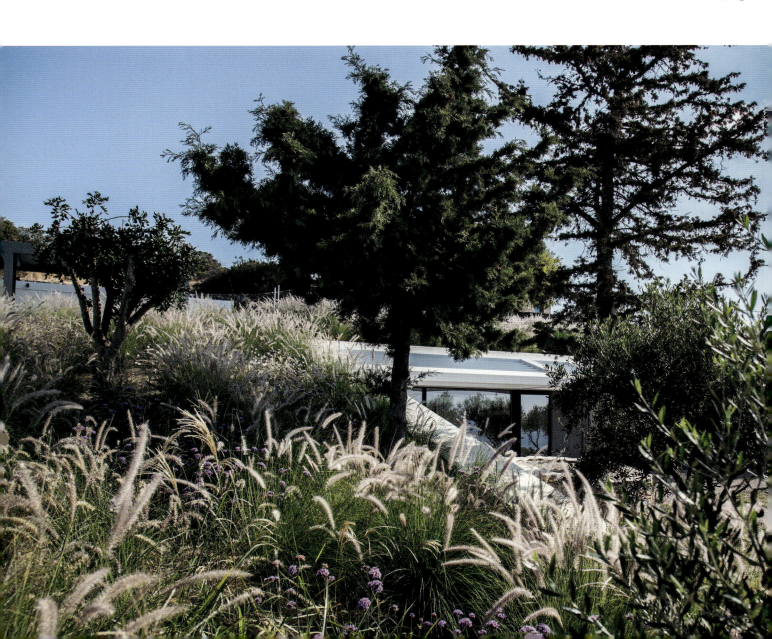

Paros, Greece

This cave-like house on the Greek island of Paros takes advantage of local planning regulations that allow subterranean structures to be larger than if they were built above ground. Secret Garden House is located in Faragas in the south-west of the island and was designed as a tranquil summer retreat where its owners can relax both indoors and outdoors. A planted roof hides the building from sight, while large openings lining the living spaces provide spectacular sea views.

Athens-based studio Scapearchitecture attempted to create a building that nestles discreetly within the existing landscape rather than standing out as one more white box on the coastline. Working in conformity with the Greek Building Code set out in 2012, the architects proposed a house with a total floor area of roughly 100 square metres, which is twice what would normally have been permitted for the plot. The regulations state that the built area can be doubled as long as the natural slope is restored and the building's roof is covered with plants.

The property is positioned between a small olive grove and a group of pine trees that define the site's boundaries. Stone steps connect a car port with the main house, which is partially submerged in the lower portion of the site. The steps continue to a large terrace farther up the slope, which provides space for outdoor living and dining with views towards the nearby island of Antiparos.

A gravel path leads through the existing olive trees to the front of the building, which extends almost 17 metres into the hillside. Living areas and bedrooms arranged along the main elevation incorporate sliding doors that connect these spaces with the garden. The landscape design and planting round the house are integral to the project, helping to preserve and partially restore the natural slope. The building's green roof is covered with evergreen plants, most of which are local species, while gravel paths evoke the tones of the surrounding earth.

< The summer residence is embedded in a hillside and covered with a green roof that restores the natural slope.

v The house is designed as a cave-like building with large openings that allow breezes to cool the shaded interior.
> The pool area and outdoor living space on the upper portion of the site has the best views of the sea.

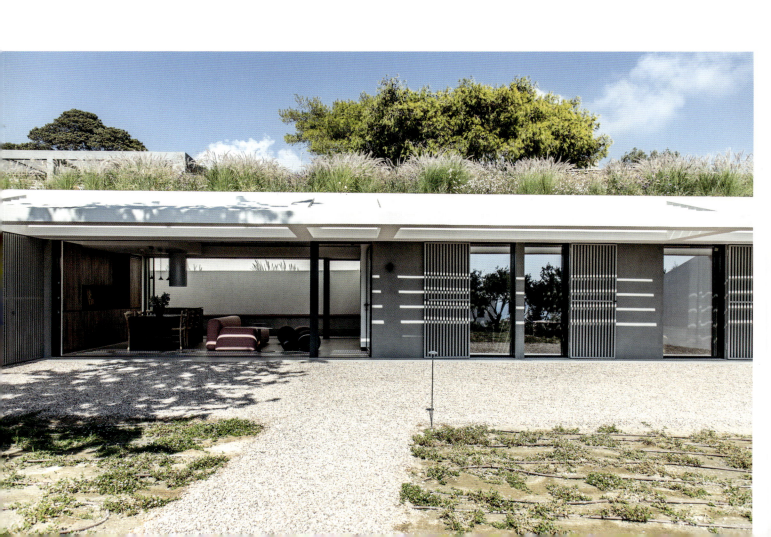

Skamlings-banken

CEBRA

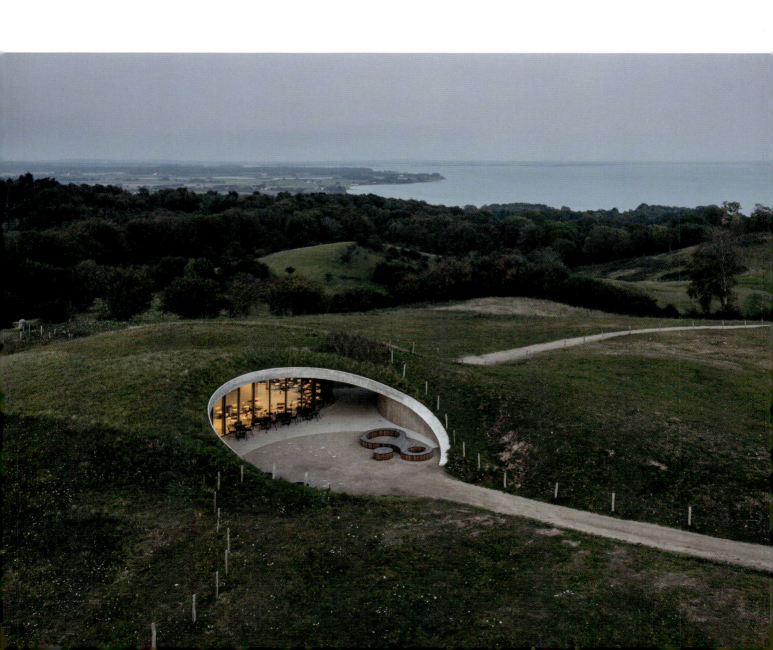

Sjølund, Denmark

The Skamlingsbanken visitor centre is designed as an architectural portal to the moraine landscape of the Kolding region in southern Denmark. The building's mound-like roof and rounded openings help it to blend in with the undulating terrain. By concealing most of the structure beneath a layer of earth and grass, Danish architecture firm CEBRA was able to maintain the visitors' focus on the landscape and its important history.

Skamlingsbanken holds a significant place in Denmark's past. The site was used for civil gatherings and festivals, due to the natural shelter afforded by the rolling hills and steep gorges. The visitor centre aims to connect the past, present and future by creating a forum for conversations about contemporary topics such as climate change. By immersing visitors in nature, the architecture encourages them to consider how the glacial landscape evolved, and to learn about the region's role in supporting democracy. The building serves as a location for events and contains an exhibition dedicated to Skamlingsbanken's history.

CEBRA designed the visitor centre to become part of the rich and fertile landscape, which was formed during the last ice age. The building resembles a softly curved hill intersected by two circular cuts. These openings frame views of the surroundings and create sheltered outdoor areas adjacent to the entrances. Meandering paths that lead into and through the building join up with a network of routes that encourages visitors to explore the area.

The visitor centre's largely open-plan interior is lined with full-height windows that maintain a connection to the landscape. Curving concrete walls gently guide visitors towards different zones, including an exhibition space, teaching areas and a café. The interior uses local materials such as wood and a terrazzo floor that incorporates chunks of natural stone. The building's green roof was seeded with a mixture of native grass species to help support the protected area's unique nature and biodiversity.

< The visitor centre blends in with the undulating landscape of hills and hollows.

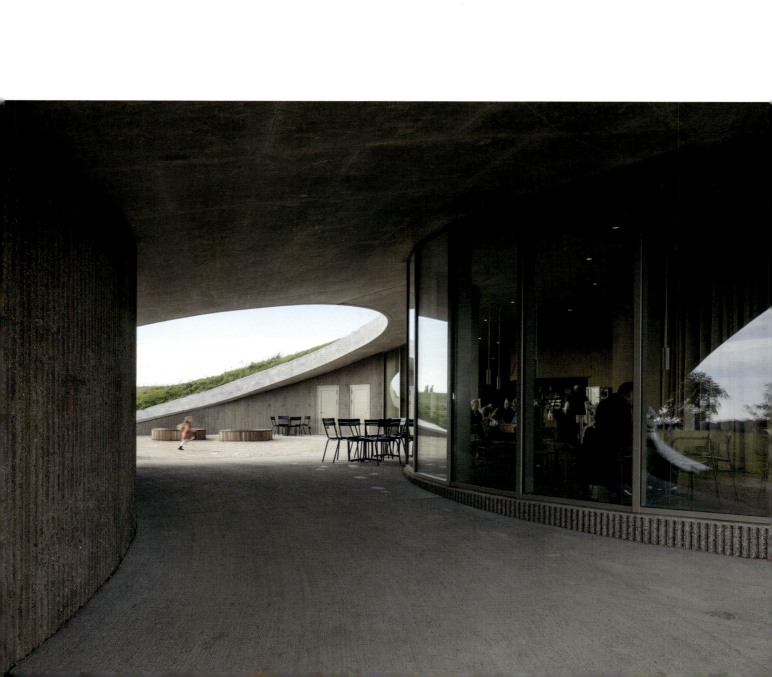

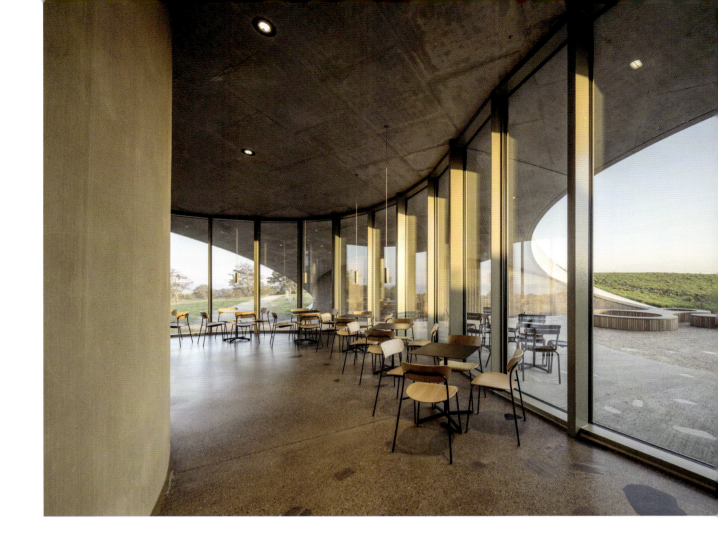

< Two circular cuts guide visitors into the building and back out to reconnect with a network of paths.
∧ Fully glazed walls maintain a connection with the natural surroundings throughout the exhibition space and café.

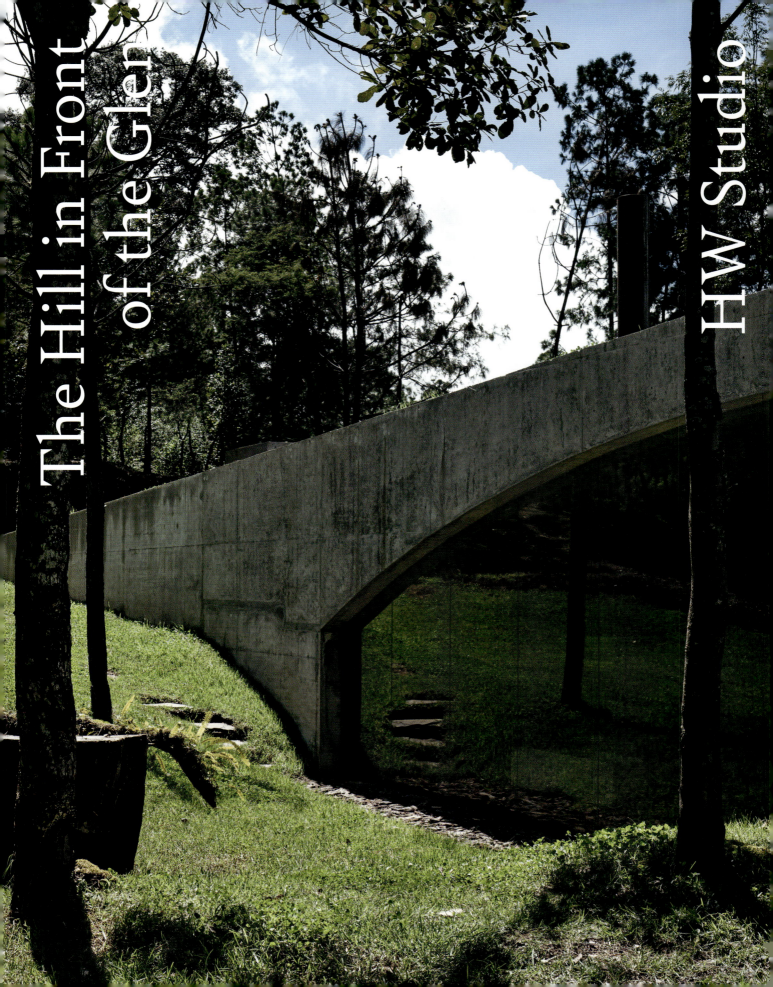

The Hill in Front of the Glen

HW Studio

Morelia, Mexico

The Hill in Front of the Glen was designed by local architecture office HW Studio to feel secluded and protected, allowing its owner to relax when visiting his rural retreat outside Morelia, Mexico. The architects created a building that evokes the image of a child hiding beneath a bedsheet and peeking out from under it. The result is an unusual arched structure that is embedded in the forest, with curved openings framing views of surrounding nature.

The house is slotted in among existing trees and is almost invisible from above due to its grass-covered roof, which rises up as if a strip of turf has been lifted to protect the building hidden underneath. Two parallel concrete walls support the roof, while a narrow slit sliced into the earth leads to an entrance near the centre of the house. The path is just wide enough for solitary access but expands at one point to curve round an old tree.

A hallway at the heart of the house connects with an open-plan living area on one side and a row of bedrooms on the other. Internally, the exposed concrete walls and ceilings form a vaulted structure that evokes a dark yet cosy cave. Wooden flooring and joinery soften the overall aesthetic and introduce warm, natural surfaces. Raw steel used for the dining table and a suspended chimney flue complete the minimal material palette.

The brief for the project was to create a peaceful retreat for the client's family that feels completely disconnected from the city. The house has no television or internet, with lighting and appliances hidden from view to ensure the focus is solely on the natural world outside. The public areas look out onto a wooded ravine, while the bedrooms on the opposite side open onto a narrow courtyard with views of the treetops and sky.

< A pair of arching concrete walls support a green roof that drapes over the building.

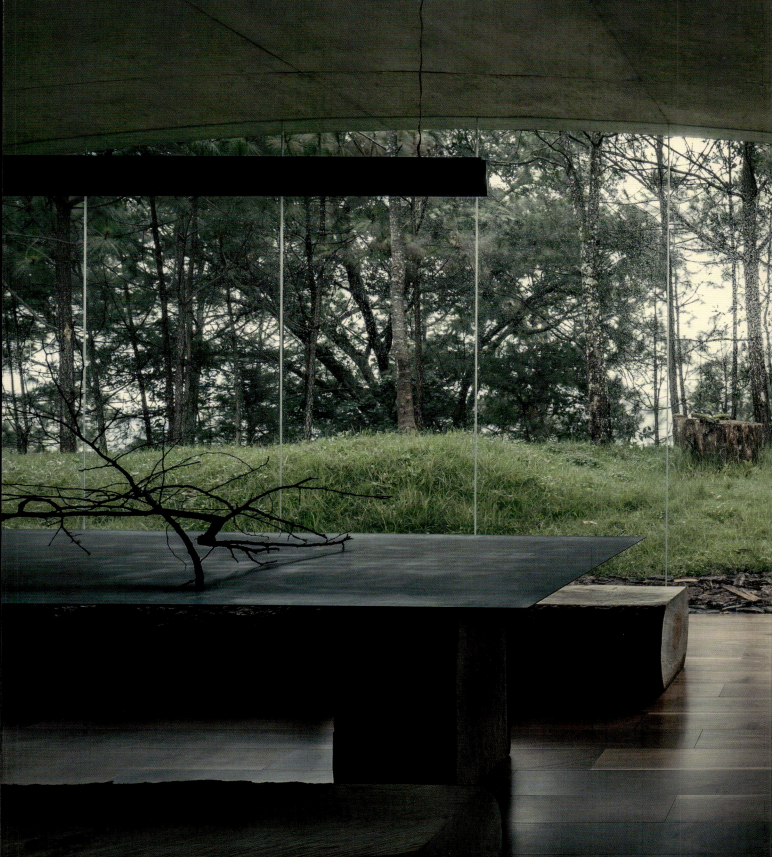

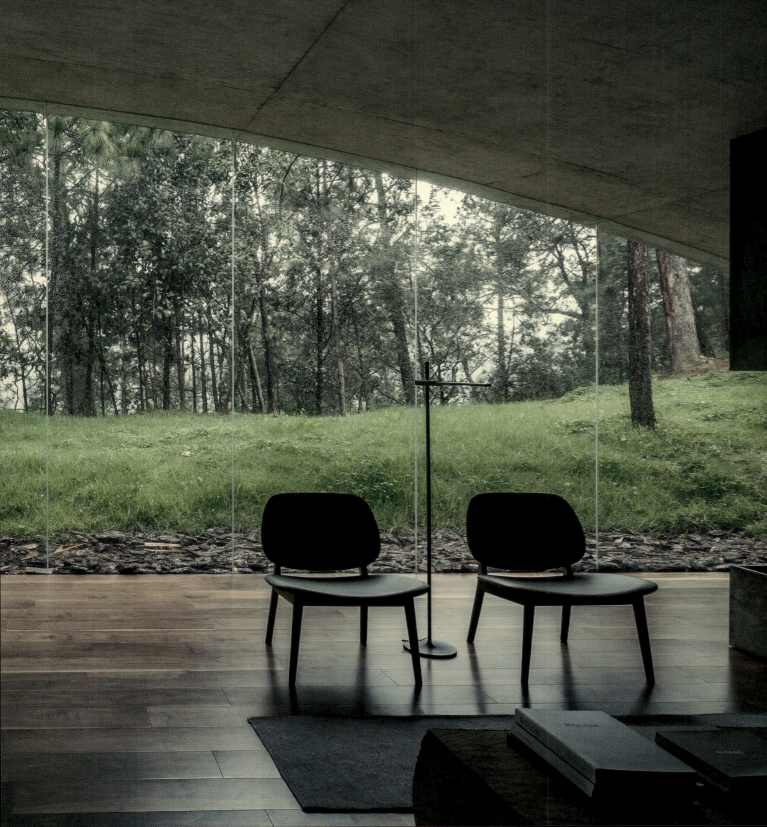

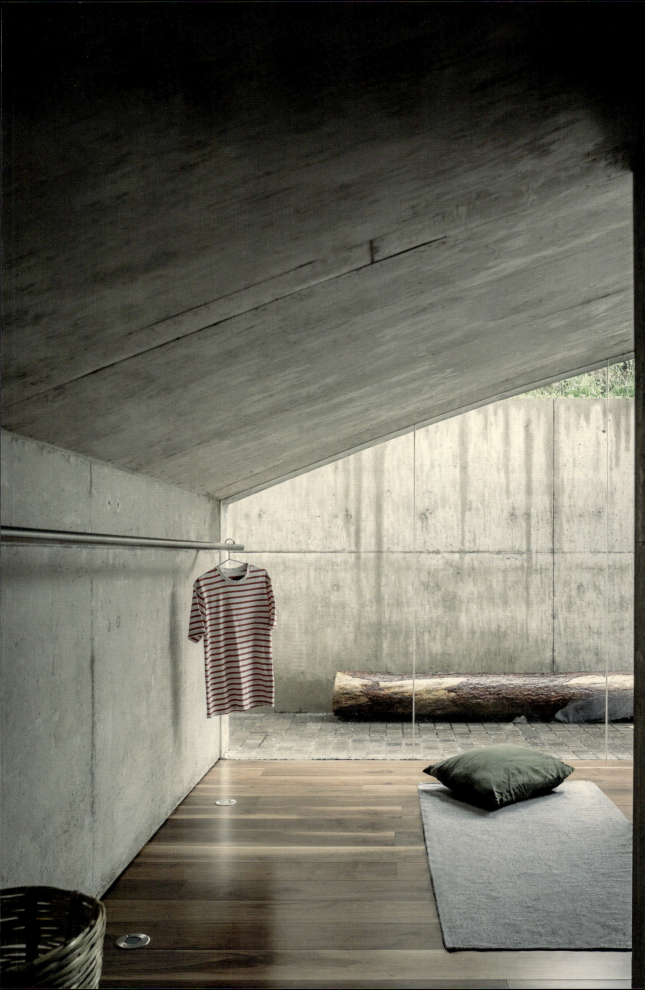

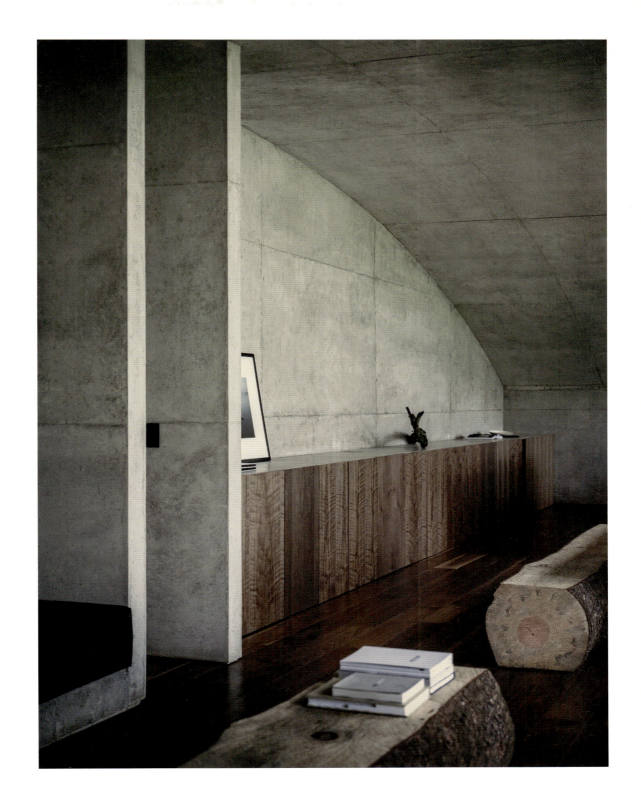

<< The interior evokes a dark yet cosy cave connected to the surrounding forest by large glazed surfaces.
< Bedrooms open onto a private courtyard concealed behind a protective concrete wall.
∧ The natural texture of wood contrasts with the concrete and introduces a warm, tactile element.

Tirpitz

BIG

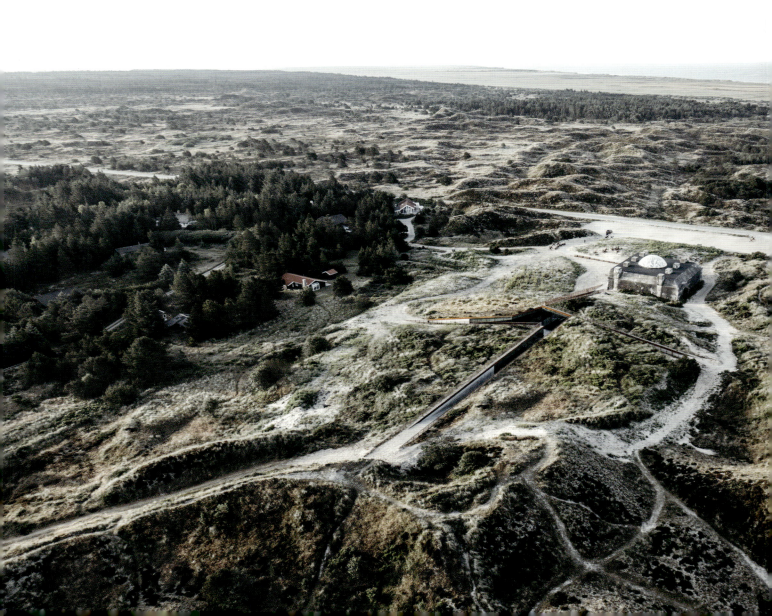

Blåvand, Denmark

The Tirpitz bunker was constructed in 1944 as part of Adolf Hitler's Atlantic Wall defences, which stretched all along Denmark's west coast. The concrete structure was designed to house two naval guns protecting the sea route to Esbjerg harbour, but the surrender of German forces and the end of the Second World War meant it was never completed. Now, the bunker forms the most visible part of a modern exhibition complex designed by Bjarke Ingels Group (BIG) to tell the story of the west Jutland region.

The majority of the Tirpitz museum is buried into the landscape to minimise disruption to the fragile coastal ecosystem. Its four connected exhibition areas are arranged round a central courtyard, with each one exploring a different aspect of the region's history and culture.

Upon arrival, visitors first encounter the monolithic bunker before following a pathway that leads through the dunes towards the courtyard. Further passages carved into the landscape connect the central terrace to an existing network of trails that wind among the dunes. Glass walls lining the open-air space allow daylight to enter the four separate blocks and filter down into the subterranean exhibition spaces.

The museum is entered via a steel bridge that leads towards a café and reception area. A glass-walled staircase descends to a foyer on the lower level, where circulation spaces, toilets, a cloakroom and storage are slotted in between the galleries. The four walls enclosing the foyer are rotated slightly to create openings leading into each of the exhibition spaces. The building's concrete construction evokes the old Tirpitz bunker, which is connected to the new museum by an underground tunnel. The concrete walls support roof decks covered with sand and grass that visitors can clamber over to gain a better view of the bunker and the surrounding landscape.

< The Tirpitz museum is reached via pathways cut into sand dunes in Blåvand on Denmark's west coast.

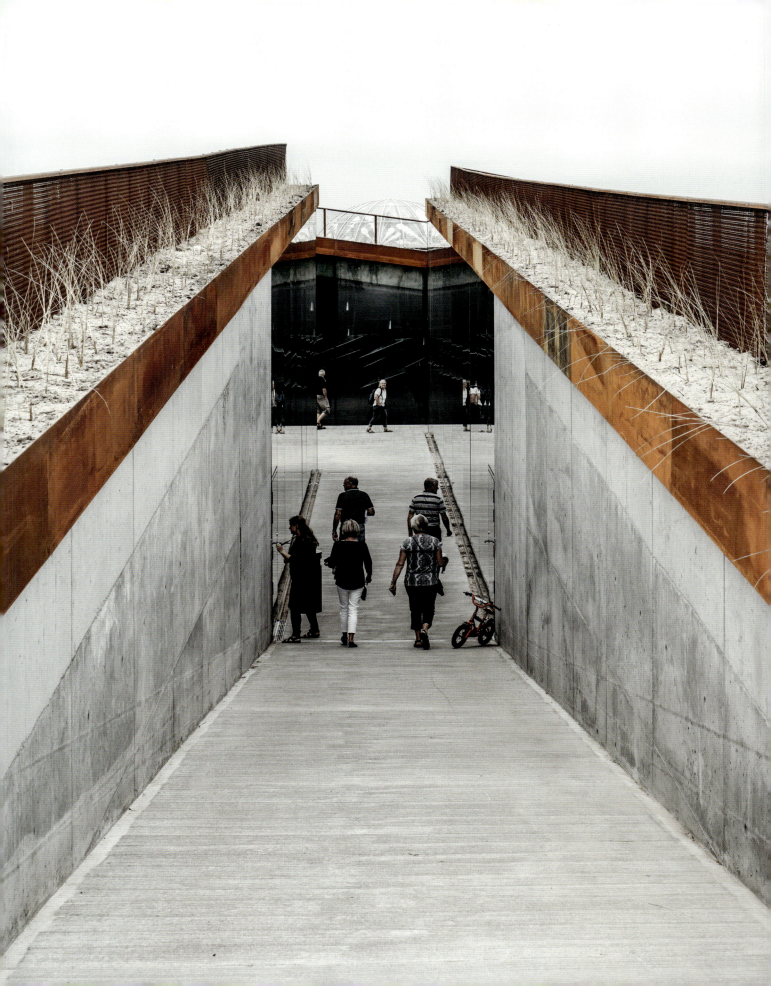

< Sloping paths lead to a central clearing surrounded by four galleries that descend underground.
v Windows lining the courtyard allow daylight to reach the subterranean spaces and provide a visual connection with the courtyard.

Tirpitz / Denmark

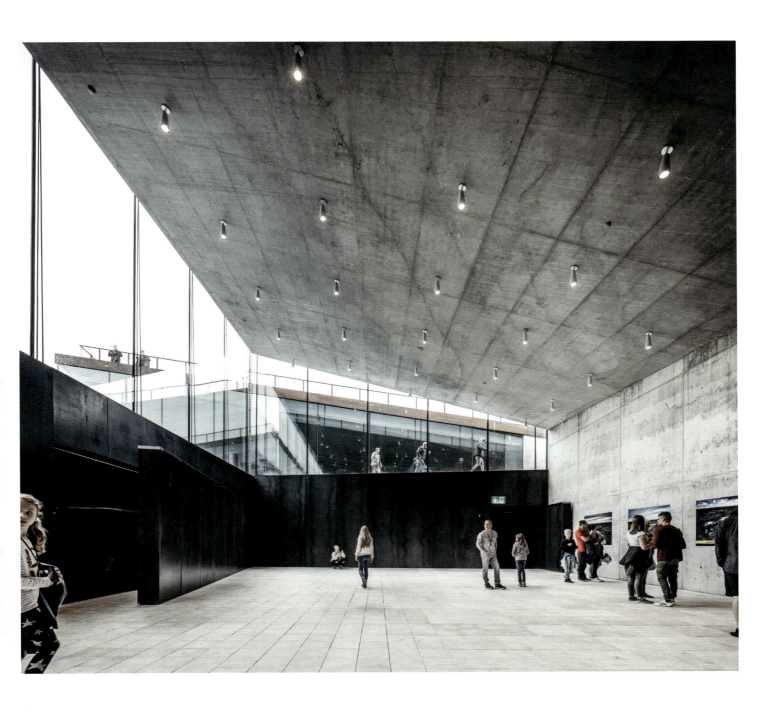

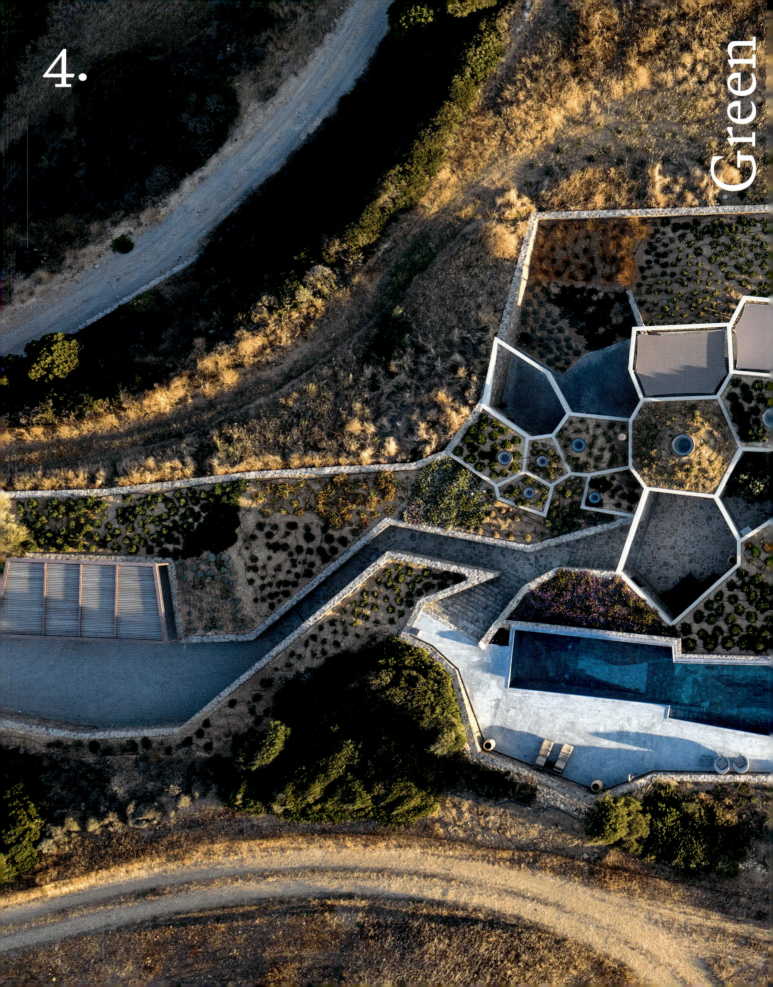

4.

Green

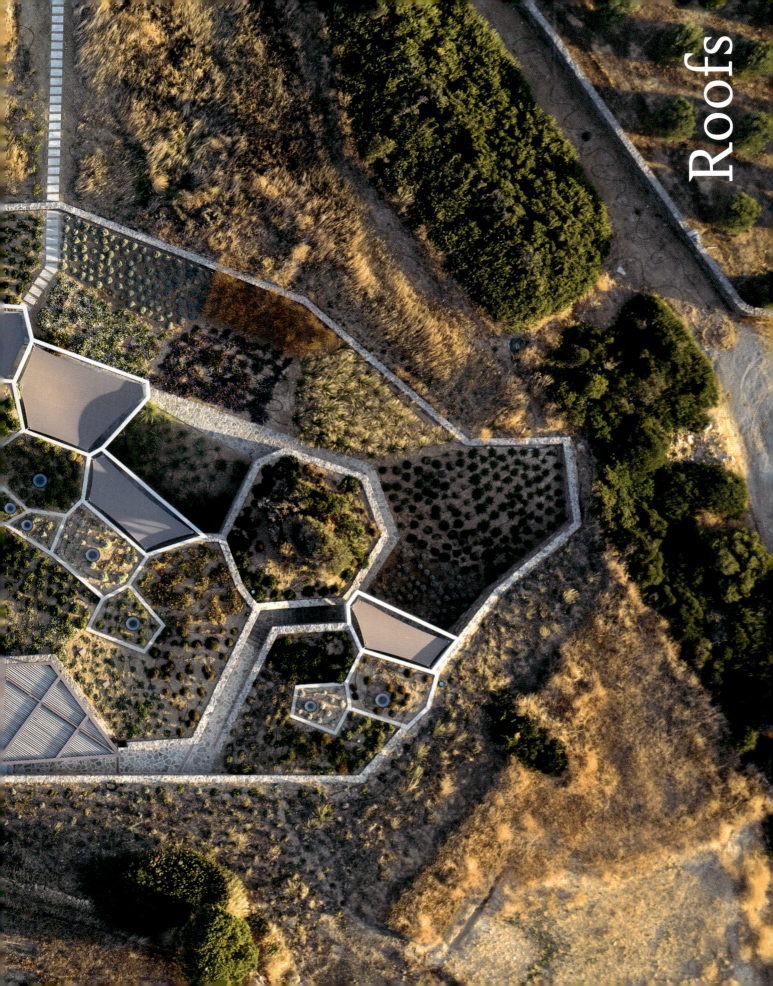

Roofs

4. A green roof is a roof surface on a building that is partially or completely covered with vegetation and a growing substrate, which are laid on top of a waterproof membrane. Green roofs are becoming increasingly popular as an alternative to more conventional roofing solutions as they offer several practical, aesthetic and ecological benefits. In rural settings, in particular, they can be planted with local species of flora to help a building blend in with its surroundings while also contributing to the site's biodiversity.

Roofs covered with earth and plants have been used for centuries to provide a protective and insulating surface that requires minimal maintenance. Green roofs made by placing strips of sod or turf on top of layers of water-resistant birch bark were common in Scandinavia throughout the Viking period and the Middle Ages. They were eventually superseded by tile roofs during the eighteenth and nineteenth centuries, but are still used for newly built cabins in some regions. The Åkrafjorden Cabin designed by architecture firm Snøhetta, for example, features a turf-covered log roof that is informed by traditional Norwegian construction methods (page 126).

Green roofs evolved as a direct response to the environmental conditions in certain locations, as well as to the materials available for building. Modern planted roofs must be intelligently designed to suit a project's context and climate. These roofs are typically categorised as intensive, semi-intensive or extensive, depending on the depth of the planting medium and the amount of labour required to maintain them. The type of roof selected depends on the typical weather conditions, maintenance considerations, and what benefits the greenery may offer.

In urban environments, green roofs are sometimes specified to help improve air quality and to slow water run-off, easing pressure on drainage infrastructure. Planted roof surfaces may also perform a practical role as a resource – for example, as part of an urban farming complex. One of the projects included in the Hidden in the City section is a university building in Bangkok, Thailand, featuring a terraced roof planted with more than 40 species of edible crop (page 70).

The majority of the case studies included in this section are residential buildings in countryside locations where green roofs are used to preserve the existing scenery and ecology of their sites. Several of these projects could have featured in the Underground Buildings section and vice versa; green roofs often form an extension of the existing landscape, and the spaces beneath them may therefore be considered to be below ground. The buildings presented over the following pages are included here because their green roofs are integral to their design, or are implemented in a particularly unusual or innovative way.

The latest computer-aided design programmes and advanced engineering technologies enable the construction of complex and expressive green roofs. Parametric modelling software was used to develop the undulating roof form of The Macallan's distillery in Scotland (page 148), for example, which features several domes sheltering the production and visitor areas below. The humped roof evokes the outline of the nearby hills and is covered with grasses and other plants that replicate a wildflower meadow.

Greek firm DECA Architecture used computer software to develop the geometric design for the roof of its Hourglass Corral residence on the island of Milos (page 136). The roof consists of cells covered with different types of aromatic plant, creating a pattern that expresses the building's unusual configuration when viewed from above. The planted surface helps the holiday home disappear into its natural setting and references the traditional local model of dividing land for domestic and agricultural uses.

In both urban and rural contexts, green roofs retain or reintroduce plants that help to beautify the setting and support biodiversity. Architect Bartłomiej Drabik was keen that his House Behind the Roof in a suburb of Kraków, Poland (page 140), would contribute to the greening of the estate on which it is built. The large surface area of the house's sloped green roof exceeds the footprint of the building. As Drabik points out: 'What has been taken from nature has been given back with interest.'

The popularity of green roofs is surging as architects, planners and developers increasingly seek out more sustainable and contextually appropriate building methods. Covering a roof surface with sedum, moss or grasses is a straightforward way to conceal a building in a sensitive environmental context while creating a natural habitat for birds, bees, butterflies and other insects. Intensive green roofs supporting trees, lawns and edible crops represent a more significant undertaking, but advances in the systems used to irrigate, feed and maintain the plants should allow for their more widespread application. The varying approaches outlined in this section all bring architecture and nature closer together, resulting in buildings that will help to support a more sustainable future.

Åkrafjorden Cabin

Snøhetta

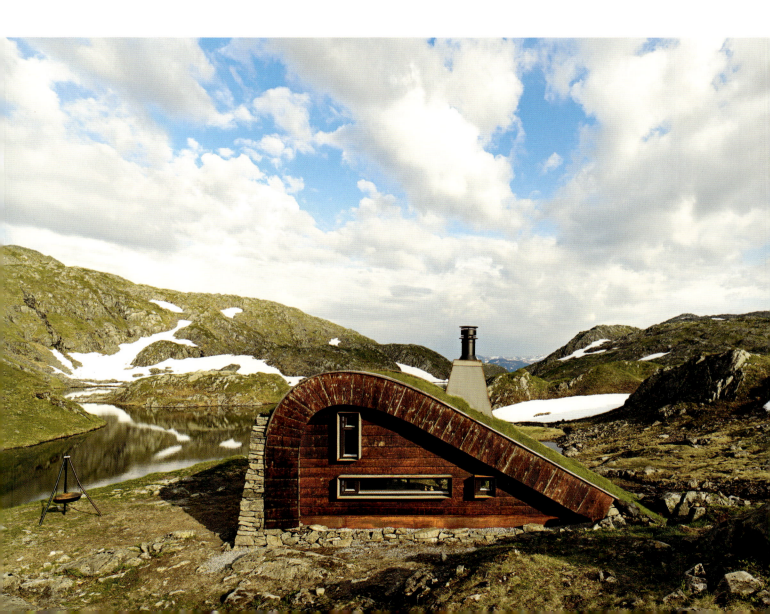

Etne, Norway

This hunting lodge is located in a mountainous area close to Åkrafjorden in western Norway. International architecture firm Snøhetta designed the compact cabin for an entrepreneur with a keen interest in environmentally friendly business models, who wanted a simple off-grid shelter his family could use throughout the year. The remote lakeside plot on the family's estate is accessible only by foot or on horseback, and the building is carefully integrated into the landscape.

The hut's size, shape and materials all help it to blend in with the rugged terrain. The unusually shaped structure was created using two curved steel beams connected by a layer of hand-cut logs. This combination of modern steel-frame construction with traditional Norwegian log building gives the cabin its distinctive character. The sloping roof is covered with grass, so the building appears to grow out of the landscape, while vertical surfaces are clad in stone and tar-treated wood to complement the natural surroundings. In winter, when the cabin's roof is often covered with snow, only the dark façades remain visible. This makes it resemble some of the rocky outcrops that protrude above the surrounding grass and heather.

The lodge was designed to be as compact as possible in order to minimise its impact on the unspoiled natural environment, with a total built area of just 35 square metres. At times it is used to host more than 20 people, so Snøhetta created a versatile interior that allows for various activities. The internal layout is informed by traditional mountain cabins that feature a central fireplace as a focal point. Benches arranged along the outer walls provide space for seating during the day and sleeping at night. A small area at the entrance contains facilities for cooking and storage. Narrow, steel-framed windows incorporated into one of the elevations frame specific views, while a large opening on the opposite side looks out towards the lake and the mountains beyond.

< The hunting lodge is integrated into an unspoiled landscape in a mountainous region of western Norway.

^ A material palette including tar-treated wood, weathering steel and stone complements the rugged surroundings.
> The building's curving form appears to rise up from the earth and is topped with a grass roof.

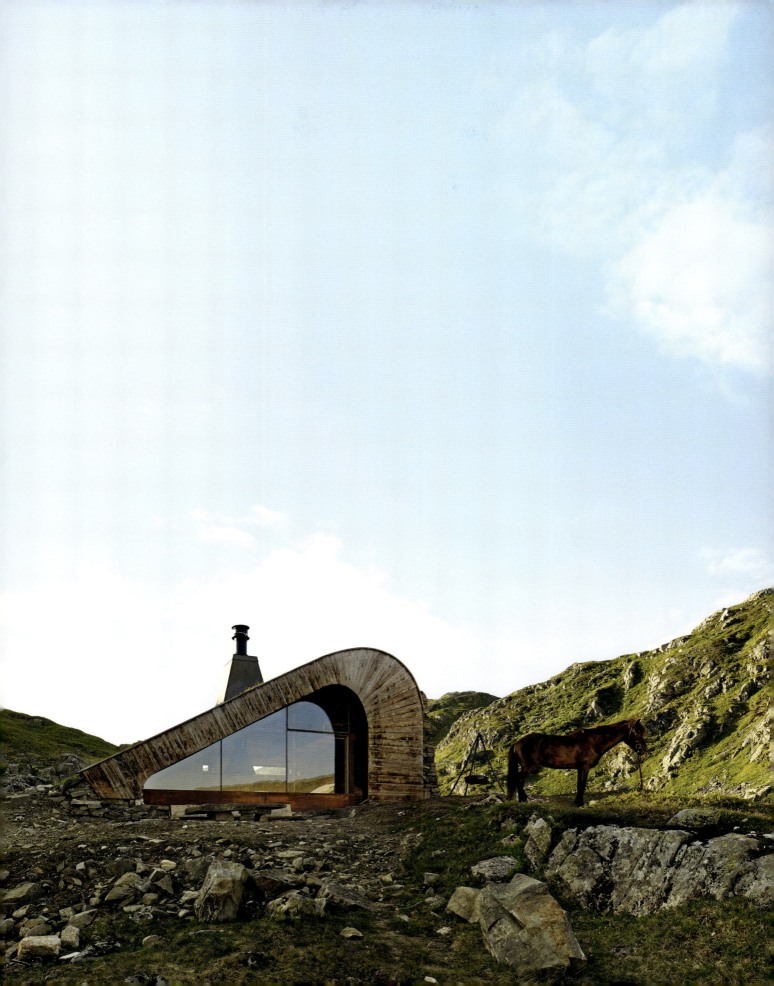

Green Line House

Mobius Architekci

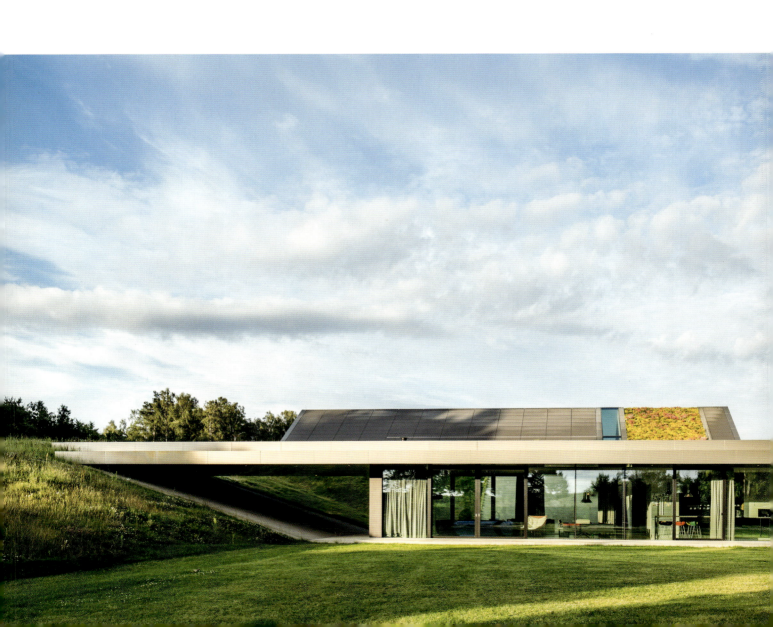

Warmia, Poland

A sunken courtyard forms the social heart of this home in Poland's Warmia-Masuria province. The majority of the building is set below the level of a grass embankment to hide it from view. A pitched roof that extends above the embankment is covered with grass on one side to help camouflage it within the surrounding meadow, while the opposite side facing the courtyard is covered with large-format cement cladding panels that express the building's modern character.

The property is located in an area that is popular with private investors because of its low building density and proximity to a beautiful natural landscape of forests and lakes. Przemek Olczyk of Warsaw-based Mobius Architekci designed the house to blend in with its surroundings, while providing its owners with approximately 500 square metres of contemporary living space.

The building features a U-shaped plan that references the layout of the region's traditional farms. Its position within the large site was informed by a natural incline used as part of an embankment to hide the living spaces on the ground floor. The project's title, Green Line, refers to a grass-covered, reinforced-concrete roof slab that encircles the courtyard. The slender slab joins up with the pitched roof and cantilevers out beyond the façades to emphasise its lightweight construction.

Rooms lining the courtyard feature glazed walls and sliding doors connecting the internal and external spaces. The central terrace is protected from the strong prevailing winds and is connected to the upper floor by a large staircase set into the embankment. The main living area is situated in the south-west corner of the building to make the most of the available sunlight. In addition to the glazed elevations, aluminium and ceramic façade panels contribute to the building's contemporary aesthetic, while the pitched roof and gable walls clad with timber battens nod to the region's more traditional architecture.

< The house's slender planted roof slab extends from the top of an embankment.

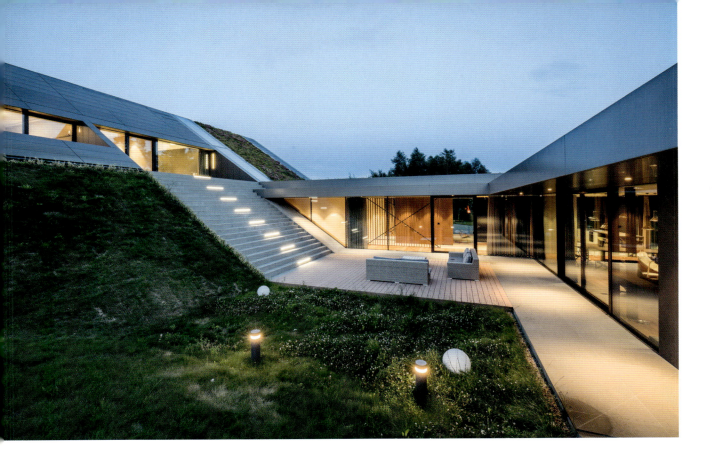

^ The building is positioned below the height of the embankment to partially conceal it from view and to protect it from strong winds.
> Glass walls and openings in the roof provide views of the surroundings from the living areas and circulation spaces.
>> The pitched roof references the region's vernacular buildings and is covered with plants that evoke a wildflower meadow.

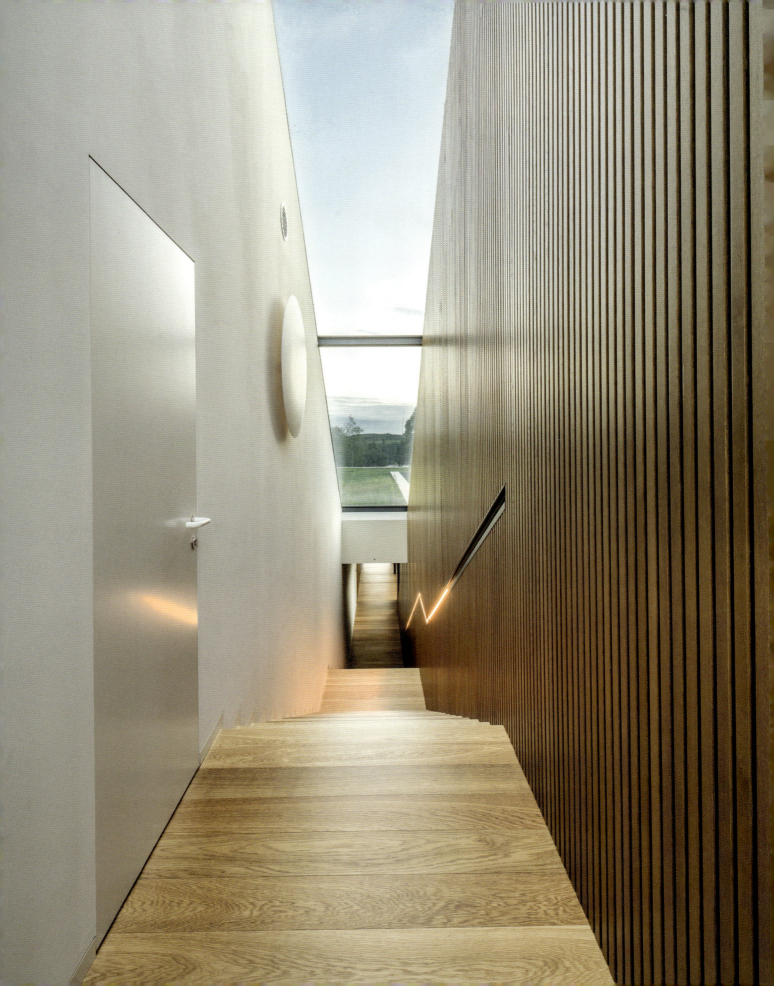

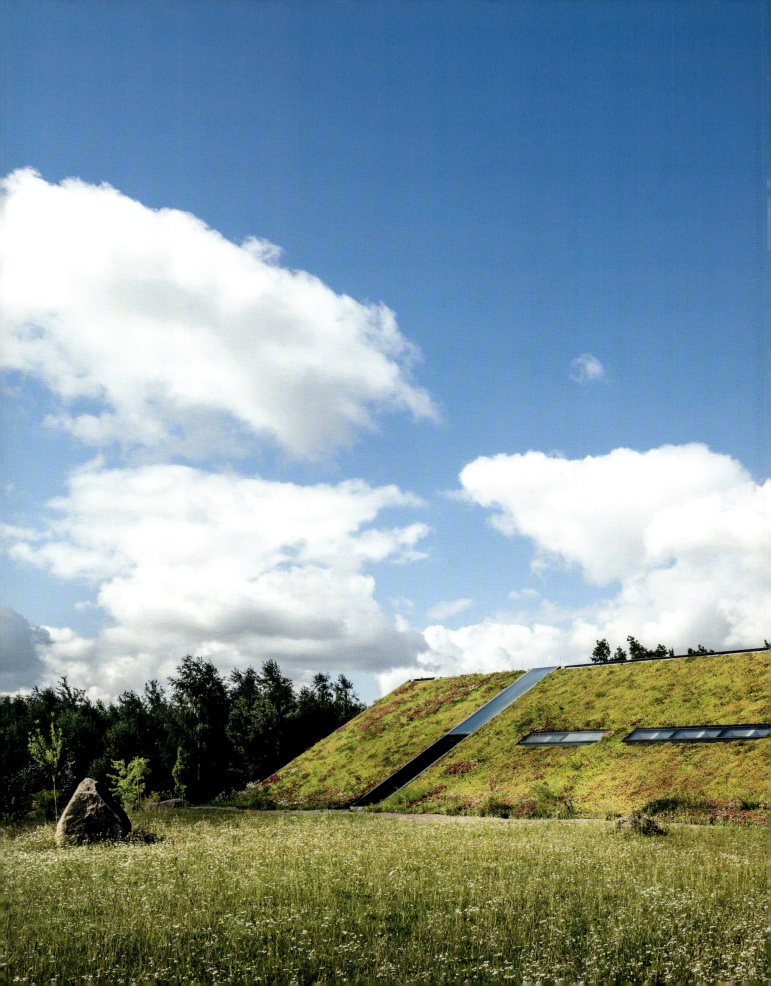

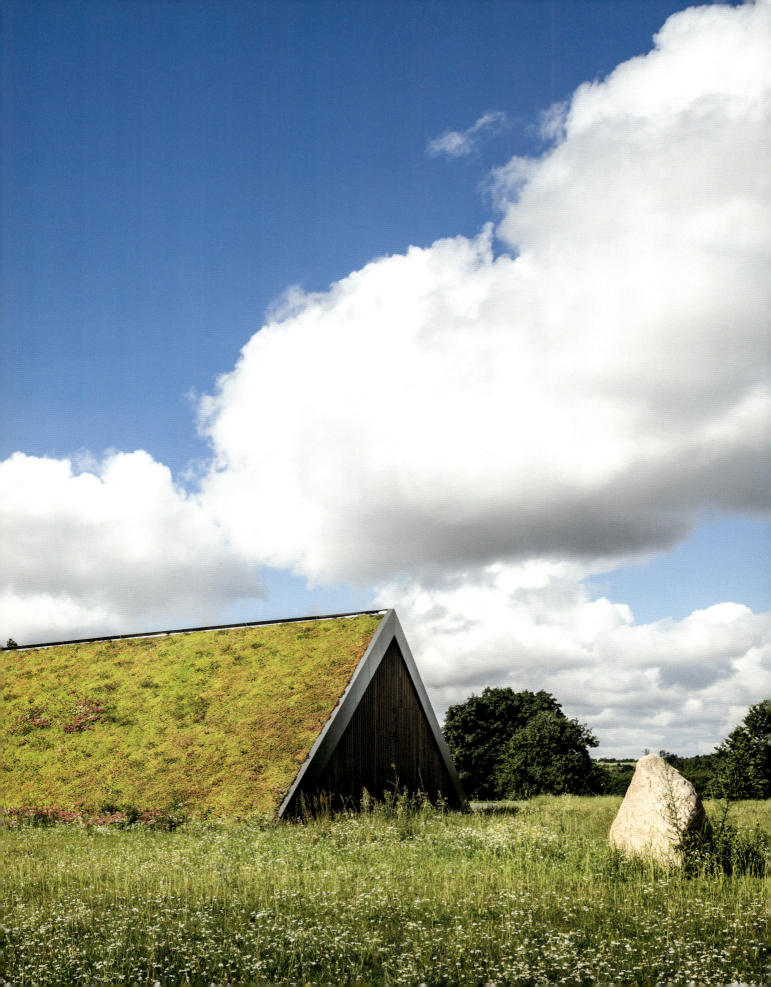

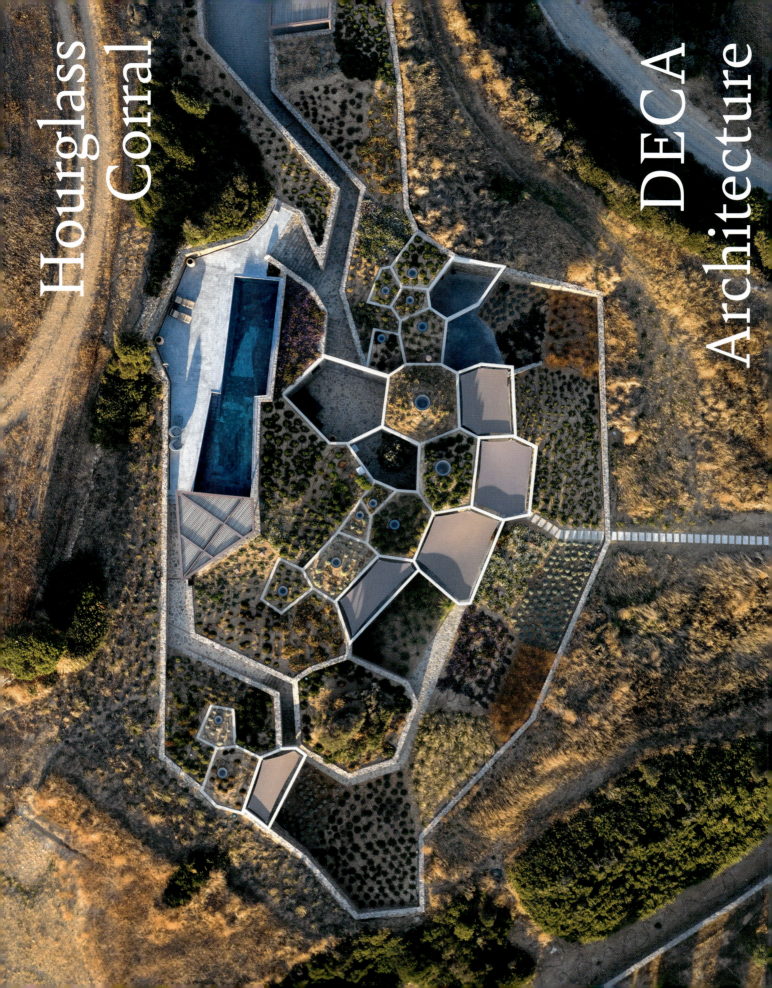

Milos, Greece

Irregularly shaped rooms topped with planted roofs combine to form this house embedded in the landscape on the Greek island of Milos. Hourglass Corral is the largest residence completed by Athens-based DECA Architecture on a 90,000-square-metre site that the studio has been developing for over a decade. The four-bedroom house hunkers down into the earth to hide it from view and features living spaces oriented to make the most of vistas towards a nearby olive grove and the Aegean Sea.

The property forms part of the Voronoi's Corrals project, which DECA Architecture is using to explore more sustainable approaches to development in island communities. The building's plan was created using a formula devised by Russian mathematician Georgy Voronoi, which generates an organic grid linking various points on a plane. Courtyards, living areas, bedrooms and utility spaces were positioned and shaped using parametric design tools to optimise the available views and natural features.

The property features rough stone walls that encircle the living areas – except for the southern elevation, which incorporates full-height windows. Each section of the roof is planted with a different species of aromatic plant used for extracting essential oils. The earth-covered surface insulates the building and helps it blend in with the landscape, while the distinctive cellular pattern reveals the underlying spatial organisation. Circular roof lights at the centre of each cell allow daylight to reach the rooms below, which open onto terraces shaded by cantilevered canopies.

Hourglass Corral encapsulates many of DECA Architecture's core ideas about preserving the landscape and heritage of the Cyclades islands while facilitating contemporary leisure activities. In particular, the building's cultivated roof references the local tradition of dividing land into areas for domestic and productive uses.

< A mathematical system helped determine the optimal position and size of cells that form the house's rooms and outdoor spaces.

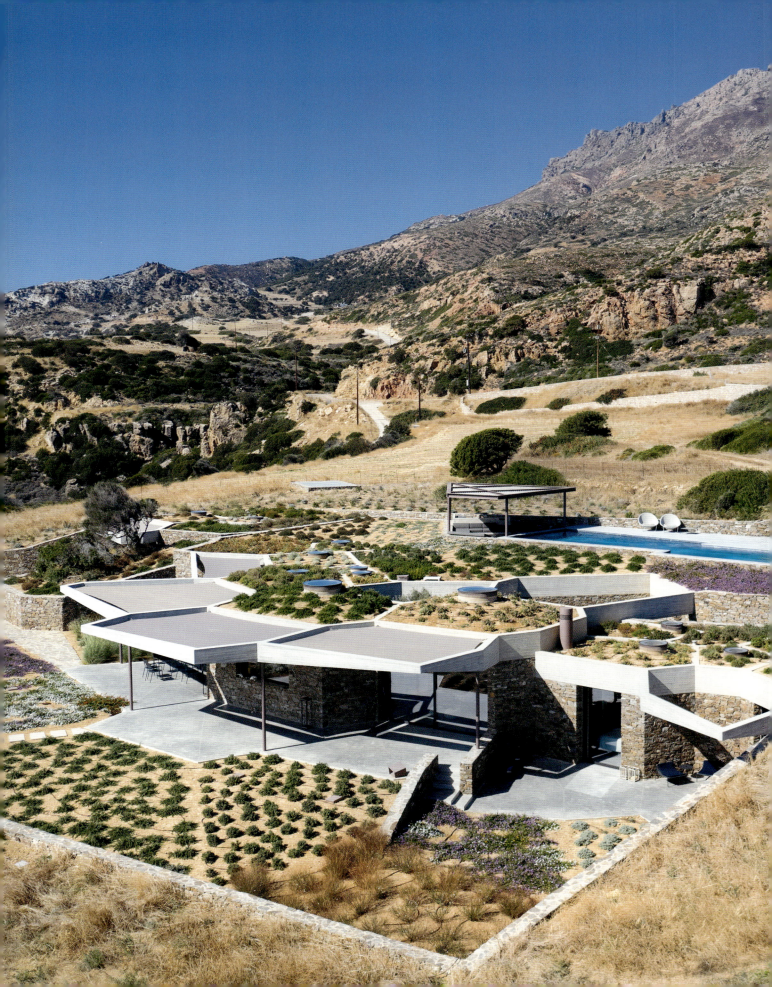

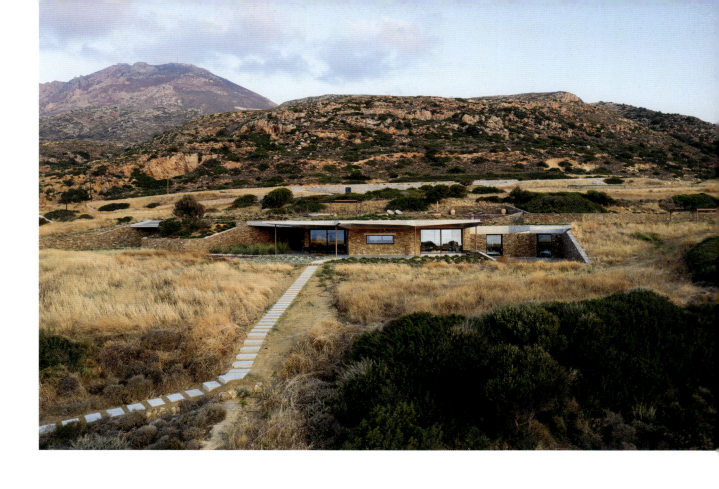

< Each roof cell is planted with a different Mediterranean species that is used to produce essential oils.
∧ The project demonstrates how holiday homes can be designed to support wild, rural and domestic land uses.

House Behind the Roof

Superhelix - Bartłomiej Drabik

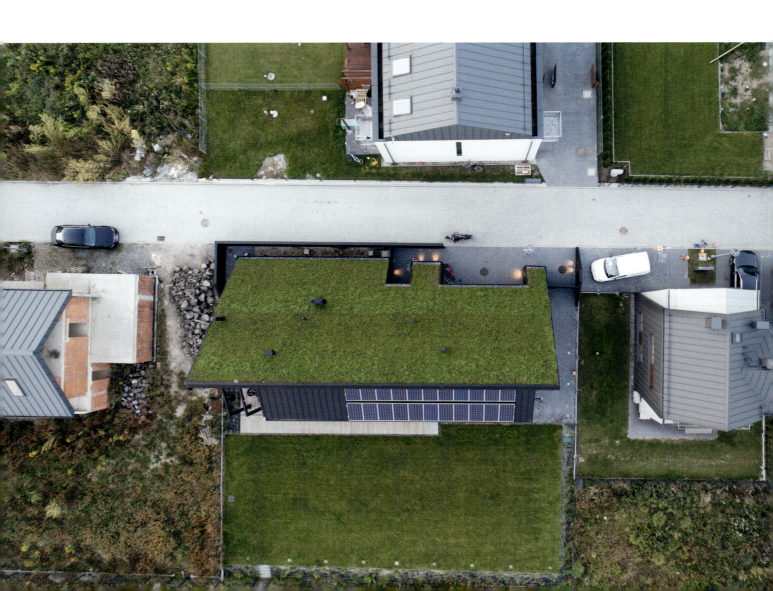

Kraków, Poland

When viewed from above or from the adjacent road this house in a suburb of Kraków, Poland, is almost entirely hidden by its large, sloping green roof. The building is located on an estate comprising ten single-family homes that are clustered densely together due to the high price of land in this area. The angled roof shields the house from view and protects the privacy of its owners.

House Behind the Roof was designed by architect Bartłomiej Drabik in response to local planning regulations stipulating that properties must have sloping roofs. Drabik's proposal features a green roof with a 45-degree pitch that extends almost to ground level on the northern side. The roof's surface area exceeds that of the building itself, therefore increasing rather than decreasing the amount of green space on the site. It is planted with succulents requiring minimal care, which will thrive despite receiving limited direct sunlight.

The roof was constructed using laminated timber beams arranged in a diagonal grid, which is exposed both outside and inside the building. A secondary south-facing roof is topped with solar panels to provide the home with renewable energy. A band of windows inserted between the two roofs allows daylight to penetrate into the centre of the house.

The building's interior features a rectangular plan arranged over two storeys. The ground floor accommodates the main living spaces, as well as a guest room, toilet, utility rooms and a garage. The first floor contains the main bedroom with its own dressing area and bathroom, along with two further bedrooms, a second bathroom and a playroom. Full-height glazing on the ground floor and narrower windows on the level above all look out onto the private garden at the rear, while the street-facing elevation remains windowless to prevent overlooking.

< The house is hidden from the access road and its neighbours by a giant sloping roof.

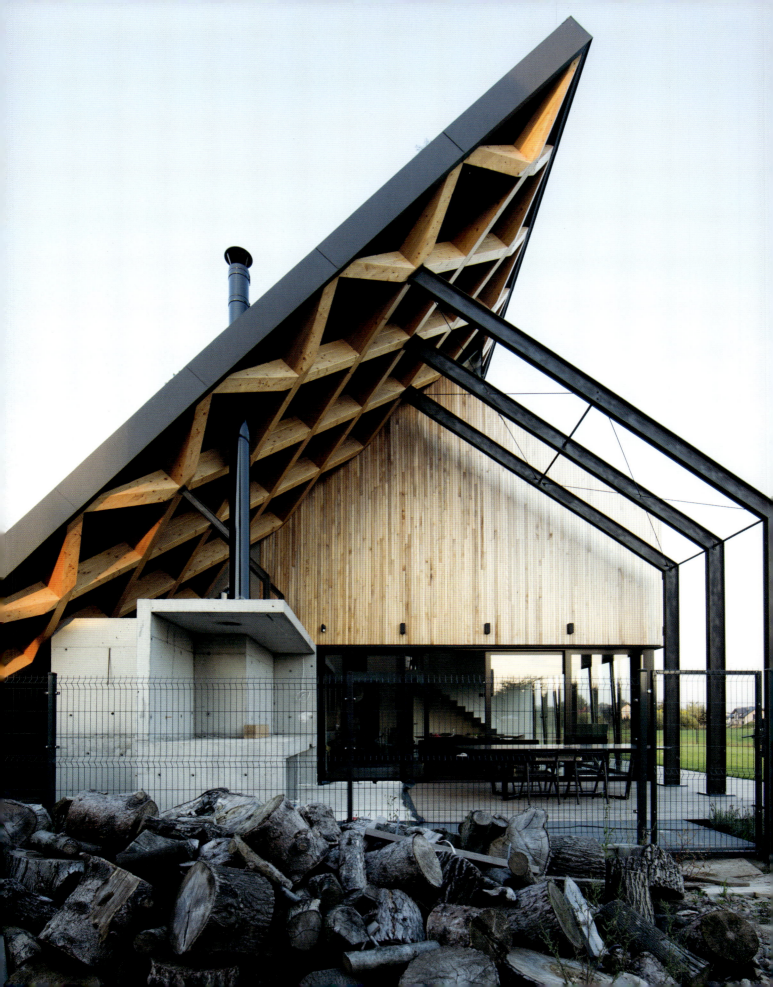

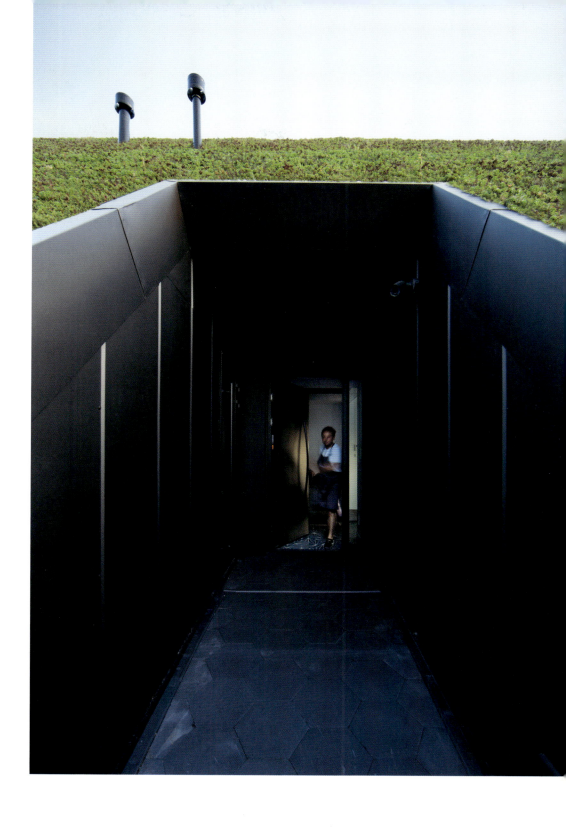

< The roof structure comprises a diagonal grid of laminated timber that is exposed externally and also penetrates the building's interior.
^ The succulents used to cover the north-facing roof surface do not require direct sunshine or regular watering.

Planar House

Studio MK27

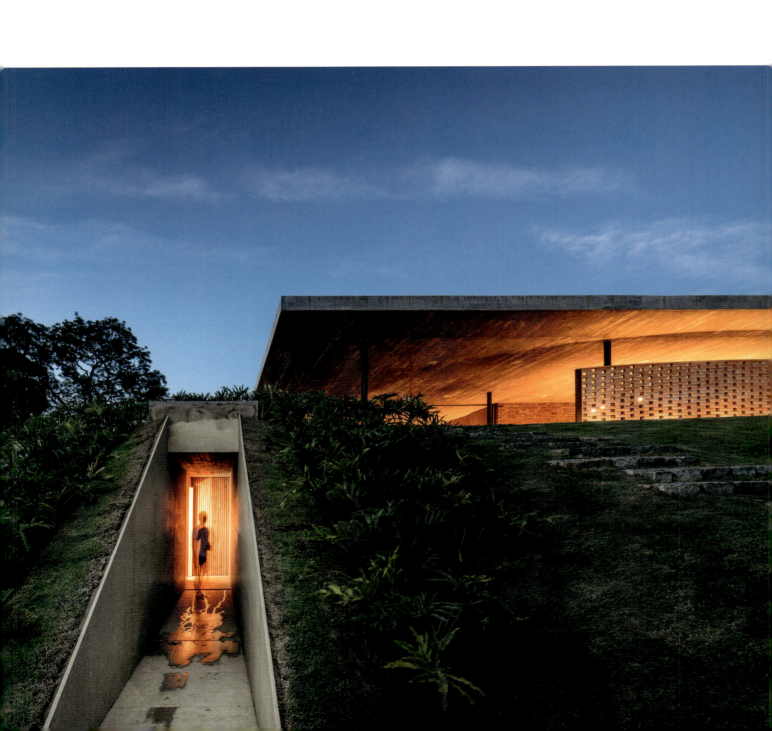

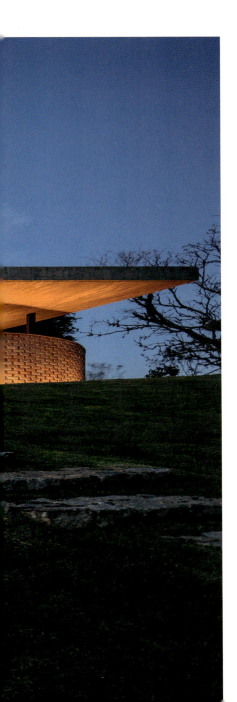

The enormous grass-covered roof of the Planar House by São Paulo-based Studio MK27 completely covers the single-storey living spaces below and ensures the building sits discreetly in its picturesque surroundings. The property is located in the Porto Feliz region to the west of São Paulo and is carefully inserted into the gently undulating terrain in order to minimise its visual impact. The green roof conceals the building from a road above, causing it to appear as a continuation of the surrounding lawn.

The planar surface of the rectangular roof represents a strong expression of the horizontal elements often employed by architect Marcio Kogan's firm in its projects. In addition to camouflaging the house, the green roof helps to insulate the internal spaces. It incorporates solar panels, along with skylights that allow natural light to reach some of the central areas. The concrete slab is supported by a series of cross-shaped metal pillars. It extends beyond the house's perimeter walls to shelter open-air living and dining areas to the south, as well as a car-parking space to the north.

Beneath the roof, a long corridor separates a row of five bedrooms with en-suite bathrooms on one side of the house from a series of service areas including the kitchen, laundry room, a gym and a TV room. The house was designed in collaboration with architect Lair Reis and features interiors by Diana Radomysler. The main living spaces, situated at either end, are enclosed by sliding glass walls that can be retracted to connect the rooms to sheltered terraces. A curving brick wall meanders along the length of the building's east elevation to shield it from the road. This freestanding partition embraces the entrance garden, while its perforated construction creates kinetic patterns of light and shadow as the sun's angle changes throughout the day.

< The house's narrow roof plane is supported by metal pillars and appears to float above a curving, perforated brick wall.

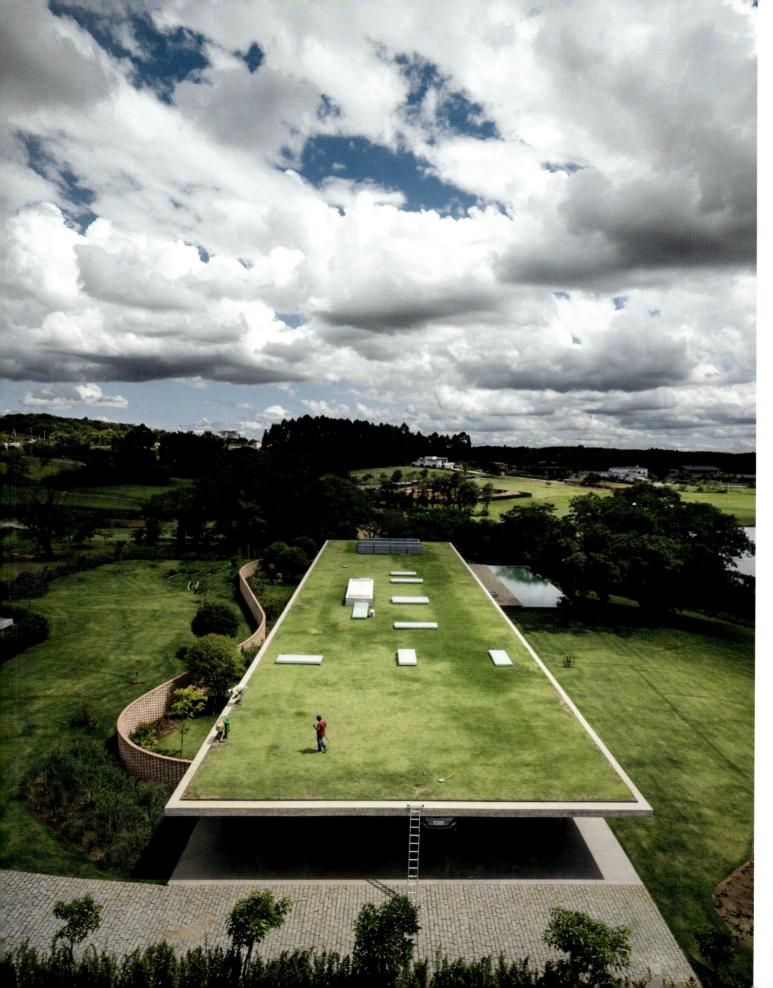

< The green roof mimics the surrounding lawn and contributes to the building's thermal performance.
∧ Sliding glass doors enclosing the living areas can be retracted to turn the entire house into an open-air terrace.

Green Roofs

147.

The Macallan Distillery

Rogers Stirk Harbour + Partners

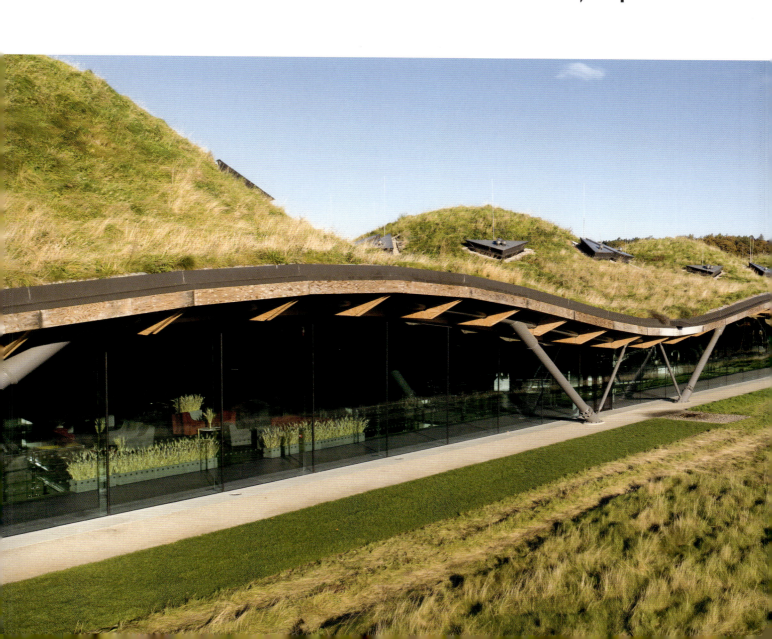

Speyside, Scotland

The undulating green roof of The Macallan Distillery is designed to blend in with the natural landscape of the Scottish Highlands, while expressing its highly engineered, man-made structure. Situated at the heart of the whisky maker's 158-hectare estate, the dramatic and innovative building allows visitors to engage directly with the various stages of the distilling process.

The Macallan, which has been producing single-malt whisky on this site in Scotland's Speyside region since 1824, asked architecture firm Rogers Stirk Harbour + Partners to design a facility that would provide a more immersive, engaging and memorable visitor experience. The new distillery complex includes an open-plan production hall lined with a 10-metre-high glass wall that allows visitors to view the equipment used for mashing, fermentation and distilling. Maturing whisky casks are also displayed in a circular, double-height private cellar within the visitor centre.

The building is dug into the natural sloping contours of the site, which is surrounded by farmland used for growing barley. Its humped form is influenced by archaeological earthworks found throughout Scotland. The architects worked with engineering firm Arup to develop a complex roof structure that rises and falls to reflect the component parts of the distillery underneath. Four of the humps cover the three still houses and mash house, with the taller fifth peak marking the location of the entrance and visitor centre.

The distillery's rolling green roof is one of the largest in Europe, covering an area of just over 12,000 square metres. It was designed to minimise the building's visual impact on the landscape and to evoke the nearby hills. Approximately 380,000 individual components were required to assemble the roof, which combines a tubular-steel support frame with a domed timber gridshell. It is topped with plants chosen to replicate a Scottish wildflower meadow. Inside the building, the warm timber roof is complemented with a simple palette of materials including the locally sourced and hand-made copper pot stills.

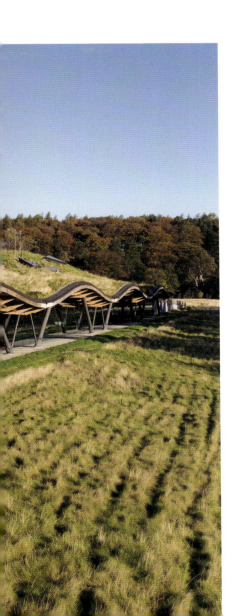

< The distillery and visitor centre's undulating green roof reflects the linear arrangement of the production cells.

∧ The roof structure comprises around 3,600 wooden beams and 2,500 roof panels that are exposed internally.
> The green roof is intended to look man-made, while also evoking the hills of the surrounding countryside.

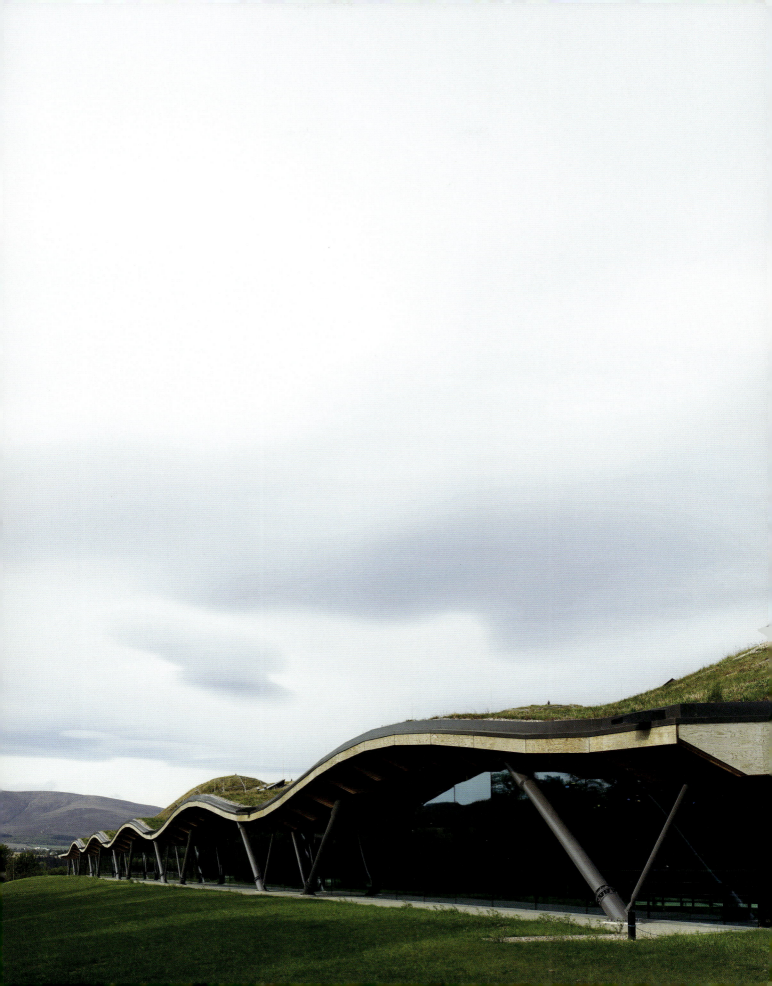

Villa Aa

C.F. Møller Architects

Vestfold, Norway

The owners of a farm near the Oslofjord set out to create a home for the next generation of their family that would be almost invisible when viewed from the existing historic farmhouse. Scandinavian firm C.F. Møller Architects embedded the new residence in a slope below the main property and added a grass roof so it appears as an extension of the lawn.

The design of Villa Aa responds to the site's topography and to regulations outlining what may be constructed in this protected landscape. By integrating the house into the terrain, the architects were able to make the most of views towards the fjord while minimising its visibility. The building's green roof forms an accessible garden overlooking a paved terrace. It incorporates several skylights that provide daylight to the rooms below. In front of the house, a swimming pool and a pond planted with aquatic species evoke the way light reflects off the surface of the nearby fjord.

The villa's main entrance is reached by following a pathway carved into the hill that curves down from the parking area. A small sunken courtyard at the centre of the building provides an alternative entrance, which is reached by descending a set of steps flanked by large planters.

The main living areas and three bedrooms are arranged along the southern side of the property and look out onto the garden through a fully glazed façade. An axis extending east to west towards the rear of the house contains the bathrooms and service areas, as well as a smaller living room and an office that doubles as a guest bedroom. The use of concrete for the house's walls, floors, stairwells, steps and pools references the construction of an existing barn on the farm. The polished concrete flooring extends out onto the large terrace, helping to connect the internal and external living spaces.

< The villa was designed as an invisible addition to a historic farm and is integrated into the landscape below the existing house.

v Skylights penetrating the planted roof allow daylight to reach rooms at the rear of the building.
> The southern façade incorporates full-height glazing with large sliding sections that connect the living areas with a terrace.

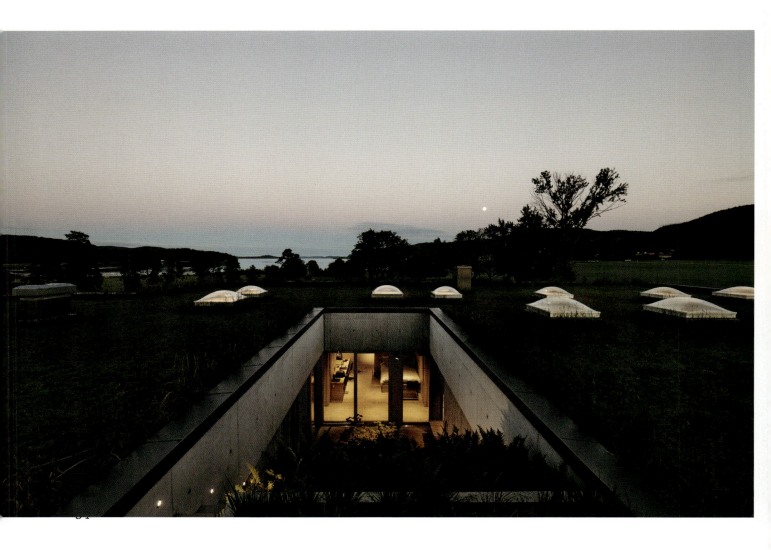

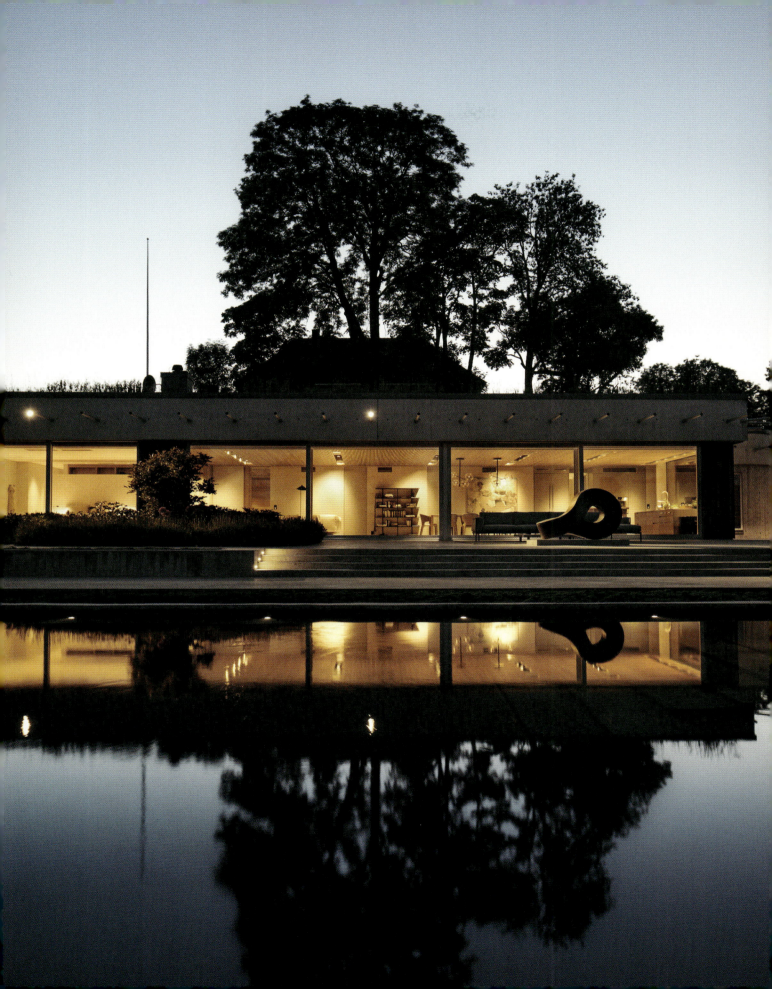

5.

Glass

and Mirrors

5.

Glass is one of the most versatile and ubiquitous of all man-made materials. In architecture, it enables buildings to be made watertight and resistant to weather, while allowing daylight to enter through windows, glass doors or transparent curtain walls. Glazing forms an invisible barrier that can be used to protect and insulate, as well as creating surfaces that allow views into, out from or straight through a building. By taking advantage of the potential for glass to be both transparent and reflective, architects can manipulate how a building's mass is perceived, or cause it to disappear into its surroundings.

Although glass may be used to create a see-through skin enclosing a space, the idea of an entirely glazed, invisible building is generally considered impractical due to the need for a supporting structure and the lack of privacy it would provide. Influential projects – such as the Edith Farnsworth House designed by Ludwig Mies van der Rohe (1951) and Philip Johnson's Glass House (1949) – demonstrated how glass-and-steel construction methods could be used to create buildings with open-plan living spaces surrounded entirely by glazed walls. These buildings were conceived as indoor–outdoor shelters that minimise any visual interruption to the existing landscape and immerse their occupants in the environment. Mies once said: 'We should attempt to bring nature, houses, and the human being to a higher unity.' Glass allows architects to fulfil this objective of bringing people closer to nature.

Many contemporary architects are influenced by the innovative ways in which Mies, Johnson and other twentieth-century modernists used glass. Several of the projects in this book incorporate large glazed surfaces that blur the boundaries between interior and exterior space.

Ernesto Pereira's Cloaked House, which features in the Hidden in Nature section (page 20), looks out through glazed walls across a verdant Portuguese valley. As Pereira points out, the use of glass aims to reduce the building's presence within the surrounding nature, allowing it to 'blend, hide and transform with it'. Slovenian studio OFIS arhitekti's Glass House demonstrates a more extreme and technical approach to building with glass – using it for the structural walls of a retreat in Spain's Gorafe desert (page 174). The triple-glazed surfaces allow views in every direction and help the building to merge with the unspoiled nature.

Just like glass, mirrored materials have an almost magical and illusory quality that can be harnessed to help buildings blend in with any setting. A popular option with architects is one-way mirrored glass, which can be used like standard glass to provide a visual connection with the surroundings from inside. When viewed from outside, a thin metallic coating produces reflections that hide the interior from view, as demonstrated at the Sacromonte Landscape Hotel in Uruguay (page 180). Large glazed panels can be used to cover entire façades, resulting in seamless mirrored surfaces that reflect the sky as well as the surroundings. Mirrored glass clads the striking Depot Boijmans Van Beuningen art storage facility (page 168), which architecture firm MVRDV designed to reflect the surrounding Museumpark and the Rotterdam skyline. The spherical building is covered with 1,664 curved-glass panels, including sections at the base that open to provide vehicle access to the depot and disappear into the façade when closed.

Metal cladding materials such as mirror-polished stainless steel can be used to create reflective surfaces that help reduce a building's visual mass. An added benefit of these materials is that they may be curved or shaped in various ways to create interesting effects. Rural Design's Invisible House in Scotland (page 186) is clad with gently pillowed stainless-steel shingles that soften and distort the reflections. In addition to helping the house merge – 'chameleon-like', according to the architects – with its scenic setting, the shingles create a rippling effect that changes as the viewer moves round the building.

Plastics offer another option for architects looking to introduce reflections in their projects. Mirrored acrylic, polycarbonate and other types of plastic are typically more affordable than glass or metal. They may also be shatterproof, impact resistant, more lightweight and easier to cut to size than mirrored glass. Cost savings were a key reason for architects Ignacio de la Vega and Pilar Cano-Lasso's choice of mirrored methacrylate plastic to clad a compact extension in the garden of their own home (page 164). The material produces slightly warped reflections that enliven the façade while allowing the building to disappear among the dense planting.

The buildings featured in this section all use glass or mirrored surfaces in innovative ways to help them merge with their surroundings. These man-made materials can play visual tricks by allowing us to look through surfaces or reflecting views back at us. They can make a built volume appear smaller than it really is, or make it hard to spot altogether. By harnessing the illusory qualities of glass and mirrors, architects can create playful and mysterious buildings that appear different each time we look at them.

Arcana

Leckie Studio

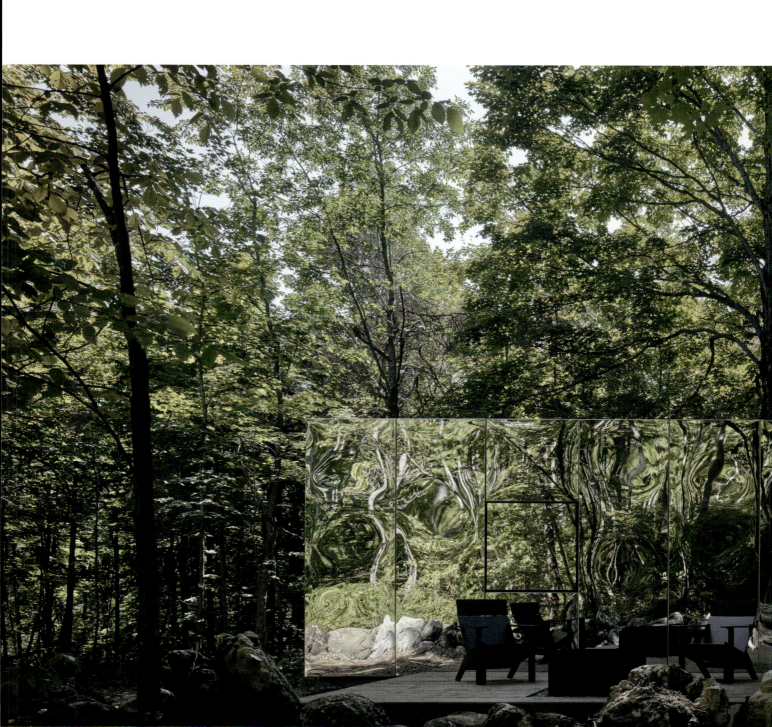

Ontario, Canada

Arcana is a wilderness experience that encourages guests to immerse themselves in nature by staying in minimalist cabins designed to complement their remote forest setting. The compact mirrored structures were developed by Vancouver-based architect Michael Leckie, who is a partner in the company that launched its debut site two hours north-west of Toronto in 2021. The cabins are entirely covered with mirrored panels that help them disappear among the dense woodland.

The design for the buildings evolved from an earlier system that Leckie created following several years of research into prefabricated, off-grid structures. The main aim was to create micro-retreats that can be installed in any wilderness location to let guests connect with nature. Each of the timber volumes is clad with mirror-polished stainless steel that camouflages it in its natural setting. The metal surfaces also produce slightly distorted reflections that prevent birds or wildlife from accidentally striking them.

The original prototype for the cabins featured a queen bed, kitchenette, bathroom and table for dining or working, as well as a private deck with a fire pit that guests can use for relaxing outdoors. Arcana has since developed a larger cabin with a floor area of approximately 25 square metres and a full-height picture window that enhances the sense of connection with the woodland. The pared-back interiors are clad in maple wood with black steel accents to create a calming space that complements the surrounding natural environment.

< Arcana's cabins are covered with reflective polished steel that makes them almost invisible in the deciduous woodland setting.

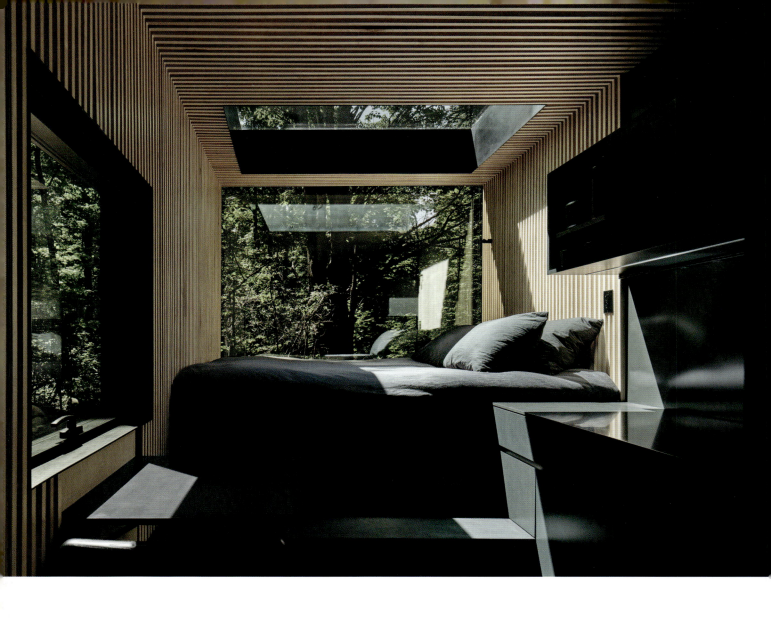

∧ Minimalist interiors ensure the guests' attention is focused on views through the large openings.
> One-way mirrored glazing is used for the large window at one end of the cabin and a smaller operable window in the main façade.

Arcana / Canada

Madrid, Spain

Mirrored panels cladding the exterior of this small residential extension in Madrid, Spain, create distorted reflections that make the surrounding garden feel larger than it really is. Architects Ignacio de la Vega and Pilar Cano-Lasso designed the structure as an affordable way to extend their own house without disturbing the existing garden. The mirrored surfaces allow the building to disappear into the vegetation while concealing the private spaces inside.

Having searched unsuccessfully for a house in the city that would provide the space and connection to nature they wanted, the newlyweds decided to renovate and extend a former painting studio owned by de la Vega's father. The existing building was surrounded by a mature garden, which informed the design of the extension. Rather than imitating the style of the single-storey whitewashed structure, the new addition uses sheets of mirror-finished methacrylate to reflect the nearby plants and pond.

The extension is designed to shield the most private areas of the house, forming a compact hideout that feels protected by its illusory external skin. The project, which the architects called *la madriguera,* or 'the burrow', is an attempt to demonstrate the importance of privacy and introversion in small-scale domestic architecture. Mirrored methacrylate was chosen for the cladding because it offered a more affordable alternative to stainless steel. The plastic also produces intriguing reflections that shift as the viewer moves round the building.

The simple, galvanised-steel structure contains a bedroom and shower room which are both lined with wood to give the interiors a warm and cocooning feel. A carefully positioned oculus looks out towards the garden while limiting direct views into the bedroom. The oculus and other window frames are made from brushed galvanised steel that softens the natural light passing through the openings. A pair of skylights made from the same material penetrate the bedroom ceiling.

< The compact extension features a circular window that looks out onto the adjacent garden and pond.

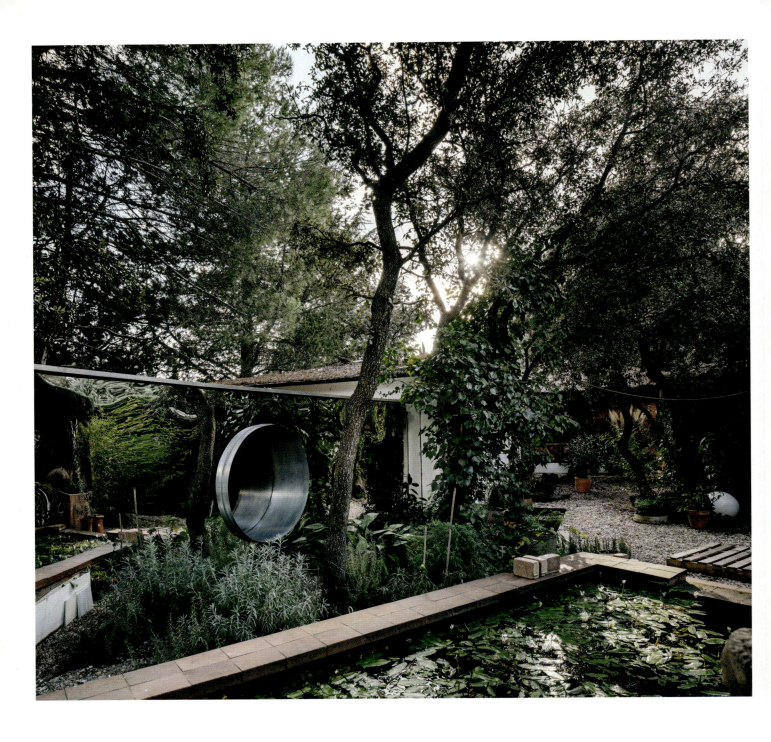

∧ Mirrored cladding produces distorted reflections of the surrounding plants and buildings.
> The oculus is framed with galvanised steel that helps to brigthen the compact living spaces.

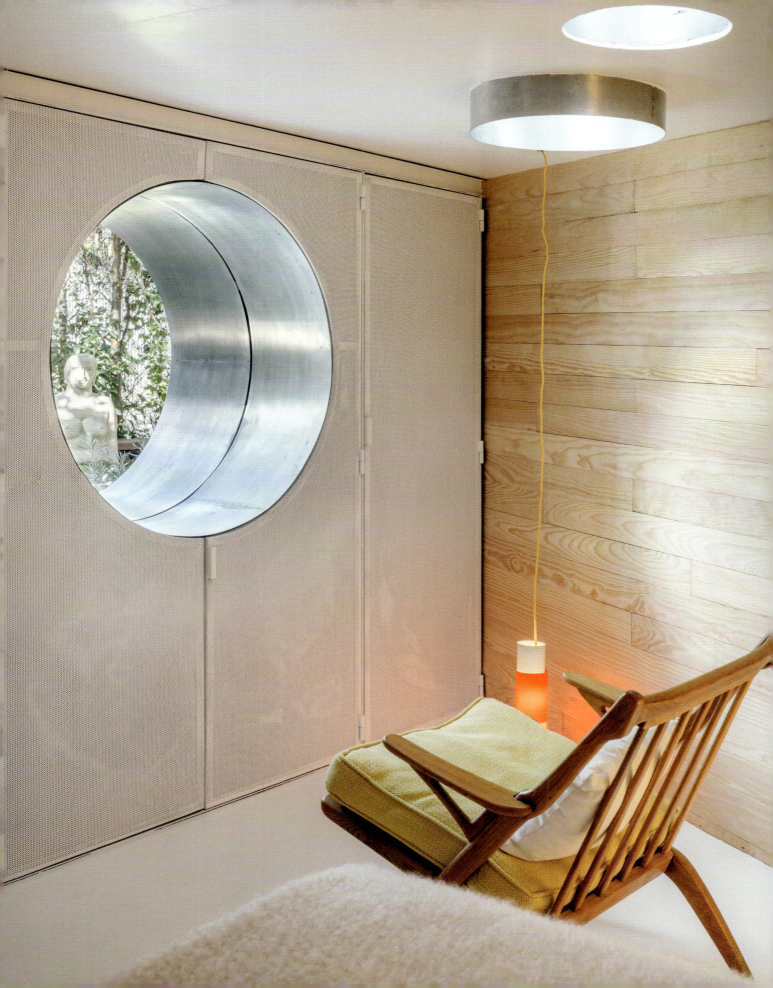

Rotterdam, The Netherlands

When the Museum Boijmans Van Beuningen decided to commission a depot to house its vast art collection, it specified that the new building must blend in with its setting in the centre of Rotterdam. Local firm MVRDV won a design competition held in 2013 with its proposal for an ovoid volume covered with 1,664 mirrored panels that reflect the surrounding park and the city beyond. The result is a seamless, shimmering object topped with trees that enhance its connection with the verdant park.

The Depot Boijmans Van Beuningen occupies a prominent site within the existing Museumpark, which was designed by landscape architect Yves Brunier and architecture firm OMA in the 1990s. The 39.5-metre-tall building is shaped like a bowl with a small base that minimises the amount of space taken away from the park at ground level. The volume expands outwards as it rises, culminating in a publicly accessible rooftop garden populated with birch trees, fir trees and grasses that is larger than the building's footprint.

Whereas the exterior cladding is intended to minimise the building's visibility, the depot's interior seeks to showcase objects that are typically hidden from sight while in storage. The depot is described as 'the world's first publicly accessible art storage facility'. It presents the vast majority of the museum's 151,000 artefacts as they would be found in a typical storage facility, hanging from a rack, displayed in a cabinet, or exhibited in one of the 13 large display cases suspended in the atrium. Fragile or delicate items are stored in controlled environments and may be visited on request. Processes including the conservation, restoration, packing and transportation of the artworks can also be viewed by visitors, who navigate through the building using zigzagging staircases that traverse a central atrium.

< The world's first publicly accessible art storage facility is covered with 1,664 mirrored panels.

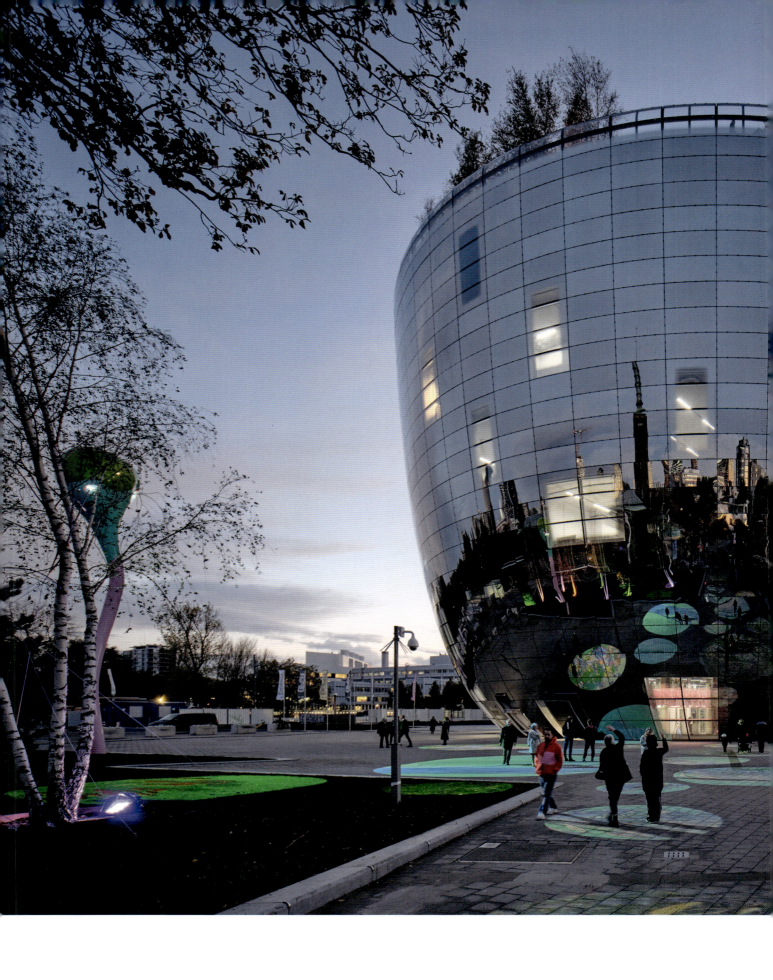

Depot Boijmans Van Beuningen / The Netherlands

Glass and Mirrors

<< The building is topped with a roof garden that expands the park's area and provides views over the city.
v Visitors can view artefacts that would otherwise be inaccessible while being kept in storage.
> Crisscrossing staircases extend past glass vitrines displaying a selection of the depot's collection.

Glass House

OFIS arhitekti

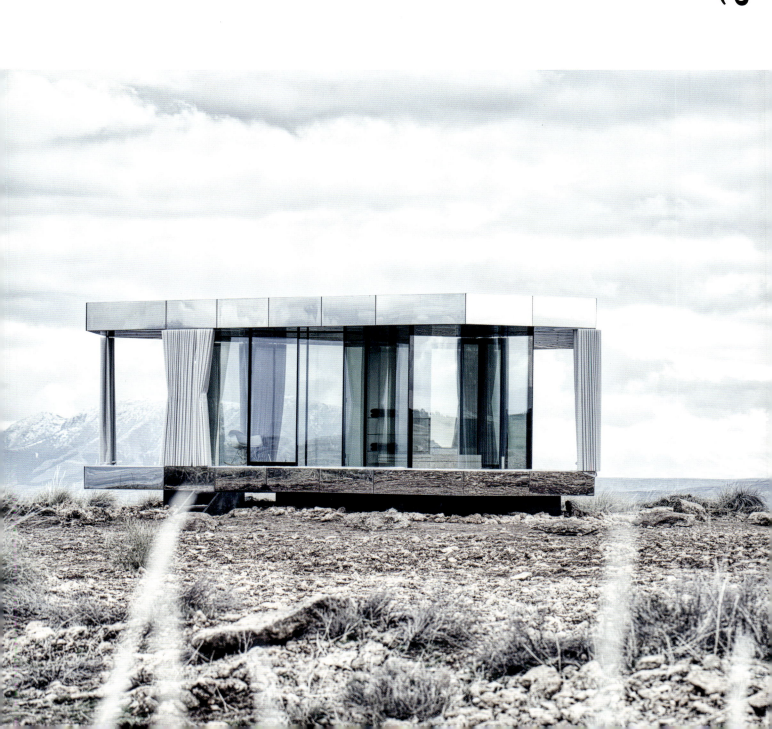

Gorafe, Spain

Slovenian studio OFIS arhitekti looked to push the boundaries of structural glass when designing this prototypal retreat for a site in Spain's Gorafe desert. The 20-square-metre building's supporting walls are made from vertical glazing panels that allow it to melt into the landscape, while immersing its occupants in the stunning scenery.

The project was commissioned by Guardian Glass, one of the world's largest glass producers, as a way of demonstrating innovative uses for its products. OFIS arhitekti was challenged to design a building that responds to the harsh desert climate and provides a comfortable environment for up to two guests. Working with structural engineers AKT ll and climate engineering firm Transsolar, the studio developed a simple cabin that showcases the structural and thermal properties of the triple-glazed panels.

The Glass House is arranged round a central core containing a WC along with storage and a kitchenette. The rest of the open-plan interior is organised into three parts – a bedroom, bathroom and living space – that are enclosed by glass walls, allowing views in all directions. Sliding doors connect each space with an external platform that is shaded by an overhanging roof structure. This wooden canopy is supported by the vertical glazing panels, which also protect the interior from strong desert winds. The thermally efficient glass envelope features an invisible coating to reflect the intense sunlight.

The project aims to limit its impact on the environment by using minimal foundations so the building can easily be removed, leaving little trace behind. The passive design relies on shading to protect the interior against solar radiation, and incorporates roof-mounted photovoltaic cells to produce renewable energy. The use of glass and mirrored cladding also helps to reduce the cabin's visual impact in this unspoiled natural setting.

< Glass House is a research prototype developed to test the structural and thermal properties of glass.

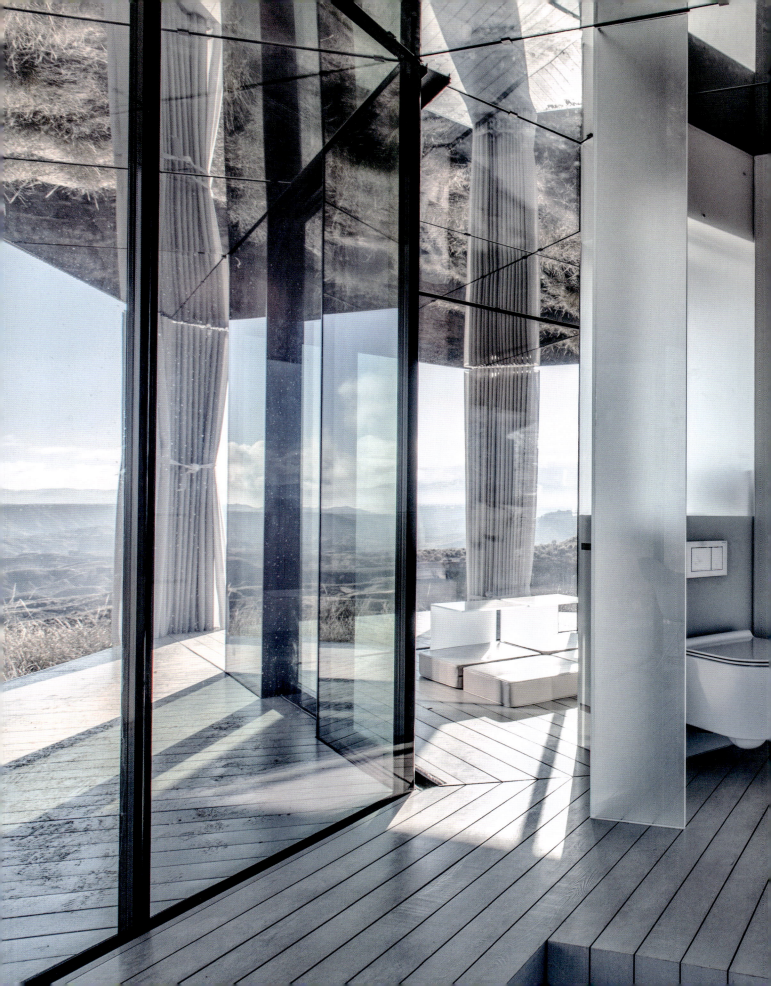

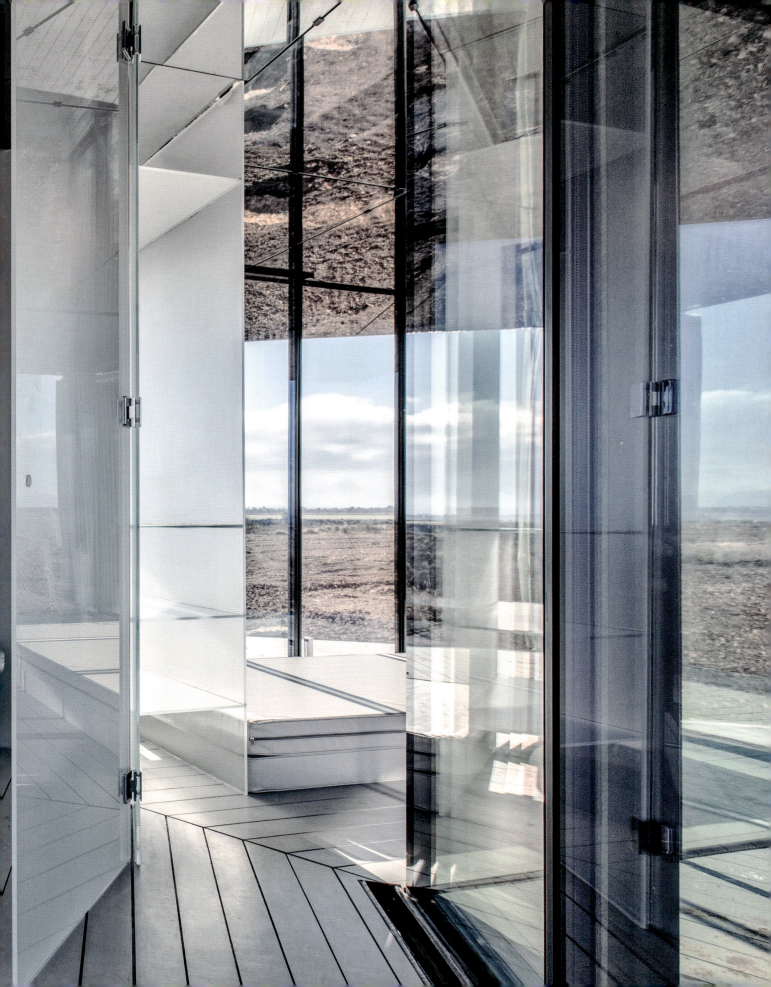

<< The compact interior is arranged around a sanitary core and features mirrored ceilings to enhance the sense of space.
v Vertical glazing panels used as structural walls combine with a mirror-clad shading envelope that protects the interior.

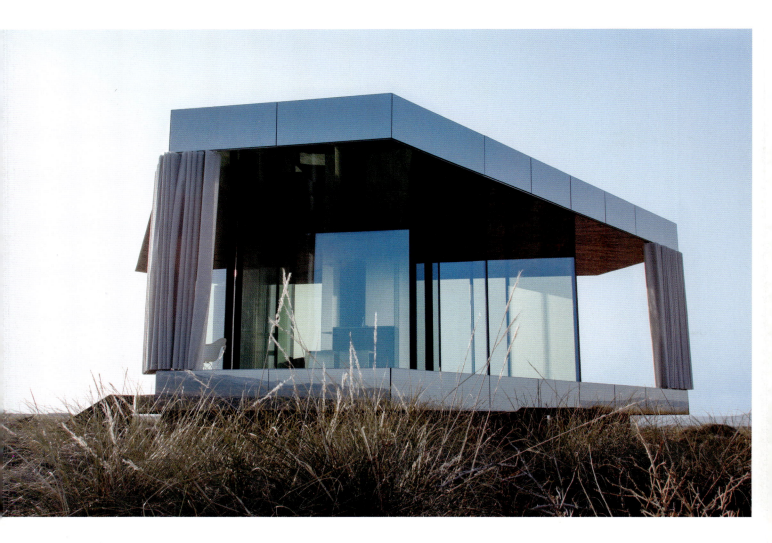

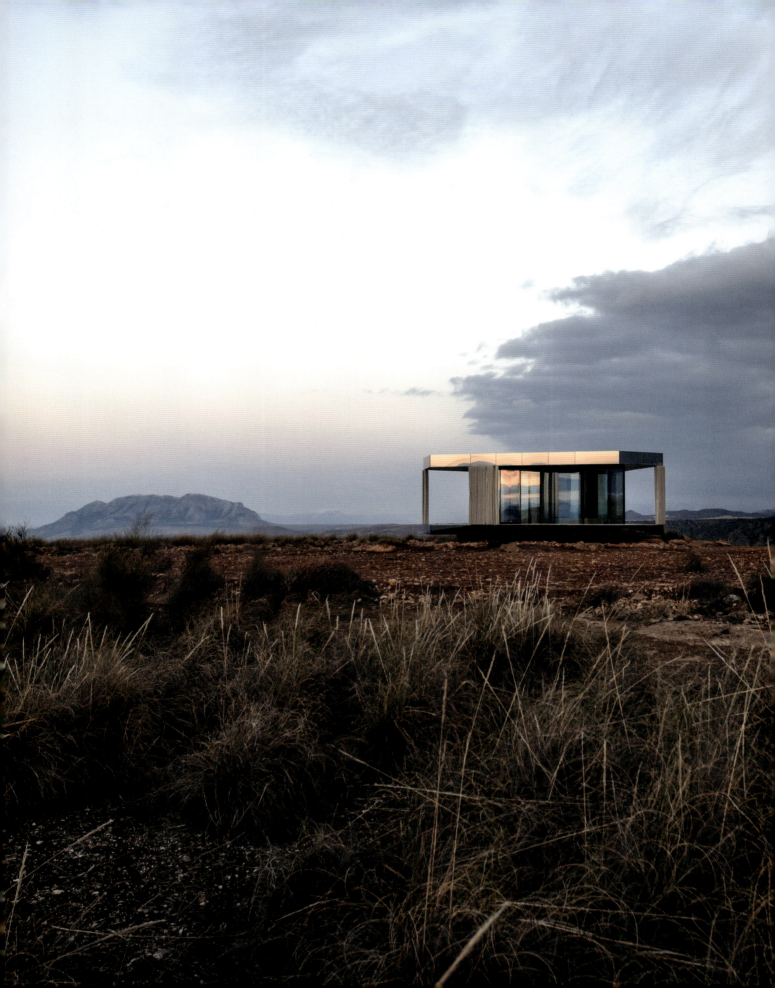

Sacromonte Landscape Hotel

MAPA

Maldonado, Uruguay

Façades made from one-way mirrored glass enable these cabins at the Sacromonte wine estate in southern Uruguay to blend in with the rugged landscape. The seamless glazed surfaces reflect the sky and the undulating terrain, softening the rigid geometric forms and making them almost invisible when viewed from certain angles. Natural materials that clad the remaining elevations complement the surroundings and reinforce the resort's sustainable credentials.

The cabins were designed by architecture firm MAPA as luxury accommodation at the Sacromonte vineyard, which covers more than 100 hectares of wild sierra landscape in the Maldonado region. The four rooms completed so far (nine more are planned to be added later) are carefully positioned within the hilly topography to optimise views and ensure privacy for the occupants. The compact dimensions of the cabins minimise disruption to the unique ecosystem, while their green roofs support the estate's biodiversity.

The buildings were prefabricated in a factory in Montevideo and driven more than 200 kilometres to the site. The metal-framed structures were then hoisted by a crane onto foundation walls made from locally sourced stone. Each plinth is shaped to fit the contours of its individual plot, providing an outdoor living area with a circular pool integrated into the decking.

The 60-square-metre cabins contain an open lounge, dining area and bedroom that looks out onto the landscape. A wall to the rear of this space encloses wet areas including the kitchen and bathroom, along with a fireplace and a cosy reading nook. The rear elevations are covered with circular slices of wood that resemble log piles. Walls at either end are clad with vertical timber slats and incorporate large sliding panels that connect the living spaces with outdoor terraces. The timber façades and green roofs help the buildings blend in with the natural scenery, while the mirrored elevations reflect the ever-changing skies.

< A sheet of one-way mirror camouflages the cabins while expressing their modern construction.

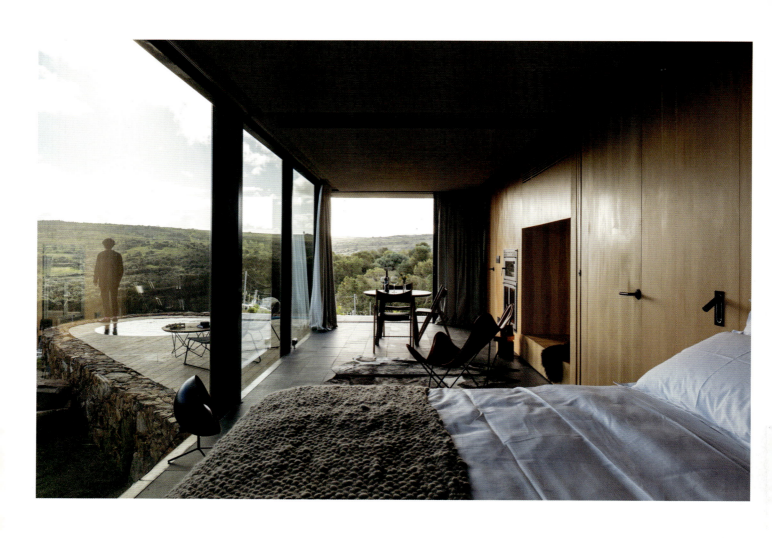

^ A wooden wall separates the open bedroom and living area from functional spaces including the kitchen and bathroom.
> Circular pools inserted into the wooden decking reflect the ever-changing skies.

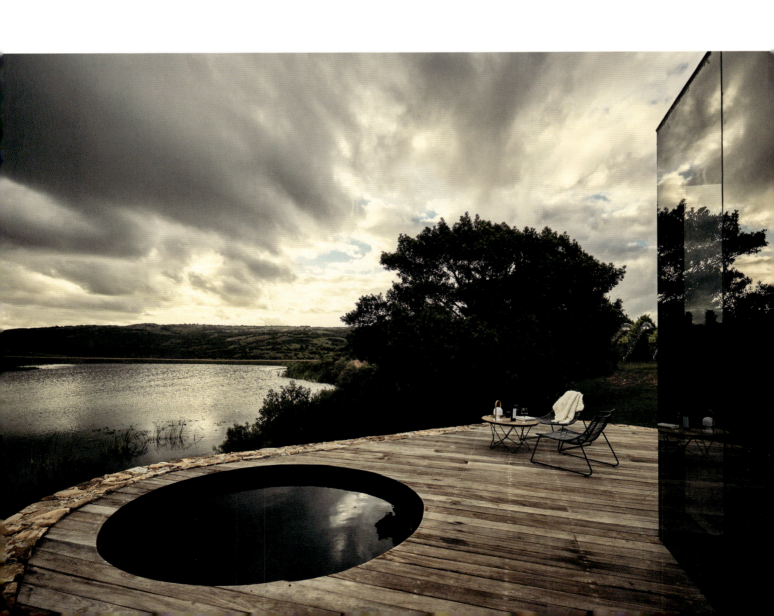

Sacromonte Landscape Hotel / Uruguay

184. The mirrored glass allows an uninterrupted view across the vineyard and the surrounding nature.

Sacromonte Landscape Hotel / Uruguay

185. Glass and Mirrors

The Invisible House

Rural Design

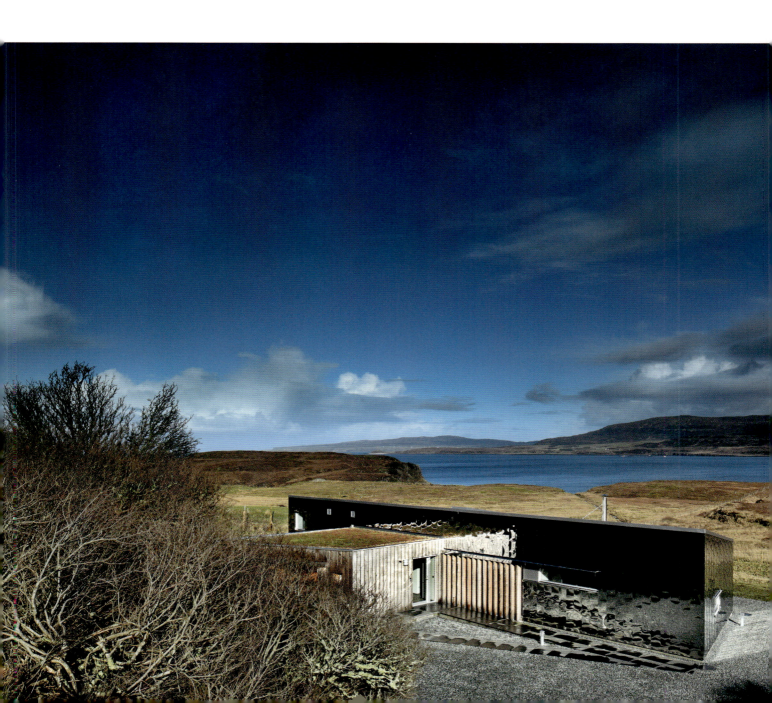

Isle of Skye, Scotland

Local architecture office Rural Design created this mirror-clad house for a scenic site on the Isle of Skye off Scotland's west coast. The original brief was for a two-bedroom house that would replace a derelict stone hut visible from the nearby road. The architects decided to retain and restore this existing landmark, with the new building positioned over the crest of a hill where it is hidden from view.

The clients liked the idea of incorporating reflections in the design, so the architects researched mirrored materials that would be suitable for use in this scenic setting. The solution identified by Rural Design was to clad the building in shingles made from marine-grade polished stainless steel that could be installed straightforwardly by local contractors. Each of the shingles is made from a metal sheet that is bent slightly to create a pillowed form. The gentle bulges soften the aesthetic of the façades and produce a rippling effect as the viewer moves round the building.

The house hunkers down to reduce its visual impact on the site and features large openings that provide panoramic views over the nearby sea loch and its islets. The main shed-like volume is adjoined by two horizontal elements that reference ad-hoc outbuildings and extensions found throughout the region. One of these volumes is clad in stainless-steel panels with a matte finish, while the other is wrapped in larch planks and topped with a grass roof to tie in with the surrounding natural environment.

Internally, the house's linear plan contains an open-plan living space that is bookended by private bedroom wings. The timber-clad entrance volume accommodates a utility area, sauna and shower room as well as external storage, while the steel-covered extension shelters a terrace off the lounge. A palette of natural materials including stone floor tiles and timber ceilings further complements the tones and textures visible outside, enhancing the connection with the landscape.

< The mono-pitched, metal-clad volume is designed to merge with the Scottish scenery.

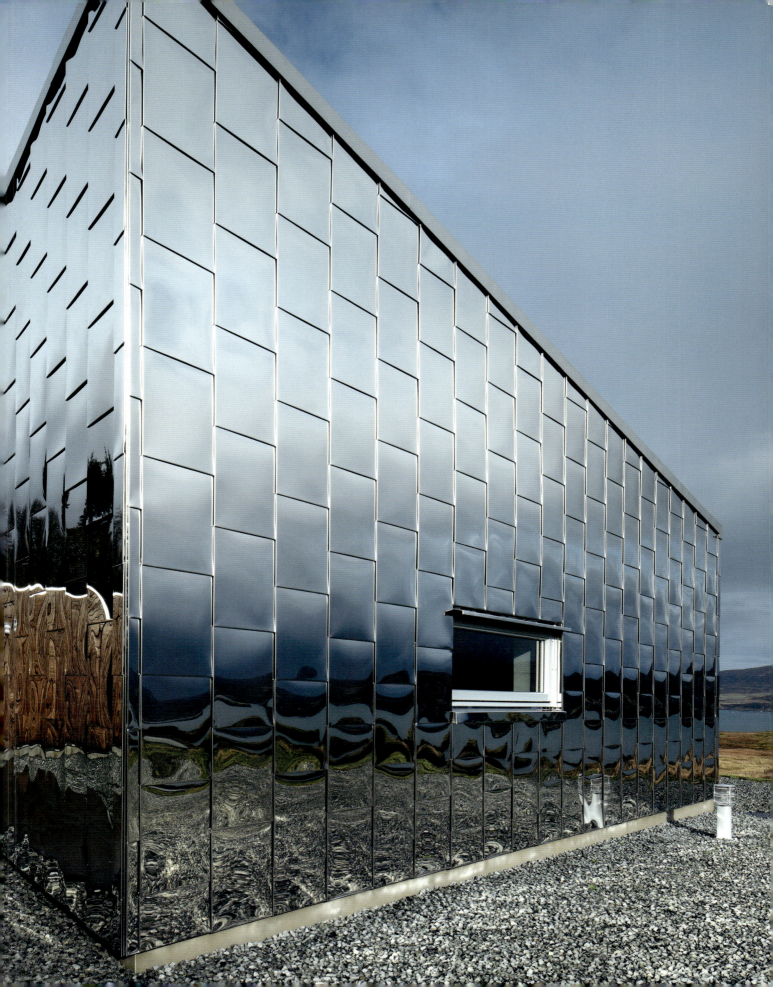

< The building is covered with staggered shingles made from marine-grade polished stainless steel.
∧ The slightly pillowed shape of the metal panels softens the appearance of the otherwise hard material.

189.

v Horizontal additions on either side of the main structure contain a sheltered terrace and utility spaces including the house's entrance.
> The open-plan living space is lined with large openings framing views of the landscape.

credits

Front cover image, Hill Country Wine Cave by Clayton Korte. Photography by Casey Dunn / pp. 12-13 High Desert Retreat by Aidlin Darling Design. Photography by Joe Fletcher / pp. 16-19 Chapel of Sound by OPEN. Photography by Jonathan Leijonhufvud / pp. 20-23 Cloaked House by Ernesto Pereira. Photography by João Morgado / pp. 24-27 Costa Rica Treehouse by Olson Kundig. Photography by Nic Lehoux / pp. 28-33 High Desert Retreat by Aidlin Darling Design. Photography by Adam Rouse / pp. 34-37 House of the Big Arch by Frankie Pappas. Images 1 and 2, © Frankie Pappas; image 3 © Dook + © Visi / pp. 38-43 Holiday Home by Thingvallavatn; architecture by KRADS, photography by Marino Thorlacius / pp. 44-49 Under by Snøhetta. Image 1 © Ivar Kvaal, image 2 © André Martinsen, image 3 © Inver Marie Grini/Bo Bedre Norge, image 4 © Ivar Kvaal / pp. 50-51 Amos Rex by JKMM Architects. Photography by Angel Gil / pp. 54-57 Amos Rex by JKMM Architects. Photography by Mika Huisman / pp. 58-63 House in Konohana by FujiwaraMuro Architects. Photography by Toshiyuki Yano / pp. 64-69 Shiroiya Hotel by Sou Fujimoto Architects. Photography by Shinya Kigure / pp. 70-75 TURF by Landprocess. Images 1-3 by Landprocess; image 4 by Panoramic Studio/Landprocess / pp. 76-79 The Earth by TEAM_BLDG. Photography by Jonathan Leijonhufvud / pp. 80-85 V&A Exhibition Road Quarter by AL_A. Photography © Hufton + Crow. / pp. 86-87 Hill Country Wine Cave by Clayton Korte. Photography by Casey Dunn / pp. 90-93 Hill Country Wine Cave by Clayton Korte. Photography by Casey Dunn / pp. 94-97 Jipyoung Guesthouse by BCHO Architects. Photography by Sergio Pirrone / pp. 98-103 N Caved by Mold Architects. Images 1-3 by Yiorgis Yerolymbos, image 4 by Panyotis Voumvakis / pp. 104-107 Secret Garden House by Scapearchitecture. Photography by Ioanna Roufopoulou / pp. 108-111 Skamlingsbanken by CEBRA. Photography by Adam Mørk / pp. 112-117 The Hill in Front of the Glen by HW Studio. Image 1 by Dane Alonso; images 2-4 by César Béjar / pp. 118-121 Tirpitz by BIG. Photography by Rasmus Hjortshøj - COAST / pp. 122-123 Hourglass Corral by DECA Architecture. Photography by Yiorgis Yerolymbos / pp. 126-129 Åkrafjorden Cabin by Snøhetta. Photography by James Silverman / pp. 130-135 Green Line House by Mobius Architekci. Photography by Paweł Ulatowski / pp. 136-139 Hourglass Corral by DECA Architecture. Photography by Yiorgis Yerolymbos / pp. 140-143 House Behind the Roof by Superhelix - Bartłomiej Drabik. Photography by Bartłomiej Drabik / pp. 144-147 Planar House by Studio MK27. Photography by Fernando Guerra / pp. 148-151 The Macallan Distillery by Rogers Stirk Harbour + Partners. Image 1 by Gordon Burniston Photography. Images 2-3 by Mark Power, Magnum Photos for The Macallan / pp. 152-155 Villa Aa by C.F. Møller Architects. Photography by Ivar Kvaal / pp. 156-157 Glass House by OFIS arhitekti. Photography by Gonzalo Botet / pp. 160-163 Arcana by Leckie Studio. Photography by Andrew Latreille / pp. 164-167 La Madriguera by Delavegacanolasso. Photography by Imagen Subliminal (Miguel de Guzmán + Rocío Romero) / pp. 168-173 Depot Boijmans Van Beuningen by MVRDV. Photography by Ossip van Duivenbode, © DACS 2022 / pp. 174-179 Glass House by OFIS arhitekti. Images 1, 2 & 4 by Gonzalo Botet; image 3 by Jose Navarrete / pp. 180-185 Sacromonte Landscape Hotel by MAPA. Images 1, 2 & 4 by Leonardo Finotti; image 3 by Tali Kimelman / pp. 186-191 / The Invisible House by Rural Design. Photography by Nigel Rigden / Back cover: image 1, Planar House by Studio MK27. Photography by Fernando Guerra; image 2, V&A Exhibition Road Quarter by AL_A. Photography © Hufton + Crow; image 3, N Caved by Mold Architects. Photography by Yiorgis Yerolymbos

Texts
Alyn Griffiths

Copy editing
First Edition Translations

Book design
Tina Smedts – De Poedelfabriek

www.lannoo.com

Sign up to our newsletter for updates on our latest publications on art, interior design, food, travel, photography and fashion, as well as exclusive offers and events.

If you have any questions or comments about the material in this book, please contact our editorial team: art@lannoo.com

© Lannoo Publishers, Belgium, 2022
D/2022/45/20 - NUR: 648/653
ISBN 9789401482103

All rights reserved. No part of this publication may be reproduced or transmitted in any form or by any means, electronic or mechanical, including photocopy, recording or any other information storage and retrieval system, without prior permission in writing from the publisher.

Every effort has been made to trace copyright holders. If, however, you feel that you have been inadvertently overlooked, please contact the publisher.